THE PICTOGRAPHS OF ADOLPH GOTTLIEB

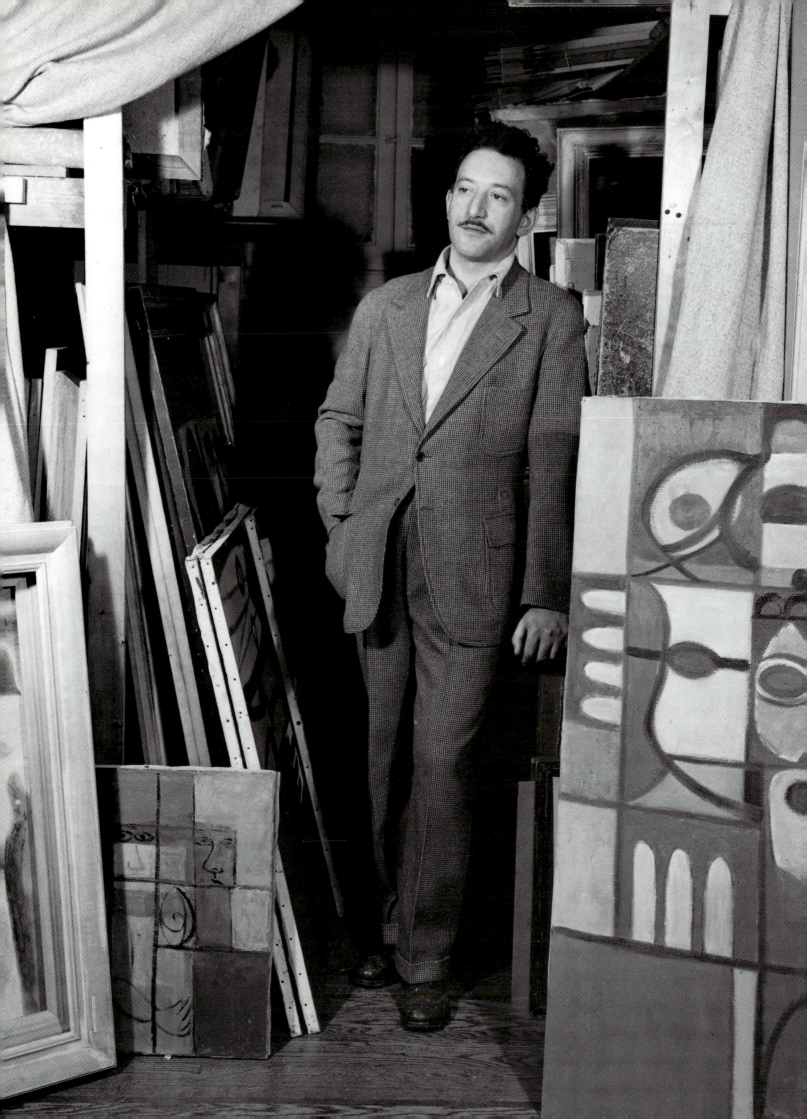

THE PICTOGRAPHS OF ADOLPH GOTTLIEB

Organized by

Sanford Hirsch

for the

Adolph and Esther Gottlieb Foundation

Essays by

Lawrence Alloway

Sanford Hirsch

Charlotta Kotik

Linda Konheim Kramer

Evan Maurer

Published by Hudson Hills Press, New York

in association with the

Adolph and Esther Gottlieb Foundation, Inc.

TOUR ITINERARY

September 24, 1994 – January 2, 1995
THE PHILLIPS COLLECTION
Washington, D.C.

February 4 – April 2, 1995
PORTLAND MUSEUM OF ART
Portland, Maine

April 21 – August 27, 1995
THE BROOKLYN MUSEUM
Brooklyn, New York

November 30 – January 28, 1996
THE ARKANSAS ARTS CENTER
Little Rock, Arkansas

Hudson Hills Press, Inc.
Suite 1308, 230 Fifth Avenue
New York, NY 10001-7704

Library of Congress Cataloguing-in-Publication Data

The pictographs of Adolph Gottlieb / Lawrence Alloway . . . [et al.].—
 1st ed.
 p. cm.
 Includes bibliographical references and index.
 ISBN 1-55595-114-7 (cl.) ISBN 0-9642065-0-1 (ppb)
 1. Gottlieb, Adolph, 1903–1974—Exhibitions. I. Alloway,
Lawrence, 1926–
ND237.G614A4 1994 94-21579
759. 13—dc20 CIP

Cover: *The Enchanted Ones*, 1945, Plate 17

Frontispiece: Aaron Siskind
Adolph Gottlieb in his painting and
storage area, Brooklyn, New York
ca. 1942
Courtesy of Adolph and Esther Gottlieb
Foundation, Inc., New York

CONTENTS

CONTENTS

PREFACE AND ACKNOWLEDGEMENTS

From 1941 to 1953 Adolph Gottlieb created more than three hundred Pictograph paintings. Prior to this survey, there have been two studies focused on these paintings. A 1968 retrospective exhibition of Gottlieb's career, organized jointly by the Guggenheim and Whitney Museums in New York, divided the artist's career into Pictographs and later work. A group of forty-two Pictographs were exhibited at the Guggenheim's facility, accompanied by an essay on the work by curator Diane Waldman. In 1977 Karen Wilkin organized a smaller survey of Pictographs for the Edmonton Art Gallery, which traveled to five other Canadian museums.

Pictographs are mentioned in various histories of American art of the 1940s, but a relatively small number of this important group of paintings has been seen. New approaches to the history of postwar American art have been devised, and new information has come to light since the last review of these paintings. The selection that follows is an attempt to show the range and diversity of this group of paintings. It is the largest group of Pictographs to be seen together, and the essays contained in this book allow for a discussion of several aspects of this significant period in Gottlieb's career.

If one word can be used to describe the Pictographs, it is complex. Much of the discussion about contemporary art today, in 1994, concerns an openness to cultural sources other than those approved as Western "high art." Contemporary art is also involved in a consideration of meaning and intent, which concerns signification and the subjectivity of interpretations, as well as it involves allusion and allegory, and fresh approaches to the formal concerns of painting. These are all issues Gottlieb addressed in his Pictographs of the 1940s. In fact, they are the considerations that motivated Gottlieb to abandon the ideas of painting he knew, and to begin painting Pictographs. He described the radical nature of this shift in his art in 1941, saying that "it looked as if I didn't know how to paint."

Adolph Gottlieb arrived at a critical stage of his art somewhat earlier than most other New York School artists. By the early 1940s his paintings were included in several gallery and museum exhibitions and collections. Gottlieb was an active and respected presence among his peers, as these activities suggest: he was an original member of "The Ten," from 1935, and of the American Artists Congress, although he left that organization in 1939 in protest and became a founding member of the Federation of American Painters and Sculptors; he and Rothko wrote to E. A. Jewell, art critic of *The New York Times* in 1943, defining the content and function of modern American art in a now-famous letter; he organized artists' "Forums" in the

late 1940s and a protest about an exhibition at the Metropolitan Museum of Art, which led him to be identified with a group of artists labeled "The Irascibles."

The success of Gottlieb's paintings demonstrated that American artists could produce work equal to that of their European contemporaries. Ironically, as Lawrence Alloway has pointed out elsewhere, Gottlieb's early start has hindered appreciation of his role as a leader and of the complex paintings he created in the 1940s. Because histories of abstract expressionism tend to look to artists' groups to define the period, or assume a starting point late in the decade, Gottlieb's pioneering role is overlooked. We hope this project will help correct the record.

This survey of Adolph Gottlieb's Pictographs was proposed by Lawrence Alloway in 1987, and he and I began selecting paintings and discussing ideas about the project at that time. Esther Gottlieb was involved as supporter, critic, and invaluable source of information and insights from the beginning. The unfortunate deaths of both Esther, in November 1988, and Lawrence, in December of the next year, made this project more difficult to complete. I have tried to keep in mind their high standards of achievement and their demands for substantial research and insightful thinking. While this cannot be the project they would have produced, I hope they would be proud of the results. This survey is respectfully dedicated to the memories of my good friends Esther Gottlieb and Lawrence Alloway.

Many people deserve thanks for their hard work and dedication to this project. First of all, to the authors who produced original scholarship on different aspects of these paintings while putting up with prodding and cajoling about everything from research material to mudane concerns like deadlines, my appreciation for your efforts and your patience. Charlotta Kotik, Linda Konheim Kramer, and Evan Maurer each contributed substantial essays based on original research. Their different approaches to the Pictographs help illuminate the complexity of these paintings. They are a welcome addition to the scholarship of American art at mid century. Thanking these three talented individuals as a group does not lessen my grateful appreciation for the experience of working with each of them. I have learned much from my discussions with Charlotta, Linda, and Evan, and from the thoughtful essays they authored.

The very hard work of organizing schedules, loans, materials, documents, permissions and more was accomplished through the dedication of Susan Loesberg, with the assistance of Amy van Aarle, of the Gottlieb Foundation. They are also responsible for compiling and updating the bibliography in this book. This project simply could not have been completed without them. Susan and Amy have my sincere gratitude and esteem for many difficult jobs well done.

The production of this book was entrusted to my friends at Perpetua Press in Los Angeles. While credited as an editor, Letitia Burns O'Connor was an important guiding spirit for the production of this book. She played a crucial role in helping structure the book, and her insights and criticisms were invaluable to me. Tish is a challenging, and excellent, collaborator. The design of this book is the result of the talents and good efforts of Dana Levy. This is the fifth project Dana has designed for the Gottlieb Foundation, and it is always a pleasure to work with him. We are fortunate to have the benefit of his skills as well as his good nature.

The many private and institutional lenders to this exhibition deserve thanks and gratitude for their generosity in making their paintings available to the exhibition. The cooperation of each of them is an important contribution to the success of this project.

Thanks are also due to Eliza Rathbone of The Phillips Collection for her many efforts in support of this project and for sharing her insights about the work and this show with me. Bill Siegmann, Curator of African Art at The Brooklyn Museum, was generous in sharing his knowledge of the Gottlieb's African objects and helping to facilitate supporting materials. My grateful appreciation goes to Sylvia Sleigh for allowing us to reprint Lawrence Alloway's *Melpomene and Graffiti* article as part of this book. For their valued assistance in a variety of ways, I want to extend my thanks to Robert T. Buck, Director of The Brooklyn Museum, Ann Freedman, President of M. Knoedler & Co., Paul Anbinder of Hudson Hills Press, Manny Silverman of the Manny Silverman Gallery, Jenny Gillis of the Gottlieb Foundation,

Mary Davis MacNaughton, Director of the Williamson Gallery at Scripps College, Stephen Polcari, Director of the New York branch of the Archives of American Art, Norman Kleeblatt, Curator of Collections at The Jewish Museum, Michael Rosenfeld of the Michael Rosenfeld Gallery, Beth Phillips, Photographer, Margaret Sinozich of Gander & White, Ltd., Pamela S. Johnson, The Brooklyn Museum, and John Ruth of Frenkel and Co, Inc.

To Deborah Beblo, who had the unrewarding task of hearing my complaints and frustrations when things weren't going as I would have liked, my sincere appreciation and gratitude. I hope the results are worth it.

Finally, a special note of thanks to Dr. Dick Netzer, President of the Adolph and Esther Gottlieb Foundation, for his support of our efforts throughout this project and for sharing with me his recollections and reactions to the Pictograph paintings created by his uncle, Adolph Gottlieb, when he was a young man. Dick conveyed to me the powerful impressions these paintings made on his teenage mind and recounted his experience listening to the intense discussions between Adolph Gottlieb and Mark Rothko. The strength of those memories was a frequent reminder to me of the emotional power of these paintings. His belief in this project allowed me to follow through and bring it to completion.

SANFORD HIRSCH
Executive Director
Adolph and Esther Gottlieb Foundation

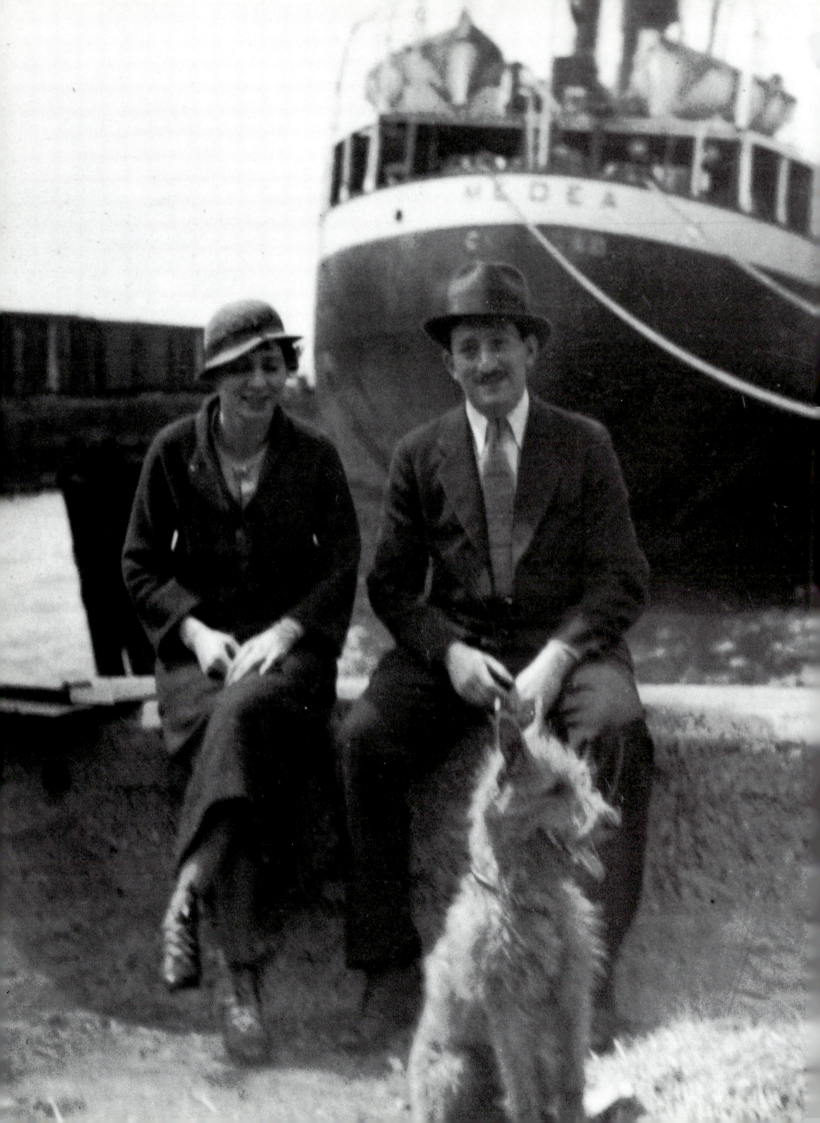

I

ADOLPH GOTTLIEB AND ART IN NEW YORK IN THE 1930s

Sanford
Hirsch

The paintings Adolph Gottlieb created between 1941 and 1953, which he labeled "Pictographs," are fashioned out of a synthesis of cultural material that this artist selected and combined in ways that were totally new. Important as individual paintings and for their impact on other artists, the Pictographs mark a major change in the way modern societies understand paintings. They are, among other things, a critical link between European modernism and American abstract expressionism. While much research has been done recently on the painters of the New York School in the middle to late 1940s, this work by definition leaves out the origins of Gottlieb's paintings, which by that time were being widely exhibited and acquired by major public and private collections. The evolution of postwar American art, especially that group known as abstract expressionist, has its roots in the 1930s—the decade in which these artists were maturing. What we can find by looking to that earlier period is a view of artists working and developing in America in ways far more complex than the commonly held account that little of importance existed on the western shores of the Atlantic until major European artists were forced into exile there in the early 1940s.

For anyone in the arts, or with an interest in world culture, New York in the 1930s and early 1940s was a dynamic center of activity. The idea that it was a provincial town isolated from the great cultural centers of Europe seems to have been predominant among the art establishment of the time and can account for the feelings of insecurity and uncertainty expressed by many American artists and writers of the period. The most curious fact about this misperception is that it persists in historical writings about the period, and thus prevents an accurate view of what artists in New York were exposed to and how that influenced their later development. This view is critical in an essay about Adolph Gottlieb's Pictographs, which owe so much to both European and non-European sources that were accessible to him and his peers.

The Pictographs are a digest of cultural images and ideas drawn from a remarkable spectrum of sources. European modernism, classicism, Native American pottery, sculpture and weaving, Jungian theories of universal archetypes, Freudian theories of the unconscious, surrealism, Oceanic and Melanesian carving and painting, African sculpture, the idiosyncratic theories of John Graham, the art of Pablo Picasso, the writings of James Joyce, and myriad other sources were combined and applied through the medium of the Pictographs. In effect, the Pictographs represent an attempt to contain and reflect, through purely visual means, the experience of one individual in the modern world. They achieve this end by transforming depiction, language, color, and design into coequal, interchangeable indicators, that exist as integral parts of a new kind of painting. As such they anticipate several of the

Adolph and Esther Gottlieb at the
 Brooklyn Pier, Brooklyn, New York
mid 1930s
©Adolph and Esther Gottlieb
 Foundation, Inc., New York

changes that were necessary for the mature painting styles of many American painters who created their most popular work in the later 1940s and early 1950s. For Gottlieb's peers, the Pictographs were an important step away from European ideas about painting.

Gottlieb was a dedicated artist, born, raised, and active in New York City, who began exhibiting with progressive American artists in 1929. His interest in European art had led him on two trips there, in 1921 (at age 17) and again in 1935, which made him unique among his contemporaries. Gottlieb traveled widely throughout France, Germany, Italy, Belgium, and Holland seeking to gain familiarity with works of art in the manner of a young professional aiming at increased knowledge of his chosen field. He was intent on seeing as much of what bore the label of art as he could, regardless of whether it was ancient or modern, European, African, American, or Asian. During his 1921 trip, he visited Paris (where he lived for about six months), Berlin, Vienna, Prague, Dresden, and Munich.[1] Each of those cities, at the time, had major collections of ancient, tribal, classical, and modern art. The 1935 excursion included a visit to the Musée Royale d'Afrique Centrale in Tervuren (near Brussels) and the Rijksmuseum in Amsterdam, and the trip was extended so that Gottlieb could see a major exhibition of Italian painting from the thirteenth through the sixteenth centuries, which was held at the Petit Palais.[2] At the end of that trip, according to Esther Gottlieb, she and her husband used the money intended for their last meal in France to purchase three African sculptures.[3]

The New York to which the Gottliebs returned in 1935 was a hotbed of cultural activity. The art critics of *The New York Times*, Edward Alden Jewell and Howard Devree, regularly complained of the difficulty of keeping up with changing trends and rapidly blending sources. The Museum of Modern Art had embarked on an exhibition program committed to showing contemporary works of art as well as interpreting the concepts that contributed to their existence. Several private galleries, including Buchholz, Pierre Matisse, Julien Levy, and Valentine, specialized in showing contemporary European modernists. The art scene was not as large as that in Paris, but major works by European contemporary artists were available in significant numbers and grouped according to a variety of themes. While the criticisms may have been questionable, reviews of these exhibitions were prominently displayed on the art pages of the major newspapers. In other fields, the works of Joyce, Ezra Pound, and T. S. Eliot were well known and well read; Martha Graham's dances with sets by Isamu Noguchi, a wholly American product, were revolutionizing the art of dance; American film and theater were thriving; and the mostly African-American idiom of jazz was becoming a commonplace of mainstream society.

The series of Pictograph paintings that Adolph Gottlieb began in 1941 originated in this cultural activity. His goal in these paintings was to place himself as an informed and intuitive artist at the center of the creative moment and, by doing so, to reach beyond what he viewed as the academicism that was stifling the art of painting. Gottlieb recalled his state of mind on starting the Pictographs:

> My personal feeling was that I was sort of repelled by everything around me...I was caught between the provincialism of the American art scene and the power of what was happening in Europe. And I felt that as an individualist I had to resist what was happening in Europe because I wanted to be my own man...this left me in somewhat of a dilemma...And I must admit that in the 30s I was sort of caught on the horns of this dilemma...trying to steer a course which would enable me to find myself and do what I felt was something that would be of some significance or anyway related to what I felt was a high standard.[4]

I. SIGNS OF THE TIMES

In the early 1930s, a small group of American artists tried to establish an independent role for themselves, and move away from the prevailing styles of regionalism, social realism, surrealism, and abstract painting. The impulse was not new to them, and several of Gottlieb's generation may have inherited this spirit from the American artists of a previous generation who were their teachers—Robert Henri and John Sloan, for example. Adolph Gottlieb, along with such friends as David Smith, Milton Avery, John Graham, and Mark Rothko, had access to a broad range

of cultural activity in New York. Various trends and ideas were represented in museum exhibitions and art galleries; many new and challenging ideas in the arts, sciences, and cultural studies were flooding into the city as critics, writers, curators, and other established authorities were rushing to define and categorize them. This was occurring at a time in the lives of Gottlieb and his peers when each was beginning to clarify the direction of his or her art. The reactions and evolution of each artist were quite different; but the common thread of an informed and emotional rejection of the major styles of the times, along with a strong drive to succeed as artists, created a forum for discussion and a sharing of values, if not a united program.

At least a few of these artists shared the idea that contemporary European art did not exactly reflect their interests or sensibilities. In the struggle to forge their own identities, some of these Americans considered the art produced by their European colleagues as an obstacle to be overcome, rather than a pinnacle of creativity to be attained. It is revealing to read David Smith's reference to an issue of *Minotaure* bought while he was in Paris in 1935 as "not so good—nature crap," or Dorothy Dehner, at the time married to Smith, writing in the same year that "*Minotaure* is coo-coo." In the same year, painter Clyfford Still wrote, "I realized I would have to paint my way out of the classical European heritage. I rejected the solution of antic protest and parody (Picabia, Duchamp and the theorist Breton) or of the adaptations of the idioms of exotic foreign cultures (Picasso, Modigliani)...."[5] These statements declare the reactions of artists who were developing a sense of values that was simply different from those of their European contemporaries. Gottlieb stated in a 1962 interview, "I didn't want to go in that direction [surrealism] because the concept was too derivative...and I didn't want to be a surrealist any more than I wanted to be a figurist."[6]

Part of the reason for the difference, and for some tension, between the Americans and their European colleagues had to do with the politics of the art world in New York in the 1930s. A review of the exhibition listings of that decade confirms that very few Americans were shown at major galleries or museums. Exceptions were sometimes made for American artists who fit a predetermined style deemed acceptable. For example, in the late 1930s and early 1940s, American art was accepted if it was regionalist or social realist: the type of work Arshile Gorky later referred to as "poor art for poor people"[7] and that Gottlieb labeled "the Corn-belt academy."[8] American surrealists had a brief chance to exhibit in the late 1930s but were invariably compared to the Europeans and judged by the critics to be, at best, worthy practitioners of an approved form. Similarly, the American Abstract Artists, a group dedicated to the ideal of a pure, plastic art, which was born in Europe in the 1910s, had some limited success; but the Baroness Hilla Rebay, who championed the style and ran the Museum for Non-Objective Art (later to become the Guggenheim Museum), preferred the purer European product.

American artists who wanted to participate as equals in developing an idea of modern art were relegated to a few small galleries. This situation was somewhat improved with the opening of Peggy Guggenheim's Art of this Century; but that was not until 1942, and while it provided an alternative, it could not match the exposure or seriously alter the prevailing mass of established opinion, which kept many serious American artists out of public view. The situation was obliquely referred to by Stuart Davis in a letter published in *The New York Times* on October 12, 1941. Davis responded to an article in which New York dealer Samuel Kootz declared that he had not seen any good, new American art in a decade. Agreeing that Kootz was probably correct in claiming not to have seen American art of high quality, Davis went on to argue that the reason the best new American art was not being shown was because of

> the vast hierarchical superstructure that makes its living, or enhances its prestige, on the work of the artist. This group, because of its ownership of all the important channels of art distribution, both economic and educational, constitutes a real monopoly in culture....The power of this group to dictate art policy and standards is enormous, and the artist has no voice whatever in its decisions.[9]

Davis' assertion is borne out by the exhibition records of the 1930s. The major venues were dominated by European artists.[10]

The situation was not lost on Gottlieb and his colleagues. In 1935 a group of painters joined together to hold discussions and organize exhibitions of their own

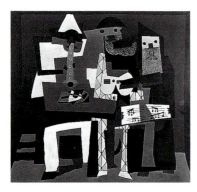

I-I. Pablo Picasso
Three Musicians
Fontainebleau, summer 1921
oil on canvas
6' 7" x 7' 3 ¾"
The Museum of Modern Art, New
 York. Mrs. Simon Guggenheim Fund.

work. Taking the name "The Ten," the original group included Rothko, Joseph Solman, Naum Tschacbasov, Ilya Bolotowsky, Ben-Zion Harris, Yankel Kufeld and Louis Schanker, along with Gottlieb.[11] These young artists shared a sense that neither pure abstraction nor detailed representation was the proper direction for contemporary art. While each had a different approach to painting and the approach of each artist changed and matured over the five years they exhibited together, they all worked toward an expressionist, slightly abstract style.[12] Responding to the bias against progressive American art in the museums and galleries, they organized one of their exhibitions in protest to the policies of the Whitney Museum of American Art, which concentrated on regionalist and social realist themes. The catalogue text of that exhibition notes, "The title of this exhibition ["Whitney Dissenters"] is designed to call attention to a significant section of art being produced in America.... It is a protest against the reputed equivalence of American painting and liberal painting."[13] The Ten exhibited as a group from 1935 until 1940.

While American artists were having a hard time getting their work exhibited in museums and commercial galleries, there was no shortage of modern European painting on view in New York. For most of the decade, two discernible trends could be identified in the galleries which showed works of modern artists. Many claimed a certain legitimacy by exhibiting the work of contemporary artists, but only work that was several years old and thus could claim a pedigree. A few more adventuresome dealers showed the most recent and challenging work. The Museum of Modern Art, which opened its doors in 1929, organized numerous exhibitions based on pertinent and challenging contemporary ideas, not simply showing the latest work but examining the concepts and motivations which underlay the work. Even though there was much activity and the art of contemporary Europe was available in large number and variety, a basic conservatism prevailed that informed the policies of the gallery and museum world of the time. Validation by some existing system was necessary for an artist or a work of art to be exhibited. Whether that was acceptance in Europe or adherence to an accepted style, the result was that very little experimentation was allowed within galleries or museums.

Picasso was both a looming presence and major stumbling block for the Americans. Throughout the 1930s, not a year passed without a major Picasso exhibition in New York. John Graham refers to him in 1936 as the "greatest artist of the past, present and future."[14] In that same year there were no less than four Picasso retrospective exhibitions in New York, and the Museum of Living Art acquired a major painting, *Three Musicians* of 1921 (fig. I-I).[15] While he was widely admired by American artists, their respect for Picasso's work did not translate into parody, nor was it undiluted. In a letter written in December 1934, David Smith reveals one of his aims, which was shared by at least some of his New York colleagues: "I hope to get organized with a viewpoint not subject to the French School and dear old Picasso."[16]

At the same time, New York galleries and museums included a broad range of contemporary art in their exhibitions. To continue with the example of 1936, the Museum of Modern Art held a retrospective of John Marin as well as its famous "Cubism and Abstract Art" and "Fantastic Art, Dada and Surrealism" shows; the Julien Levy Gallery held one-person exhibitions of de Chirico, Dali, and Tchelitchew; and Karl Schmidt-Rotluff, Henri Matisse, Max Ernst, Joan Miró, and many others were presented in major one-person exhibitions at different venues.

Along with the large numbers of modern and contemporary European artists whose work was being shown in New York, the influence of so-called "primitive" cultures was making itself felt in the arts on several levels.[17] Certainly, there was an awareness of European artists' reliance on African or Oceanic models and motifs, and surrealist artists referred to the art of tribal cultures and that of children, the self-taught (also labeled "primitive"), and the mentally ill as vaguely analagous examples of the uninhibited expression of subconscious material. The "Fantastic Art" show at the Museum of Modern Art essentially formalized that notion, including examples of the art of the Renaissance and later Europe, a few tribal objects, some works by children, some by self-taught artists, and some by the "insane." The centerpiece of the show, however, was the section of surrealist art. The exhibition as a whole was organized to demonstrate the surrealist concept that the subconscious had always

of cultural activity in New York. Various trends and ideas were represented in museum exhibitions and art galleries; many new and challenging ideas in the arts, sciences, and cultural studies were flooding into the city as critics, writers, curators, and other established authorities were rushing to define and categorize them. This was occurring at a time in the lives of Gottlieb and his peers when each was beginning to clarify the direction of his or her art. The reactions and evolution of each artist were quite different; but the common thread of an informed and emotional rejection of the major styles of the times, along with a strong drive to succeed as artists, created a forum for discussion and a sharing of values, if not a united program.

At least a few of these artists shared the idea that contemporary European art did not exactly reflect their interests or sensibilities. In the struggle to forge their own identities, some of these Americans considered the art produced by their European colleagues as an obstacle to be overcome, rather than a pinnacle of creativity to be attained. It is revealing to read David Smith's reference to an issue of *Minotaure* bought while he was in Paris in 1935 as "not so good—nature crap," or Dorothy Dehner, at the time married to Smith, writing in the same year that "*Minotaure* is coo-coo." In the same year, painter Clyfford Still wrote, "I realized I would have to paint my way out of the classical European heritage. I rejected the solution of antic protest and parody (Picabia, Duchamp and the theorist Breton) or of the adaptations of the idioms of exotic foreign cultures (Picasso, Modigliani)...."[5] These statements declare the reactions of artists who were developing a sense of values that was simply different from those of their European contemporaries. Gottlieb stated in a 1962 interview, "I didn't want to go in that direction [surrealism] because the concept was too derivative...and I didn't want to be a surrealist any more than I wanted to be a figurist."[6]

Part of the reason for the difference, and for some tension, between the Americans and their European colleagues had to do with the politics of the art world in New York in the 1930s. A review of the exhibition listings of that decade confirms that very few Americans were shown at major galleries or museums. Exceptions were sometimes made for American artists who fit a predetermined style deemed acceptable. For example, in the late 1930s and early 1940s, American art was accepted if it was regionalist or social realist: the type of work Arshile Gorky later referred to as "poor art for poor people"[7] and that Gottlieb labeled "the Corn-belt academy."[8] American surrealists had a brief chance to exhibit in the late 1930s but were invariably compared to the Europeans and judged by the critics to be, at best, worthy practitioners of an approved form. Similarly, the American Abstract Artists, a group dedicated to the ideal of a pure, plastic art, which was born in Europe in the 1910s, had some limited success; but the Baroness Hilla Rebay, who championed the style and ran the Museum for Non-Objective Art (later to become the Guggenheim Museum), preferred the purer European product.

American artists who wanted to participate as equals in developing an idea of modern art were relegated to a few small galleries. This situation was somewhat improved with the opening of Peggy Guggenheim's Art of this Century; but that was not until 1942, and while it provided an alternative, it could not match the exposure or seriously alter the prevailing mass of established opinion, which kept many serious American artists out of public view. The situation was obliquely referred to by Stuart Davis in a letter published in *The New York Times* on October 12, 1941. Davis responded to an article in which New York dealer Samuel Kootz declared that he had not seen any good, new American art in a decade. Agreeing that Kootz was probably correct in claiming not to have seen American art of high quality, Davis went on to argue that the reason the best new American art was not being shown was because of

> the vast hierarchical superstructure that makes its living, or enhances its prestige, on the work of the artist. This group, because of its ownership of all the important channels of art distribution, both economic and educational, constitutes a real monopoly in culture....The power of this group to dictate art policy and standards is enormous, and the artist has no voice whatever in its decisions.[9]

Davis' assertion is borne out by the exhibition records of the 1930s. The major venues were dominated by European artists.[10]

The situation was not lost on Gottlieb and his colleagues. In 1935 a group of painters joined together to hold discussions and organize exhibitions of their own

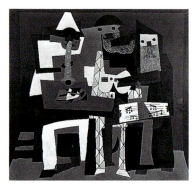

I-I. Pablo Picasso
Three Musicians
Fontainebleau, summer 1921
oil on canvas
6' 7" x 7' 3 ¾"
The Museum of Modern Art, New
 York. Mrs. Simon Guggenheim Fund.

work. Taking the name "The Ten," the original group included Rothko, Joseph Solman, Naum Tschacbasov, Ilya Bolotowsky, Ben-Zion Harris, Yankel Kufeld and Louis Schanker, along with Gottlieb.[11] These young artists shared a sense that neither pure abstraction nor detailed representation was the proper direction for contemporary art. While each had a different approach to painting and the approach of each artist changed and matured over the five years they exhibited together, they all worked toward an expressionist, slightly abstract style.[12] Responding to the bias against progressive American art in the museums and galleries, they organized one of their exhibitions in protest to the policies of the Whitney Museum of American Art, which concentrated on regionalist and social realist themes. The catalogue text of that exhibition notes, "The title of this exhibition ["Whitney Dissenters"] is designed to call attention to a significant section of art being produced in America.... It is a protest against the reputed equivalence of American painting and liberal painting."[13] The Ten exhibited as a group from 1935 until 1940.

While American artists were having a hard time getting their work exhibited in museums and commercial galleries, there was no shortage of modern European painting on view in New York. For most of the decade, two discernible trends could be identified in the galleries which showed works of modern artists. Many claimed a certain legitimacy by exhibiting the work of contemporary artists, but only work that was several years old and thus could claim a pedigree. A few more adventuresome dealers showed the most recent and challenging work. The Museum of Modern Art, which opened its doors in 1929, organized numerous exhibitions based on pertinent and challenging contemporary ideas, not simply showing the latest work but examining the concepts and motivations which underlay the work. Even though there was much activity and the art of contemporary Europe was available in large number and variety, a basic conservatism prevailed that informed the policies of the gallery and museum world of the time. Validation by some existing system was necessary for an artist or a work of art to be exhibited. Whether that was acceptance in Europe or adherence to an accepted style, the result was that very little experimentation was allowed within galleries or museums.

Picasso was both a looming presence and major stumbling block for the Americans. Throughout the 1930s, not a year passed without a major Picasso exhibition in New York. John Graham refers to him in 1936 as the "greatest artist of the past, present and future."[14] In that same year there were no less than four Picasso retrospective exhibitions in New York, and the Museum of Living Art acquired a major painting, *Three Musicians* of 1921 (fig. I-I).[15] While he was widely admired by American artists, their respect for Picasso's work did not translate into parody, nor was it undiluted. In a letter written in December 1934, David Smith reveals one of his aims, which was shared by at least some of his New York colleagues: "I hope to get organized with a viewpoint not subject to the French School and dear old Picasso."[16]

At the same time, New York galleries and museums included a broad range of contemporary art in their exhibitions. To continue with the example of 1936, the Museum of Modern Art held a retrospective of John Marin as well as its famous "Cubism and Abstract Art" and "Fantastic Art, Dada and Surrealism" shows; the Julien Levy Gallery held one-person exhibitions of de Chirico, Dali, and Tchelitchew; and Karl Schmidt-Rotluff, Henri Matisse, Max Ernst, Joan Miró, and many others were presented in major one-person exhibitions at different venues.

Along with the large numbers of modern and contemporary European artists whose work was being shown in New York, the influence of so-called "primitive" cultures was making itself felt in the arts on several levels.[17] Certainly, there was an awareness of European artists' reliance on African or Oceanic models and motifs, and surrealist artists referred to the art of tribal cultures and that of children, the self-taught (also labeled "primitive"), and the mentally ill as vaguely analogous examples of the uninhibited expression of subconscious material. The "Fantastic Art" show at the Museum of Modern Art essentially formalized that notion, including examples of the art of the Renaissance and later Europe, a few tribal objects, some works by children, some by self-taught artists, and some by the "insane." The centerpiece of the show, however, was the section of surrealist art. The exhibition as a whole was organized to demonstrate the surrealist concept that the subconscious had always

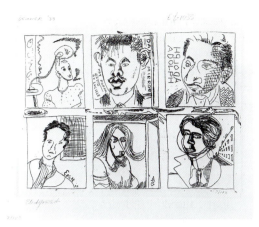

I-2. *Portraits of Adolph Gottlieb, Esther Dick Gottlieb, Edgar Levy, Lucille Corcos Levy, David Smith, Dorothy Dehner Smith*
1933 (print run 1974)
etching
5 ¾ x 7 ¾"
© 1979 Adolph and Esther Gottlieb Foundation, Inc., New York

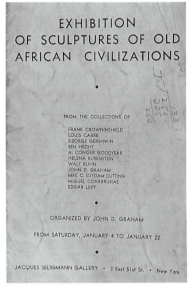

I-3. Catalogue from the exhibition "Sculptures of Old African Civilizations," organized by John D. Graham, Jacques Seligmann Gallery, New York, January 4–January 22, 1936

been the root of artistic thought and creativity in Western cultures, and that work created by untutored and uninhibited hands was closer to the source.[18]

The influence of the surrealists on Gottlieb and his peers was, of course, a major one, and not to be discounted. Many of their theories about art-making, especially those about the importance of subconscious material and the methods of reaching it, were critical to the younger Americans. At the same time, other influences and trends were also affecting American artists, not the least of which was a need, as Gottlieb stated, to find their own voices.

In the 1930s, Gottlieb's circle of friends included his Brooklyn neighbors, artists Edgar Levy, Lucille Corcos, David Smith, and Dorothy Dehner. Like Adolph and his wife, Esther, these married couples were all young artists whose situation as immediate neighbors from 1934 to the end of the decade made their relationship especially close. An etching in which each of these artist creates a portrait of the other documents one evening of their friendship in 1933 (fig. I-2).[19] Milton Avery was another close friend of the Gottliebs and would remain one throughout his life, as were John Graham and Mark Rothko. Barnett Newman and his wife Annalee were also part of the Gottliebs' group in those years. Most of these individuals were dedicated and progressive artists. They were aware of developments in Europe, could see examples in museums and galleries, if not reproduced in one of the magazines like *Minotaure* or *Cahiers d'Art,* which they regularly obtained. As a group, they must have maintained a dynamic dialogue, given their level of interest and involvement and their subsequent achievements.

John Graham appears to have played the role of intermediary between the art worlds of Europe and America for the group of artists of which Gottlieb was a part. Not only was he an artist who had lived in Paris and still traveled back and forth, but he was also an authority on tribal art, serving as advisor to both the Crowninshield and Helena Rubinstein collections.[20] Graham's characteristically lavish estimation of the art of tribal groups is expressed in his book *System and Dialectics of Art,* in which the author proposes abstraction as the highest form of art, and credits prehistoric, African, Greek Archaic and Classic, and some modern artists as representing the highest achievements in abstract art.[21] At least some of Gottlieb's close friends appear to have been involved with tribal arts in the early 1930s through Graham. Letters written by David Smith and Dorothy Dehner to their and the Gottliebs' mutual friends Edgar Levy and Lucille Corcos reveal the length of time that these Americans were actively interested in primitive works and their casual mixing of primitive and contemporary ideas.[22] In a letter dated September 6, 1933, Smith relates details of what seems to have been some dealing in African art:

> Crowninshield has sent me a few things...I'm sending tomorrow a M'pongwe XV Century mask—white face of magic clay rather Chinese looking...Graham intends to have a big Negro art show this winter....[23]

In 1935 Smith wrote to Levy from Athens as he observed the excavations around the Parthenon:

> I've been reading Pliny & Vitruvius & Theophrastus and learning their methods...one realizes what Jesus rococo shit the Greeks did with colored statues too...those beautiful patinas, the result of age and decay—are half of the value....[24]

Graham organized the "big Negro art show," a large exhibition of 134 sculptures, at the Seligmann Gallery in January of 1936 (fig. I-3). Graham refers to African sculpture in his catalogue essay as "an art resulting from a highly developed aesthetic viewpoint; from logical 'argumentation' and consummate craftsmanship....The art of Africa is classic, in the same sense that the Egyptian, Greek, Chinese and Gothic arts are classic."[25]

The Museum of Modern Art had displayed its own exhibition of "African Negro Art," curated by James Johnson Sweeney, in March 1935. Sweeney's show consisted of almost 600 objects including sculpture, artifacts, and weavings. In his catalogue essay, the curator refers to the qualities of African art as "essential plastic seriousness, moving dramatic qualities, eminent craftsmanship and sensibility to materials, as well as to the relationship of material with form and expression."[26]

Far from being a cultural backwater in the 1930s, the range of material on display and themes of exhibitions in New York were as sophisticated as those seen today. Alfred H. Barr, Jr., director of the Museum of Modern Art, led the way in exhibiting an array of culturally and thematically diverse works in his institution

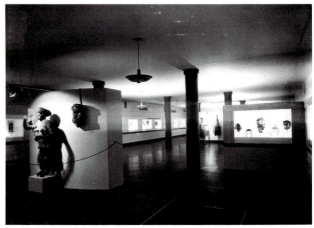

I-4. Installation view from the exhibition "Prehistoric Rock Pictures in Europe and Africa." April 28, 1937 through May 30, 1937. The Museum of Modern Art, New York. Photograph courtesy The Museum of Modern Art, New York.

I-5. Interior of Mask Exhibition. Fall 1939–Winter 1940. The Brooklyn Museum, Brooklyn, New York. Photograph courtesy The Brooklyn Museum.

dedicated to (and known as) "the Modern." In addition to many exhibitions of the works of contemporary European artists and styles, the Museum of Modern Art presented full-scale replicas of prehistoric paintings organized by anthropologist Leo Froebenius in May of 1937 (fig. I-4).[27] As described in a *New York Times* review, the exhibition, installed on three floors, included "splendid facsimile drawings in color. Some of them are enormous. One rock painting...covers, as reproduced, an entire wall at the museum."[28] Another review notes, "Mr. Barr has performed a service by assembling on the fourth floor, for purposes of comparison, some work by Miró, Arp, Klee, Masson, Lebedev, and Larionov, artists of the twentieth century."[29] Among the many other shows at the Modern were "Twenty Centuries of Mexican Art" in 1940 and "Indian Art of the United States" in 1941. Both exhibitions displayed objects ranging in age from the prehistoric to the contemporary.

The Museum of Modern Art was not the only institution that served as a resource for a broad range of cultural material. The Brooklyn Museum, within walking distance of Gottlieb's home at the time and where Gottlieb exhibited some of his work in annual invitational exhibitions, housed large and impressive collections of Native American and Egyptian objects and somewhat smaller collections of African and Ancient Near Eastern work, as well as its notable collection of American art and European works. In 1939 the Brooklyn Museum organized and displayed a collection of 150 masks (fig. I-5) "ranging from a Ptolemaic carvartonnage [sic] mask and the...Fayum portrait encaustic...to modern gas masks, a surgical mask...Tibetan monstrosities, Kwakiutl Indian and Aztec masks, work of mound builders, African and other religious ceremonial masks, Oriental theatrical examples and medieval armor...arranged in groups with admirably terse accompanying descriptive matter."[30] In 1941 the Metropolitan Museum of Art put on an exhibition of art from Australia, which included aboriginal work along with paintings of nineteenth- and twentieth-century artists of European ancestry.

In addition to this activity in the most popular art galleries and museums, New York was home to various other sources which Gottlieb and some of his colleagues used regularly. On permanent display at the American Museum of Natural History, for example, were holdings of art and artifacts of Native America (especially comprehensive was the collection of Northwest Coast tribes, fig. I-6), Mexico and Central America, Africa, and to a lesser degree the Near East. The museum regularly published materials and held lectures on these cultures (fig. I-7).[31] In essence, New York in the 1930s was a perfect breeding ground for a generation of dedicated young artists.

Gottlieb and his colleagues certainly participated in and discussed all this activity. One distinction between Gottlieb and the others in his group was the fact that he had been to Europe on his own as a teenager and had traveled widely and experienced European collections of traditional, ancient, and tribal arts to a greater degree than anyone except Graham. As a result of his experiences, Gottlieb's interests were more defined than those of his colleagues. This made him something of a senior figure in the group.

Gottlieb exhibited with The Ten in the mid to late 1930s, showing expressionist realist paintings along with his friends Milton Avery and Mark Rothko. It was a period and a style that Gottlieb later called a false start.[32] More important perhaps than his

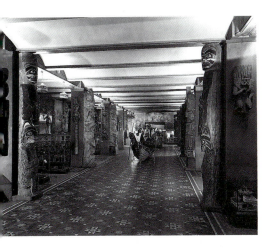

I-6. General view of the Northwest Coast Indian Hall (view from south end of the hall), 1943. American Museum of Natural History, New York. Neg. /Trans. no. 318931 (Photo by T.L. Bierwert). Courtesy Department of Library Services, American Museum of Natural History.

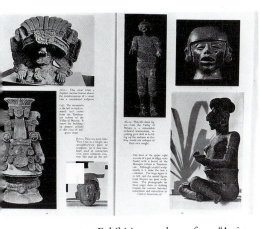

I-7. Exhibition catalogue from "Artists and Craftsmen in Ancient Central America," Guide Leaflet Series, No. 88, by George C. Vaillant, The American Museum of Natural History, New York, 1935 (2nd printing, 1940), pp. 90–91. Courtesy American Museum of Natural History.

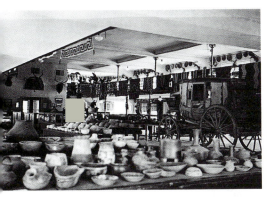

I-8. Arizona State Museum interior, 1936. Arizona State Museum, University of Arizona.

painting at this period were his routine visits to the galleries and museums and his discussions of contemporary issues with his artist colleagues. He also maintained an involvement in a literary discussion group whose members included Barnett Newman and Gottlieb's cousin, the poet Cecil Hemley. Gottlieb's interest in literary ideas was demonstrated earlier, in paintings of the late 1920s based on T. S. Eliot's "The Waste Land," and he maintained an interest in such writers as Eliot, Joyce, and Pound.

In the fall of 1937, the Gottliebs moved to Tucson, Arizona, for Esther Gottlieb's health. It was the first time Gottlieb, as an adult, lived outside New York and away from the pressures of trying to exist as an artist and keep up with the rapidly changing trends for a prolonged period. Mary MacNaughton notes his sense of isolation and ultimately the independence and freedom this gave him.[33] These feelings are borne out by the letters Gottlieb wrote to his friend Paul Bodin in New York. They reveal both Gottlieb's disenchantment with the New York scene and his ability to value works of art from different cultures as equal to those of European heritage. Gottlieb wrote on March 3, 1938:

> We get the Sunday Times every Wednesday and judging from the reproductions, not to speak of Jewell's articles, which reach an all-time high for imbecility, we don't seem to be missing much. From what I gather is going on (aside from Cezanne and Picasso now and then) I wouldn't swap all the shows of a month in N.Y. for a visit to the State Museum here which has a marvellous collection of Indian things (fig. I-8).[34]

and again on April 23, 1938:

> Thanks a lot for the clippings...In general the reviews seem disappointing at least the ones we have seen. I don't know how Milton [Avery] feels—to me it is discouraging. Only the slick painters get the gravy.[35]

That Gottlieb was reassessing his personal approach to painting at a time when the art most easily accessible to him was that of Native American groups was important to the conceptual development of the Pictographs.

By the time he returned to New York in the fall of 1938, Gottlieb's work had changed radically. He had returned to the elements that had first attracted him to painting, the flat planes and subdued harmonies that he admired in the works of Cézanne and Braque. Some of the Arizona paintings were exhibited in New York in 1939 and were criticized by the members of The Ten for being too abstract. This was a period of intense self-examination for Gottlieb, one of a series of such periods which were characteristic of this artist as he reached a turning point. Gottlieb examined all the facets of painting which seemed to him to be of importance. Beginning with the Arizona still lifes, which predict concerns that manifested themselves as "Imaginary Landscapes" in the 1950s, Gottlieb experimented first with abstraction and then with an American type of surrealism reminiscent of artists like Peter Blume or O. Louis Guglielmi, but he didn't produce many paintings in either approach.[36] In 1940 and early 1941 Gottlieb produced wholly abstract paintings, which were formal precedents for the Pictographs. These paintings reflect in part Gottlieb's attempts to synthesize major concerns, in this case, biomorphism and abstraction. The Pictographs themselves reflect what MacNaughton has called a "wedding of Abstraction and Surrealism."[37] The seeds of such integration, however, were inherent in the cultural atmosphere of New York and foretold by events of the late 1930s.

The fears engendered by the destructiveness of modern warfare underlie much of the culture of this century. The destruction wrought by World War I shocked Europe, while the United States was spared most of its horrors. One of the primary reactions in this country was isolationism, which remained a powerful political force until, and for some time after, the attack on Pearl Harbor in December 1941. The danger of widespread conflict in Europe became manifest again in 1936 with the outbreak of the Spanish Civil War. The news media and politicians throughout Europe and the United States tried to avoid the issue of a threatening militant facism by downplaying this conflict. However, many idealistic people from several Western countries volunteered and fought for the Spanish Republic.

Gottlieb and many of his peers were associated with the progressive American Artists' Congress through the 1930s. An art world that had formed its politics around the imminent crises caused by the Great Depression was forced to attention in 1937 with the exhibition, at the Spanish Pavillion of the Paris International Exposition, of

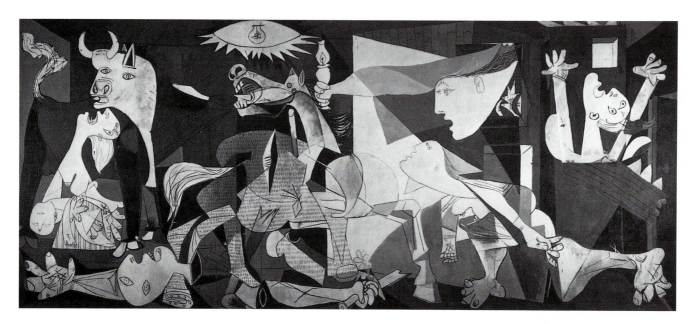

I-9. Pablo Picasso
Guernica
1937
oil on canvas
11' 5 ½" x 25' 5 ¾"
Museo Nacional Centro de Arte Reina
 Sofía. On permanent loan from the
 Prado Museum.

Picasso's *Guernica* (fig. I-9), a painting that confronts the horror and brutality of modern war. Immediately, the exhibition of this painting became the subject of battles among artists, dealers, collectors, and critics. The questions raised serve to point out the revolutionary nature of this painting and the divided thinking within art communities on both sides of the Atlantic. The debate continued for the next several years, at each new exhibition venue.[38] Among those Americans who found fault was E.A. Jewell, chief critic of *The New York Times.* Indicative of Jewell's feelings were statements made in a November 1939 review of the Museum of Modern Art's forty-year retrospective exhibition of Picasso:

> Somewhat the same apparently confused and desperate mood of palingenesis might account also for the shockingly trivial, enormous *Guernica.* Its only merit, so far as I can see, resides in a certain rather elementary structural form. As a social tract the grotesque *Guernica* might well, I should think, be looked upon as libelous.[39]

Alfred H. Barr, Jr., writing of the painting in 1946, included examples of the criticisms leveled at this painting and ends his discussion with a brief and direct challenge to the critics to "point out another painting of the decade, indeed, the century, that is as good."[40] Clement Greenberg, in a 1957 essay on Picasso, finds negative values in the painting based solely on its refusal to rely on the principles of abstraction, as he defined those principles. This sort of comment may serve as an indication of the beliefs of the American Abstract Artists group to whose members and beliefs Greenberg had closely allied himself in the 1930s. Gottlieb, Rothko, Smith, Graham, Newman, and others, however, formed an opposition to the idea of pure art and were dedicated to painting that was directly connected to human experience.

Gottlieb must have perceived *Guernica* as a whole, unlike the many published critics or supporters who concentrated on style or theme. In its entirety, as Gottlieb would have viewed the painting, its revolutionary nature is enhanced. Notwithstanding the attacks on modern society by the surrealists and the dadaists who preceded them, *Guernica* is the first major modern painting to confront the human tragedy that was occurring at the moment.[41] The strategic location of the painting, done as a commission to the Spanish Pavillion at the Paris International Exposition which opened in July 1937, left no doubt about the artist's intention. Picasso's painting, his choice of subject, demanded a formal scheme different from his then-current work. The use of cubist alignments and distortions of form, in conjunction with a localized, literal organization, created a synthesis unlike any previously seen (it is this strategy that Greenberg criticizes). Its purpose was manifestly communicative, therefore in opposition to theories of pure abstraction, and certainly a jolt to those who valued this artist as the master of abstract painting. This one indisputably political painting combined so-called styles in order to succeed in its communication. The very basis of this intent, the idea of communicating to a large audience about a current

political struggle, was an assault on the dominant modes of avant-garde practice. At the same time, Picasso did not dilute his language to promote his message. Instead, he drew from previous work, and *Guernica* is built of the radical but necessary distortions which convey the horrors of a historical moment without pandering to reactionary tastes.

It is clear that New York artists were aware of the painting and the controversies that swirled around it. *The Art Digest*, a popular art magazine of the time, devoted several pages of many issues to the ongoing *Guernica* controversies, reporting opinions at each new exhibition venue. Most of the major daily newspapers in New York devoted large amounts of space and featured numerous reproductions of Picasso's work. Given the time frame of the exhibitions of *Guernica,* the painting becomes a major image in the reportage on the advance of German and Italian fascism in Europe and Africa leading to World War II.[42]

Surely, Gottlieb would have been aware of the singular importance of this painting by an artist he admired.[43] Both the emotional/societal synthesis of Picasso's message and the formal uses of cubist space and distortions to promote communication on an emotional level were devices Gottlieb would adopt in the Pictographs. In a work that is as much a tribute to another painter as Gottlieb ever attempted, the 1945 painting *Expectation of Evil* (pl.21) emulates Picasso's palette and utilizes fragments of *Guernica*'s figures. The Gottlieb painting, however, is informed by the brutality revealed at the end of World War II.

The second major event that produced radical realignments and helped shape direction among New York artists in the late 1930s was an ongoing debate published in letters and occasional articles in *The New York Times* between 1938 and 1941 on the nature of American art. The debate was brought on by two simultaneous events: the exhibition "American Art," which had been organized by the Museum of Modern Art and was being shown in Paris and London before returning to the U.S., and the 1939 World's Fair. "American Art" featured mostly regionalist and social realist painting as examples of contemporary American art. Artists working in other styles must have wondered if they were not American enough, or if American art was not modern enough. Reviews from Paris and London confirmed the worst stereotypes about American artists as naive, provincial, and second rate.[44]

The World's Fair provoked controversy almost from the moment plans were announced for a New York site. Immediately a public battle ensued, the thrust of which was that the Fair's organizers had made no attempt to present American art. This struggle ultimately produced a major building dedicated to the exhibition of American painting and sculpture, which was to be selected through a series of committees located throughout the country. The selection committees were directed to assemble the most equitable and broad representation of American art while remaining neutral to such issues as modernism, abstraction, social realism, precisionism, and any stylistic or conceptual approach. Naturally, the idea of such selection committees and their individual members, ideologies, and choices continued to be points of public and often raucous debate from the time the plan was announced through the end of the Fair.[45] The arguments that ensued, featured regularly in newspapers and art magazines, illustrate the chaotic and searching nature of the visual arts in America at the end of the decade. Essentially, these debates addressed the question "what is American about American art?"

The importance of the World's Fair exhibition was clear enough to the American art community. For the first time American artists would be exhibiting on an equal basis with their European counterparts, and with some certified "masterpieces" of Western art, at a major American venue. As the Fair exhibition became a reality, it produced a temporary but important change in the position of galleries and museums in New York. Since the controversy had become public, institutions large and small stayed open for the summer of 1939 and arranged major exhibitions in which each registered its own opinions on the issue of which styles were valid and which were not. The progressive Museum of Modern Art, in its show "Art of Our Time," which was both a World's Fair show and a tenth-anniversary exhibition that initiated its new galleries on West 53rd Street, again relegated American artists to a secondary status in its view of the modern. Only a handful of American artists were included

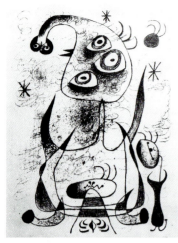

I-10. Joan Miró
Untitled, ed. 5/5
1944
lithograph
28 x 21"
Collection of Adolph and Esther
 Gottlieb Foundation, Inc., New York

among the more than two hundred artists in this important exhibition; and those Americans who did make the show, with the notable exception of Stuart Davis, were either self-taught, regionalists, social-realists, surrealists, or of an earlier generation like John Sloan, Charles Burchfield, and Georgia O'Keeffe.

For Gottlieb and his colleagues, the events of the end of the decade made each question his or her position relative to European art and to the various schools of American art. In Gottlieb's case, the process began in Arizona in 1937 and continued in discussions with Rothko, which lasted into the early 1940s. The art Gottlieb valued crossed every boundary. It originated in contemporary Europe and Mexico, or sixteenth-century Africa, or the Ancient Near East. His instincts forced him to an isolated position, since he could not accept the validity of any of the academies of the time. He valued the human, emotionally moving capacity of visual art, but that was a quality he and Rothko found lacking in the art of this period.

These two Americans took up, in their own fashions, the discussions begun in the press and determined to create a vital American art of international and universal meaning. They found the key to their aims in a search for "subject matter." As Gottlieb related the story,

> I think I managed to persuade Rothko that he had been painting a series of people standing on subway platforms, and I felt this was too close to the notion of the kind of genre painting of the American scene and so on. I had done things myself, perhaps not of people standing on subway platforms, but of a baseball game or a handball game, subjects of that nature....I felt that this was a mistake, and if we were going to find some way of striking out and doing something, the first thing that would have to be done would be to reject this kind of subject matter, this whole approach to painting. So I suggested that let's start with eliminating any subject matter of that sort—let's try classical subject matter and see what we can do with it...It was the practical necessity of first of all getting away completely from the whole cultural atmosphere which we were immersed and breaking through that.[46]

Gottlieb seized on the Oedipus myth because of its multiple associations. Oedipus is a classical theme, a traditional subject for European artists of many periods, not the least of them being the surrealists. In that respect, Oedipus is important for its Freudian association, and that connection, typical of Gottlieb's humor, is another important link—for just as Oedipus is the quintessential dilemma of separation, it is Gottlieb's declaration of independence from his surrealist contemporaries. As the Pictographs developed, each image was selected for its potential to carry several meanings and to combine with other images on a single surface in many ways, thereby creating added levels of meaning and potential meaning. The processes involved may begin with the automatic writing of surrealism, but they lead directly to the interplay of layers of personal and universal meaning which characterize later abstract expressionism.

II. THE IDEA OF MYTH AND THE PAINTING AS OBJECT

> By 1941 I had discarded all the things that might have won me a prize...In fact, I couldn't even get a show because it just looked as if I didn't know how to paint....In 1941, the thing as far as I was concerned started with some conversations I had with Rothko in which I said I think one of the ways to solve this problem that confronts us is to find some sort of subject matter other than that which is around us. ...I said, how about some classical subject matter like mythological themes? And...we agreed to do that, and Mark chose themes from the plays of Aeschylus and I tried, played with the Oedipus myth, which was both a classical theme and a Freudian theme. And, as a result, we very quickly discovered that by a shift in subject mattter we were getting into formal problems that we hadn't anticipated. Because obviously we weren't going to try to illustrate these themes in some sort of Renaissance style. We were exploring. So, suddenly we found there were formal problems that confronted us for which there was no precedent, and we were in an unknown territory.[47]

Among the most widely discussed elements in Gottlieb's Pictographs is his use of elements of classical mythology. The references to specific myths in titles and the images relating to several key elements of mythology serve to inform and direct the paintings through the context Gottlieb called "subject matter." Understanding what he meant by this phrase involves some degree of translation, as the paintings are not about myth. The references to mythology are an integral element of these paintings

and serve various functions as the paintings evolve. However, it is important to understand Gottlieb's process in developing the form, for, as he said of himself, he was a conceptual painter. He explained his thinking in a 1962 interview with Martin Friedman:

> It started with the myth, and at the time I was interested in the idea of myth, and perhaps I should explain why I was interested in myth. The interest in myth was in the air; there were a lot of poets and literary people concerned with myth and I felt it might be possible to do something with mythological subject matter apropos to the kind of subject matter that was prevalent at the time. There was the usual scene painting and the Americana type of subject matter.
>
> I had an idea that in order to arrive at a style and to develop painting ideas which would not follow the pattern of Surrealism, a purist kind of abstract painting or the Americana type of painting, it would be necessary to have an entirely different subject matter; and therefore, using the myth, the idea of myth as subject matter, really a form of sort of a groping for subject matter which would be personal and could be integrated with some notion of style and painting ideas.
>
> And I felt that any art in which style is highly developed always had a concept in which the style and the subject matter and the means that were employed were all tied together; and you couldn't just indiscriminately apply a style of painting to any subject matter.[48]

Gottlieb's orientation, his own understanding of the values of art, centers around a particular concept of the art object. It is a concept that owes a great deal to John Graham and to the African sculptures that Gottlieb admired and collected; his goal was for an integrated object which would ideally become the manifestation of the concepts it was intended to convey. At the same time, the concepts that Gottlieb valued and sought to convey owe a debt to the exhibition policies of institutions like the Museum of Modern Art, which repeatedly exhibited African, American Indian, "primitive," and other nontraditional types of art under the banner of modernity.[49] Gottlieb's resolution of this issue is in the formal presentation of the Pictographs. In these paintings, which produced in Gottlieb the feeling that he no longer "knew how to paint," European ideas about painting are supplanted with those of tribal cultures. The painting is not a picture window onto reality, a vision of the subconscious, a statement of purist philosophy, or a view of the landscape. It is, instead, an object meant to be interpreted by the viewer and to affect the viewer at a primal, emotional level.[50] Beginning with the Pictographs, painting has adapted a non-Western form. It has become a repository for a mixture of cultural, sociological, and personal themes—a mythic object for a modern society.

This concept, a radical departure from European notions of picture-making, ultimately became one of the foundations of abstract expressionism and much of the painting that followed.[51] The integrated painting/object is the formal dimension of the Pictographs. The critical difference between these paintings and their immediate predecessors, and the break with European tradition and modernism, lies in this distinction. European painting, even that most contemporary type of the late 1930s, the abstract-surrealist picture, was just that—a picture. The terms used to describe and the means used to convey information are organized around an idea of depiction or display. Communication is effected through the artist's act of laying down symbols, be they words, pictures, diagrams, or abstract shapes, on a plane within a delimited set of boundaries. The viewer approaches these messages passively, after the fact of their inscription, and interprets them on the basis of culturally acquired knowledge. Paintings, in the traditional sense, are meant to be "read." Even the most radical of the surrealists, artists like Masson or Miró (fig. I-10) who worked in an abstract vein, were dealing in what they termed "automatic writing." This form, as it was used in Europe and in America by such artists as Robert Motherwell and, initially, Jackson Pollock, did not seek to differ from the basic, narrative construct of writing.

Gottlieb's Pictographs rebel against this notion of visual art as writing. They posit an active role on the part of the viewer. They do not depend on the viewer's cultural training or acumen for interpretation. Gottlieb consistently held that these paintings were not meant to be "read," and they have been most maligned by those oriented in Western tradition who therefore insist on forcing readings on them. To interpret a Pictograph in one fashion is certainly valid, but the inherent strength of

these paintings is that they will continually redefine themselves to different viewers, or even the same viewer over time. As Gottlieb valued the role of artist as "image maker," he created and combined images that would continue to remake themselves.

This integrative concept remains so radical, even now, that many critics and historians attempt to interpret the "symbols" of the Pictographs or the psychology of the artist, or to find the antecedents of the formal evolution of these paintings. Others apply various strategies of reading the paintings in a traditional Western sense, viewing them as depictions, albeit mysterious and symbolic ones. The major importance of Gottlieb's concept (considering the relatively high visibility of Gottlieb's paintings during the early 1940s) is that it allows the departures from European styles of his colleagues such as Pollock, Rothko, Newman, and others, all of whom speak of their later work in terms strikingly similar to those Gottlieb used in reference to the concepts on which the Pictographs were based.[52] The shift in emphasis from a field used for depiction, no matter how abstract the depiction, to an integrated object, no matter how flat or what vestigial remnants of the depictive tradition persist, is the leap of faith which determines the difference between European and American avant-garde painting of the period. It begins in America with Gottlieb's Pictographs of 1941.

The choice of myth as subject matter had several motives. Of course, there was the example of the surrealist concentration on mythology and its association with the Freudian concepts to be found in the Oedipus myth. Yet, as Gottlieb stated, his interest in Oedipus was due to the myth's having both a classical and a Freudian theme. The particular way in which Gottlieb introduced mythological subject was a rejection of surrealism's dominance of at the same time that it declared the American artist's sophistication in relation to his European contemporaries. The Pictographs utilize basic themes of certain myths as a link with classical Western themes and, via that linkage, to connect with the emotional foundation of world art. It is, in effect, a Jungian interpretation of Freud. For Gottlieb, and his colleague Rothko, the themes of classical mythology linked all the major periods of Western art.

Gottlieb was familiar with Jung's theories of universal and archetypal images, and the images he set down can be easily identified within a Jungian system. It is less certain that the Jungian images Gottlieb used are related to mythology in the ways that system would assume. That is, Gottlieb was not a doctrinaire Jungian, nor was he undergoing formal or self-analysis, and he did not pretend to be. He probably felt that Jung's theories provided further validation of his own. This eclectic view, which may owe something to John Graham, can account for his inclusion of Freudian ideas as equivalents to Jung's, rather than choosing one over the other. If asked to explain this apparent dichotomy, Gottlieb would probably say that it was not his business as he was not a psychiatrist but a painter.

Emphasizing the theme of rejection, Gottlieb selected the myth of Oedipus as the beginning of his development of an American art. That tale, a classic of Freudian allusions, relates precisely the concepts that Gottlieb wished to express. Beginning with the surrealist appropriations of Freud, Gottlieb chooses the Freudian center-piece of rejection of the father; that is, Gottlieb's choice of Oedipus reflects both his awareness of surrealist dominance and his need to break with that system. Similarly, the Oedipus myth is concerned with seeing and blindness, with the centrality of perception, as symbolized by vision. What better theme, then, for an artist whose belief in painting as a purely visual means of communication was central to his efforts. At the same time, the polar opposites of vision and blindness are a prophetic start for an artist whose life's work would center around the irreconcilable conflicts within the human personality and the tensions inherent in their constantly shifting attempts at balance.

Gottlieb's means of using Oedipus concentrates on the image of the eye, seeing and blinded. Despite the centrality of themes of brutality and sexuality in the Oedipus myth, it is interesting to note that the incest theme is nowhere referred to in the imagery chosen for the Oedipus Pictographs. In fact, in the seven paintings which refer to Oedipus in the title, the imagery is almost exclusively the stylized eye. As the artist said:

> [What] I wanted to do with the Oedipus myth, and the main thing that kept sticking
> in my mind was Oedipus' blinding himself, so I painted paintings with lots of eyes and

and serve various functions as the paintings evolve. However, it is important to understand Gottlieb's process in developing the form, for, as he said of himself, he was a conceptual painter. He explained his thinking in a 1962 interview with Martin Friedman:

> It started with the myth, and at the time I was interested in the idea of myth, and perhaps I should explain why I was interested in myth. The interest in myth was in the air; there were a lot of poets and literary people concerned with myth and I felt it might be possible to do something with mythological subject matter apropos to the kind of subject matter that was prevalent at the time. There was the usual scene painting and the Americana type of subject matter.
>
> I had an idea that in order to arrive at a style and to develop painting ideas which would not follow the pattern of Surrealism, a purist kind of abstract painting or the Americana type of painting, it would be necessary to have an entirely different subject matter; and therefore, using the myth, the idea of myth as subject matter, really a form of sort of a groping for subject matter which would be personal and could be integrated with some notion of style and painting ideas.
>
> And I felt that any art in which style is highly developed always had a concept in which the style and the subject matter and the means that were employed were all tied together; and you couldn't just indiscriminately apply a style of painting to any subject matter.[48]

Gottlieb's orientation, his own understanding of the values of art, centers around a particular concept of the art object. It is a concept that owes a great deal to John Graham and to the African sculptures that Gottlieb admired and collected; his goal was for an integrated object which would ideally become the manifestation of the concepts it was intended to convey. At the same time, the concepts that Gottlieb valued and sought to convey owe a debt to the exhibition policies of institutions like the Museum of Modern Art, which repeatedly exhibited African, American Indian, "primitive," and other nontraditional types of art under the banner of modernity.[49] Gottlieb's resolution of this issue is in the formal presentation of the Pictographs. In these paintings, which produced in Gottlieb the feeling that he no longer "knew how to paint," European ideas about painting are supplanted with those of tribal cultures. The painting is not a picture window onto reality, a vision of the subconscious, a statement of purist philosophy, or a view of the landscape. It is, instead, an object meant to be interpreted by the viewer and to affect the viewer at a primal, emotional level.[50] Beginning with the Pictographs, painting has adapted a non-Western form. It has become a repository for a mixture of cultural, sociological, and personal themes—a mythic object for a modern society.

This concept, a radical departure from European notions of picture-making, ultimately became one of the foundations of abstract expressionism and much of the painting that followed.[51] The integrated painting/object is the formal dimension of the Pictographs. The critical difference between these paintings and their immediate predecessors, and the break with European tradition and modernism, lies in this distinction. European painting, even that most contemporary type of the late 1930s, the abstract-surrealist picture, was just that—a picture. The terms used to describe and the means used to convey information are organized around an idea of depiction or display. Communication is effected through the artist's act of laying down symbols, be they words, pictures, diagrams, or abstract shapes, on a plane within a delimited set of boundaries. The viewer approaches these messages passively, after the fact of their inscription, and interprets them on the basis of culturally acquired knowledge. Paintings, in the traditional sense, are meant to be "read." Even the most radical of the surrealists, artists like Masson or Miró (fig. 1-10) who worked in an abstract vein, were dealing in what they termed "automatic writing." This form, as it was used in Europe and in America by such artists as Robert Motherwell and, initially, Jackson Pollock, did not seek to differ from the basic, narrative construct of writing.

Gottlieb's Pictographs rebel against this notion of visual art as writing. They posit an active role on the part of the viewer. They do not depend on the viewer's cultural training or acumen for interpretation. Gottlieb consistently held that these paintings were not meant to be "read," and they have been most maligned by those oriented in Western tradition who therefore insist on forcing readings on them. To interpret a Pictograph in one fashion is certainly valid, but the inherent strength of

these paintings is that they will continually redefine themselves to different viewers, or even the same viewer over time. As Gottlieb valued the role of artist as "image maker," he created and combined images that would continue to remake themselves.

This integrative concept remains so radical, even now, that many critics and historians attempt to interpret the "symbols" of the Pictographs or the psychology of the artist, or to find the antecedents of the formal evolution of these paintings. Others apply various strategies of reading the paintings in a traditional Western sense, viewing them as depictions, albeit mysterious and symbolic ones. The major importance of Gottlieb's concept (considering the relatively high visibility of Gottlieb's paintings during the early 1940s) is that it allows the departures from European styles of his colleagues such as Pollock, Rothko, Newman, and others, all of whom speak of their later work in terms strikingly similar to those Gottlieb used in reference to the concepts on which the Pictographs were based.[52] The shift in emphasis from a field used for depiction, no matter how abstract the depiction, to an integrated object, no matter how flat or what vestigial remnants of the depictive tradition persist, is the leap of faith which determines the difference between European and American avant-garde painting of the period. It begins in America with Gottlieb's Pictographs of 1941.

The choice of myth as subject matter had several motives. Of course, there was the example of the surrealist concentration on mythology and its association with the Freudian concepts to be found in the Oedipus myth. Yet, as Gottlieb stated, his interest in Oedipus was due to the myth's having both a classical and a Freudian theme. The particular way in which Gottlieb introduced mythological subject was a rejection of surrealism's dominance of at the same time that it declared the American artist's sophistication in relation to his European contemporaries. The Pictographs utilize basic themes of certain myths as a link with classical Western themes and, via that linkage, to connect with the emotional foundation of world art. It is, in effect, a Jungian interpretation of Freud. For Gottlieb, and his colleague Rothko, the themes of classical mythology linked all the major periods of Western art.

Gottlieb was familiar with Jung's theories of universal and archetypal images, and the images he set down can be easily identified within a Jungian system. It is less certain that the Jungian images Gottlieb used are related to mythology in the ways that system would assume. That is, Gottlieb was not a doctrinaire Jungian, nor was he undergoing formal or self-analysis, and he did not pretend to be. He probably felt that Jung's theories provided further validation of his own. This eclectic view, which may owe something to John Graham, can account for his inclusion of Freudian ideas as equivalents to Jung's, rather than choosing one over the other. If asked to explain this apparent dichotomy, Gottlieb would probably say that it was not his business as he was not a psychiatrist but a painter.

Emphasizing the theme of rejection, Gottlieb selected the myth of Oedipus as the beginning of his development of an American art. That tale, a classic of Freudian allusions, relates precisely the concepts that Gottlieb wished to express. Beginning with the surrealist appropriations of Freud, Gottlieb chooses the Freudian center-piece of rejection of the father; that is, Gottlieb's choice of Oedipus reflects both his awareness of surrealist dominance and his need to break with that system. Similarly, the Oedipus myth is concerned with seeing and blindness, with the centrality of perception, as symbolized by vision. What better theme, then, for an artist whose belief in painting as a purely visual means of communication was central to his efforts. At the same time, the polar opposites of vision and blindness are a prophetic start for an artist whose life's work would center around the irreconcilable conflicts within the human personality and the tensions inherent in their constantly shifting attempts at balance.

Gottlieb's means of using Oedipus concentrates on the image of the eye, seeing and blinded. Despite the centrality of themes of brutality and sexuality in the Oedipus myth, it is interesting to note that the incest theme is nowhere referred to in the imagery chosen for the Oedipus Pictographs. In fact, in the seven paintings which refer to Oedipus in the title, the imagery is almost exclusively the stylized eye. As the artist said:

> [What] I wanted to do with the Oedipus myth, and the main thing that kept sticking
> in my mind was Oedipus' blinding himself, so I painted paintings with lots of eyes and

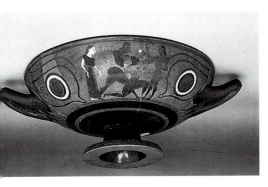

I-11. Athenian black-figured pottery Kylix

Theseus and the Minotaur on each side; also eye decoration; eye cup

6th century B.C.

The Metropolitan Museum of Art, New York, Rogers Fund, 1909.

these eyes were scattered around in compartments. Well, then the thing that became important was not Oedipus, not the Oedipus myth, and in this way I developed my own subject matter.[53]

In the entire body of Pictographs, the image of the eye is used most often. Its use in the Oedipus paintings is clear enough, but the image appears as often in other works: *Palace* (pl. 9), *Omen for a Hunter* (pl. 42), or *The Enchanted Ones* (pl. 17). Gottlieb may have intended different meanings for each usage, but it seems more likely that he found some resonating significance in this image. The example of the eye image provides a clue to Gottlieb's method in the Pictographs.

As Evan Maurer points out in his essay in this catalogue, the eye image is distinctly stylized. Maurer suggests its origins in Egyptian hieroglyphics, many good examples of which Gottlieb would have seen in various museums in New York. Yet, my sense is that the particular eye image Gottlieb referred to is that used by Attic painters of the classical period. Especially persuasive, given the Pictographs' early association with Greek mythology, is the type of work known as an "eye cup" (fig. I-11), of which there were several good examples on display at the Metropolitan Museum of Art in the 1930s. Other attributes shared in common by Attic vases and the earliest Pictographs are color, surface, and a hieratic arrangement of images on the surface. These elements are also shared by Native American pottery of the Southwest and, to a lesser extent, by major examples of the art of ancient Egypt and pre-Columbian stelae and murals (examples of which had been on permanent display at the American Museum of Natural History since the turn of the century).[54]

Still, the eye image, like the other potent images of the Pictographs, cannot be specifically assigned (the ancient Egyptian image was a model for the Greek). That very notion fit in neatly with Gottlieb's aims. He preferred imagery that he could not definitively interpret.[55] The images he used were common to various cultures and periods. The eye, for example, is not only a focus of Egyptian and Greek art but is also a prominent feature of many African tribal works, Native American art (especially that of Northwest Coast peoples), and Oceanic art. The surrealists, too, valued the eye symbol for its primal associations.[56]

In 1947 Gottlieb commented that "The role of the artist has always been that of image maker. Different times require different images."[57] His use of images reinforced his notion that the subject matter of a painting dictated its style.[58] In the case of the early Pictographs, references to myth as depicted by painters of other periods lent authenticity to Gottlieb's theory of images that retain importance through time and cultures. In other words, by drawing an eye image that approximated a type familiar to classical Greece, ancient Egypt, and other ancient and modern cultures, Gottlieb intentionally drew parallels between those societies, reinforcing his belief that some images hold power and importance in and of themselves. At the same time, his use of archaic objects as models for modern paintings allowed Gottlieb to free himself from the formal conventions of European painting. Gottlieb would have seen the closely related images and colors of Attic vases at the Metropolitan Museum and the Native American pottery he remembered from Arizona and could see at the Brooklyn Museum; their combined associations to thirteenth-century and modern European art reinforced his idea. In forging a type of modern painting which was itself an object with the purpose of conveying images, Gottlieb found a way to present images that resonate with meaning across lines of culture and history and that center on the individual, whether artist or viewer.

The cultural atmosphere of New York in the 1930s was the breeding ground for the ideas of Adolph Gottlieb and virtually all the artists known subsequently as abstract expressionists. These individuals came from different backgrounds and different artistic and intellectual orientations, but they shared the experiences of the collections, exhibitions, and press of New York. Not all participated in, but none could dismiss, the controversies that swirled around the the W.P.A., the World's Fair, or *Guernica*, and none could fail to be shaped by the democratic "we're all in this together" spirit promoted by politicians and in films, theater, and literature throughout the Great Depression. It was this singular combination of events, along with Europe's descent into fascism and World War II, that created the atmosphere for American artists to develop independently.

I-12. Adolph Gottlieb
Ascent
1958
oil on linen
90 x 60"
© 1979 Adolph and Esther Gottlieb
Foundation, Inc., New York

I-13. Adolph Gottlieb
Sea and Tide
1952
oil on canvas
60 x 72"
© 1979 Adolph and Esther Gottlieb
Foundation, Inc., New York

The Pictographs, among the earliest examples of formally developed work by this generation of Americans, uniquely combine European and non-European images and ideas. Lawrence Alloway's recollection that Gottlieb stood among his paintings "like the Colossus of Rhodes astride the harbor, and realized that the Pictographs represented a storehouse of culture" was exactly right.[59] This American artist, propelled by his sense of the complexity of human affairs, his knowledge and acceptance of many forms of visual art, and his personal ambition, translated personal experience into a universalized art form. The process of the Pictographs, Gottlieb's adaptation of automatic writing, allowed him to draw on his knowledge to develop a unique body of work and earned him a place of respect among his contemporaries. The wealth of material available to Gottlieb and the open intellectual spirit of Depression-era New York played major roles in the development of these intricate paintings.

Gottlieb's Pictographs, along with art created in the early 1940s by his colleagues Arshile Gorky, Jackson Pollock, Mark Rothko, David Smith, and Clyfford Still, are the predecessors of later forms of abstract expressionism. The formal and conceptual ground that Gottlieb broke—the centrality of the individual, the importance of the viewer as active participant, the fusion of meaning and abstraction, the painting as object rather than depiction, the reliance on visual presentation rather than narrative or symbolic language to convey emotional meaning—was fundamental to the later phase of abstract expressionist painting. It is true that other artists were working on aspects of these ideas around the same time as Gottlieb, but it was Gottlieb who first produced fully developed paintings that diverged from European models.[60] The Pictographs of Adolph Gottlieb could be seen on the walls of the same museums and galleries and reproduced and reviewed on the pages of the same newspapers and magazines as those of acclaimed European artists.[61] The paintings' success proved to American artists that they too could succeed in developing an art that was at once personal and universal, while simultaneously achieving recognition and parity with European artists within the gallery and museum world. The Pictographs were available and accessible to artists like Jackson Pollock, Willem de Kooning, and Robert Motherwell, who were involved in many of the same artistic issues but whom Gottlieb did not know personally until the middle or late 1940s.

Gottlieb came to the Pictographs out of his frustration with the ability of modern painting to deal with fundamental human issues. He reached this point at a time of world crisis, when European and Asian culture were in cataclysm and North America was directly threatened. The failure Gottlieb saw in the painting of the late 1930s was that it could not come to grips with this elemental disintegration of major societies. Against this background, Gottlieb reached for themes and images that recalled the bases of many cultures, and did so in a specifically calculated way. Gottlieb intuited a connection between the destruction being carried out by "civilized" nations and the individuals who were responsible for effecting these acts. In this view, individuals are the actors and, like the characters of classical myths, both responsible for their acts and servants to their fates. Modern theories of psychoanalysis posited a kind of human predisposition to murderous and destructive impulses and pointed to the need for each individual to maintain a balance between these urges and equally powerful creative impulses. Adolph Gottlieb arrived at his Pictographs by combining these classical and modern notions and by making painting function according to his program.[62] The Pictographs deal with themes of disintegration and integration. They propose a view of the individual psyche as imposing order, in the form of the hand-drawn grid, on the chaos of impulse, memory, and history. Like Gottlieb's later paintings, the Pictographs present these opposing themes in a dynamic, fluid state. The threat is always present that the sketched-in imposition of order may be overtaken by the numerous, varied, and unrelated powerful impulses that exist simultaneously in the human psyche.

The Pictographs also develop the conceptual basis for Gottlieb's later paintings, although critics often treat the two phases of Gottlieb's work as if they were created by different artists. The later paintings comprise two types: vertical paintings, which begin in the mid-1950s and present a disc shape at the top and a splatter at the lower section, known as the "Burst" paintings (fig. I-12), and the Imaginary Landscapes (fig. I-13), which begin around 1950 and are characterized by a horizontal format divided into two

discrete but interacting sections. The Pictographs, which contain numerous bits of imagery, seem too diffuse to fit with the simplified visual presentation of the later work. The element that characterizes all of his work, however, is this artist's interest in what he called polarities.[63]

The visual differences between the earlier and later phases of Gottlieb's career have led to his work being placed inappropriately in various surveys of the period.[64] The search for the meaning of each image Gottlieb used, or the search for the specific historic antecedent of each image, often intereferes with an ability to see and comment on the totality of a given painting or group of paintings. In the Pictographs, the notion of subject matter, which has proved to be a misleading choice of terms, was the ability of painting—the making of marks and images on a two-dimensional field—to communicate spheres of human experience, both personal and cultural, through non-narrative, visual means.[65] In departing from painting's historical reliance on narrative constructions, literal and symbolic, Gottlieb's Pictographs helped revitalize the art of painting. The means employed and the results that followed are as complex as the ambition and the society from which they originate.

NOTES

1. While there is no documented itinerary of Gottlieb's 1921 trip, his visits to these cities are based on his later notes and on markings of books purchased during that trip. He mentions having visited these cities in an August 1962 interview with Martin Friedman, Adolph and Esther Gottlieb Foundation. It is likely that he traveled to other areas as well; however, no evidence of such travels has been located.

2. Esther Gottlieb, conversation with Sanford Hirsch, January 1979.

3. Esther Gottlieb, conversation with Sanford Hirsch, January 1979.

4. Adolph Gottlieb, interview with Andrew Hudson, "Dialogue with Adolph Gottlieb - May, 1968," verbatim transcript (Adolph and Esther Gottlieb Foundation, New York), pp. 2 - 4.

5. Adolph Gottlieb, in *Clyfford Still* (New York: The Metropolitan Museum of Art, 1979). At the time, Still had his first prolonged exposure to New York, spending the summers of 1934 and 1935 at the Yaddo artist colony in Saratoga Springs.

6. Adolph Gottlieb, unpublished interview with Martin Friedman, August 1962, Adolph and Esther Gottlieb Foundation.

7. Adolph Gottlieb, quoted in David Anfam, *Abstract Expressionism* (London: Thames and Hudson, 1990), p. 54.

8. Adolph Gottlieb and Marc Rothko, letter to *The New York Times*, June 13, 1943, section 2, p. 9.

9. Stuart Davis, letter to *The New York Times*, Oct. 12, 1941.

10. The overwhelming majority of contemporary artists shown at major New York galleries of the period, such as Jacques Seligmann, Pierre Matisse, Julien Levy, Westermann, Marie Harriman, and Valentine, were European. The attitudes of those who shaped American opinion toward American artists are demonstrated in a half-page article by E.A. Jewell's in *The New York Times* of Sunday, August 14, 1938. Jewell's article is about "...the subject of American art—asking, in the first place, whether it really does exist, and, if so, why the European critics have been able to discern such scant evidence of the fact." Jewell continues, "If so many of our artists (I had been tempted to say most of our artists) prefer the easier course of parroting and aping to the harder course of coming to grips with the essentials of their own selfhood, how can we expect to advance evidence 'for the rise of a virile native school of painting' that is 'strong enough to carry conviction'?" Jewell concludes that American artists of some future time may hope to achieve the level of accomplishment of their European betters; but who and when are open questions.

11. Occasionally, other artists such as Karl Knaths, John Graham, Ralph Rosenborg, and David Burliuk were invited to exhibit with The Ten so that the number of artists shown would be as advertised. Still, they were sometimes referred to as " The Ten who are nine."

12. Gottlieb attributed his break from the group to his exhibition of paintings done in Arizona, which were criticized by some members of The Ten as being "too abstract." A founding member of the group, Gottlieb did not participate in their final exhibition in 1940.

13. Mercury Galleries, New York, *The Ten: Whitney Dissenters*, November 5 - 26, 1938.

14. John D. Graham, *System and Dialectics of Art* (New York: Delphic Studios, 1936).

15. Gottlieb claimed to have seen *Three Musicians* when it was first exhibited in Paris, in 1921. Its acquisition and display in New York must have validated his sense of having been involved in European modernism in a more direct way than his peers.

16. David Smith, letter to Edgar Levy, December 13, 1934, Archives of American Art.

17. The publication of Robert Goldwater's *Primitivism in Modern Painting* (New York: Harper & Brothers) at the end of 1938 may in one sense be viewed as a summary of trends. This formal analysis of the relationships between modern European painters and the work of tribal cultures declares (on p. xxi): "In relation to these [aboriginal or prehistoric] arts as an ideal, the modern painter must necessarily be primitivistic."

18. In his introduction to the catalogue of the exhibition, Alfred Barr writes: "Why should the art of the child and the insane be exhibited together with works by mature and normal artists? Actually, nothing could be more appropriate as comparative material in an exhibition of fantastic art, for many children and psychopaths exist, at least part of the time, in a world of their own, unattainable to the rest of us, save in art or in dreams in which the imagination lives an unfettered life." The question never asked, by Barr or the surrealists, is why people with credentials as curators or artists were needed to select the proper examples of unschooled art.

19. The plate for this etching was created by the artists in 1933, when one proof was run on Gottlieb's press. An edition of 100 was run in 1974, when David Levy found the plate among his mother's belongings. The print is accompanied by a documentation sheet signed by Dorothy Dehner, Esther Gottlieb, Edgar Levy, and David Levy.

20. In 1968 Gottlieb remembered a 1929 exhibition of Graham's "of a series of paintings which he termed at the time 'minimalism.' And I can describe the paintings: they were painted with enamels and every painting was divided in half. The upper half might be white and the lower half might be brown...but the format of the paintings, they were all very much alike...in the catalog it was called an exhibition of minimalism." Hudson interview, p. 17.

21. Graham, *System and Dialectics of Art*.

22. Edgar Levy and Lucille Corcos lived in an apartment one floor below the Gottlieb's in Brooklyn during part of the 1930s. The Gottliebs along with Edgar Levy, Lucille Corcos, David Smith, and Dorothy Dehner formed a close group of friends during this time. According to Paul Bodin, a friend of Gottlieb's, and Esther Gottlieb, the Levys' door was always open and Gottlieb would stop in to visit regularly.

23. David Smith, letter to Edgar Levy, September 6, 1933, Archives of American Art.

24. David Smith, letter to Edgar Levy, 1935, Archives of American Art.

25. John D. Graham, catalogue essay, "Exhibition of Sculptures of Old African Civilizations" New York: Jacques Seligmann Gallery, 1936).

26. James Johnson Sweeney, "The Art of Negro Africa," in *African Negro Art* (New York: The Museum of Modern Art, 1935), p. 11.

27. "Prehistoric Rock Pictures in Europe and Africa," The Museum of Modern Art.

28. Edward Alden Jewell, "The Cave Man As Artist," *The New York Times*, May 2, 1937, Section 11, p. 9.

29. Edward Alden Jewell, "Art Museum Opens Prehistoric Show," *The New York Times*, April 28, 1937, p. 21.

30. Howard Devree, "Display of Masks Seen In Brooklyn," *The New York Times*, October 25, 1939, p. 20.

31. Among the remaining works in Gottlieb's library are two of these monographs: *Indians of the Northwest Coast* by Pliny Earle Goddard, published in 1934, and *Artists and Craftsmen of Ancient Central America* by George C. Vaillant, published in 1935. Both books contain sections on the social and religious life of these peoples, and each contains many illustrations of works of art. That Gottlieb owned and retained these early editions is further documentation of his interest in non-Western cultures.

32. Adolph Gottlieb, interview with Dorothy Seckler, October 25, 1967.

33. Mary Davis MacNaughton, "Adolph Gottlieb: His Life and Art," *Adolph Gottlieb: A Retrospective* (New York: Adolph and Esther Gottlieb Foundation, Inc., 1981), p. 22.

34. Adolph Gottlieb, letter to Paul Bodin, March 3, 1938, Adolph and Esther Gottlieb Foundation.

35. Adolph Gottlieb, letter to Paul Bodin, April 23, 1938, Adolph and Esther Gottlieb Foundation.

36. At present, the Gottlieb Foundation has identified six paintings stylistically related to American surrealism; five were painted in 1939-1940 and one (*Box and Sea Objects*, Guggenheim Museum) was painted about 1942. Considering that Gottlieb's output was about 35 to 40 paintings per year, these few works should not be given undue importance.

37. MacNaughton 1981, p. 29.

38. The events surrounding the creation and exhibitions of *Guernica* are described in detail in Herschel B. Chipp's book on the painting (*Picasso's Guernica*, Berkeley and Los Angeles: University of California Press, 1988). Following the painting's exhibition at the World's Fair, the contributors to *Cahiers d'Art* published a special double issue in the summer of 1937, reproducing the painting and sketches as well as photos of the work in progress. Essays were written, according to Chipp, "on the painting, on Picasso, on his Spanish characteristics, on Franco, on Goya and El Greco, and they wrote several poetic evocations of the themes in *Guernica*." Among the essays, Chipp quotes Michel Leiris, "Picasso sends

us our letter of doom: all that we love is going to die, and that is why it is necessary that we gather up all that we love, like the emotion of great farewells, in something of unforgettable beauty."

39. E.A. Jewell, "Stature of Modern Art's Proteus," *The New York Times*, Nov 19, 1939, section 9, p. 1. Writing as favorably as he could, in another *New York Times* article of May 11, 1939, calling attention to the exhibition of the painting in New York in order to raise funds for the Spanish Refugee Relief Campaign, Jewell notes that "the peculiar idiom used gets between the artist and his theme...."

40. Alfred H. Barr, Jr., *Picasso—Fifty Years of his Art*, (New York: The Museum of Modern Art, 1946), p. 202.

41. *Guernica* was painted in May and June of 1937; the bombing of the Basque city took place in April of that year.

42. After the Paris World's Fair closed in November 1937, *Guernica* was included in an exhibition of four French artists (Matisse, Braque, Laurens, and Picasso) that toured Norway, Denmark, and Sweden from January through April 1938. It was next exhibited in London, promoted for its political theme, in October 1938 and then in Manchester in February 1939. In May of 1939, *Guernica* was exhibited in New York, hosted by the American Artists' Congress, while Gottlieb was still a member.

43. Aside from the many notices, stories and reviews in the press and the special issue of *Cahiers d'Art*, Gottlieb would most likely have been aware of a telephone message Picasso relayed to the American Artists' Congress in December 1937. Picasso's message was:

> It is my wish at this time to remind you that I have always believed, and still believe, that artists who live and work with spiritual values cannot and should not remain indifferent to a conflict in which the highest values of humanity and civilization are at stake.

44. Among the many responses to the Parisian critics, which *The New York Times* reprinted, was the following which appeared on August 21, 1938:

> My impatience has had very little to do with the imposed question of whether there is or is not an "American art," but practically everything to do with the assurance of the French critics who state that there is not.
>
> Why do they think they'd know? What reason is there to assume that the breed of French critics in general has improved and that the current ones are to be taken any more seriously than we now take their predecessors who ignored or castigated Daumier, Manet, Cézanne?

45. Original planning would have left selections to a single panel of "experts." Large-scale and vocal opposition on the part of artists' organizations, most notably the American Artists' Congress, resulted in a national series of regional competitions, in which an independent panel in each region would be charged with selection of a representative group of paintings and sculptures that would be sent to New York to be exhibited in the World's Fair pavilion. These plans were developed in 1937. From the time they were announced until the time the Fair closed in 1940, and for some time after, the idea of selection was publicly and vehemently criticized and defended from all possible sectors of the art community in the U.S.

46. Gottlieb, Friedman interview, tape 1A, p. 9.

47. Gottlieb, interview with Andrew Hudson, May, 1968, verbatim transcript, pp. 4 - 5.

48. Gottlieb, Friedman interview, tape 14, p. 7.

49. The term "primitive" in this instance refers to Western artists with no formal schooling, such as Henri Rousseau, Morris Hirshfield, John Kane, and others who enjoyed a certain popularity in the 1940s.

50. In the notes to the June 1943 letter by Rothko and Gottlieb, published in *The New York Times*, is the following statement, which was omitted in the final version:

> A picture is not its color, its form, or its anecdote, but an intent entity idea whose implications transcend any of these parts.

Cited in Bonnie Clearwater, "Shared Myths: Reconsideration of Rothko's and Gottlieb's Letter to *The New York Times*," *Archives of American Art Journal* 24, no. 1, (1984) p. 25.

51. The closest European precedents I can think of are the works of several German Expressionist painters, whose works Gottlieb would probably have seen in his travels in Europe in the early 1920s. The German painters share an emphasis on the personal and emotional and they, too, saw affinities in tribal arts, especially in African sculpture. However, the German artists, for the most part, retained the idea of the picture. Even Kandinsky and Klee, two of the most abstract of these painters, retained a semblance of depth or illusionism in their work. The Pictographs reject these devices completely.

52. "Subject matter," and its importance in abstract painting, is the most common usage, and virtually every artist associated with the New York School uses the term as the defining element of his work at one point or another. It was Gottlieb and Rothko, in their 1943 letter to *The New York Times* (see p. 63), who asserted that "the subject matter is crucial..." In that same letter, Gottlieb and Rothko assert "It is our function as artists to make the spectator see the world our way–not his way."

This sentiment was echoed in a 1951 statement by Willem de Kooning, who insisted "I force my attitude upon this world, and I have this right...." (in *Modern Artists in America*, Robert Goodnough, ed. (New York: Wittenborn, Schulz, 1951), p. 15). Another of Gottlieb's better-known statements, "Different times require different images....our obsessive, subterranean and pictographic images are the expression of the neurosis which is our reality. To my mind, certain so-called abstraction is not abstraction at all. On the contrary, it is the realismof our time," was published in *The Tiger's Eye* in 1947 ("Ides of Art," *The Tiger's Eye*, no. 2 (December 1947) p. 43). In a 1950 interview, Jackson Pollock makes a similar statement: "My opinion is that new needs need new techniques. And modern artists have found new ways and new means of making their statements. It seems to me that the modern painter cannot express this age, the airplane, the atom bomb, the radio, in the old forms of the Renaissance or of any other past culture. Each age finds its own technique." (Francis V. O'Connor, *Jackson Pollock* (New York: The Museum of Modern Art, 1967), p. 79).

53. Friedman interview, tape 1A, p. 9.

54. Several authors have pointed to the works of Northwest Coast tribes as a definitve influence on Gottlieb's development of the Pictographs, citing the fact that Gottlieb had a Chilkat blanket in his collection in the 1940s. Gottlieb did purchase the blanket (fig. II-12); however he did so in 1942, after a review of an early Pictograph exhibition drew the analogy between Gottlieb's paintings and Chilkat weavings. As indicated in this essay, Gottlieb was familiar with Northwest Coast works from displays and lectures at the American Museum of Natural History. However, the color and surface of these weavings, and the placement of images into an unyieldingly rigid grid, are formally quite different from Gottlieb's paintings. The color and surfaces of Attic, Southwestern Native American, and pre-Columbian ceramics are much closer in appearance to the Pictographs, and the placement of images, while determined by a grid structure, involve hand drawn divisions and allow some interplay among images—elements that closely resemble Gottlieb's paintings. It is also important to keep in mind Gottlieb's insistence that his references were broader than any one style or type of work. For instance, he often cited Italian trecento and quattrocento painting as a source of the formal structure of the Pictographs. It is interesting, in this contexrt, to consider a painting like Cimabue's *Virgin and Angels*, one of the major paintings at the Louvre that Gottlieb frequented daily for several months in 1921, in relation to the organization of the earliest Pictographs, such as *Oedipus* (pl. 1) and *Eyes of Oedipus* (pl. 2).

55. As Lawrence Alloway points out in his 1968 essay "Melpomene and Graffiti," which has been re-printed in this catalogue.

56. The eye image is prominent in the paintings of René Magritte and in a different way in the work of André Masson. There is also the striking usage in the Dali/Buñuel film "Un Chien Andalou."

57. *The Tiger's Eye*, no. 2 (December 1947).

58. Gottlieb, Friedman interview, tape 1A, pp. 7 - 8: "I had an idea that in order to arrive at a style and to develop painting ideas which would not follow the pattern of surrealism, a purist kind of abstract painting or the Americana type of painting, it would be necessary to have an entirely different subject matter...I felt that any art in which style is highly developed always had a concept in which the style and the subject matter and the means that were employed were all tied together; and you couldn't just indiscriminately apply a style of painting to any subject matter."

59. Lawrence Alloway, "Adolph Gottlieb and Abstract Painting," *Adolph Gottlieb: A Retrospective* (New York: Adolph and Esther Gottlieb Foundation, 1981), p. 55.

60. Gottlieb worked closely with his friend Mark Rothko at developing this new phase of American art. According to several statements by Gottlieb, corroborated by statements of Esther Gottlieb and Paul Bodin, Gottlieb and Rothko were involved in discussions about changing the nature and direction of American art from about the time of Gottlieb's return from Arizona in the fall of 1938 to the time the first Pictographs (and, presumably, Rothko's first "Mythic" paintings) were painted in 1941. This raises a question as to the dating of two Rothko paintings in the catalogue *Mark Rothko, 1903-1970 - A Retrospective*, with text by Diane Waldman. That catalogue dates the paintings *Antigone* (cat. 23) and *Untitled* (cat. 24) as 1938 and 1939-40 respectively. If this dating is accurate, there is an obvious discrepancy between Gottlieb's verison of events and that implied by the creation of these two paintings about two or three years earlier than Gottlieb's Pictographs and the balance of Rothko's Mythic paintings.

The question is complicated by parts of Waldman's text. On page 34 of the catalogue, there is a quote from Rothko's first wife, Edith Carson, who states: "His work changed dramatically in the early 40's. He and a group of painters were much concerned about subject matter and these people met at our homes. These meetings involved philosophical discussion...there were about four or five artists — Gottlieb, Newman, Bolotowsky and Tschacbasov." Carson's statement basically confirms Gottlieb's version. Waldman acknowledges the lack of exhibition opportunities for American painters in the 1930s, and notes that in 1940, "Rothko and Solman were given an unparalleled opportunity to participate in a three-man exhibition with Marcel Gromaire at the Neumann-Willard Gallery in New York. Both Rothko and Solman were delighted with the offer to exhibit on equal terms with a noted French painter" (p.33 of the Rothko catalogue). In this exhibition, Rothko showed one of his Subway scenes and two other realist paintings. In the "Second Annual Exhibition of the Federation of

Modern Painters and Sculptors" in May 1942, Rothko showed a figurative work titled *Mother and Child*, while Gottlieb's *Pictograph—Symbol* (pl. 5) was included in the same show.

I raised the question of the dating of these two paintings with David Anfam and Isabel Dervaux, who are compiling the Rothko catalog raisonné. Anfam cites parallels between imagery in *Antigone* and some of Rothko's late figural paintings as indicating a date of 1939. He and Dervaux note that Rothko was working on figural and Mythic paintings at the same time. It is curious that Rothko would have used an unparalleled opportunity, or a show of the artists group of which he and Gottlieb were founding members, to exhibit work that was not his most recent or most advanced.

While it is ultimately not very important to establish which of these two artists launched his new phase first, especially since they worked so closely together, I make this point because Gottlieb's essential contributions to the development of American painting in the early 1940s are usually passed over. Gottlieb's Pictographs, begun in 1941 and produced in significant numbers from that point on, were exhibited frequently beginning in January of 1942. They were formulated and fully developed by 1942. Rothko's Mythic paintings seem to have had a longer development time, and he does not seem to have reached a point at which he was satisfied until about 1943 or 1944.

61. Adolph Gottlieb had been exhibiting in New York since 1929. His work had been reviewed in the major daily newspapers throughout the 1930s, and he was known as a leading figure among younger artists in that decade. In 1939 he was among those who led the secession from the American Artists' Congress and helped form The Federation of Modern Painters and Sculptors.

Gottlieb received major notices in *The New York Times*, *The New York Post*, *Art News*, *The Art Digest*, *The Nation*, and the *New York World Telegram* in May, June, and December of 1942, and January and February 1943. His work was included in the Samuel Kootz book *New Frontiers* in *American Painting*, published in January 1943, and in several shows, and noted in many reviews throughout that year. The letter to the editor of *The New York Times* by Gottlieb and Rothko, which is often cited among the earliest documents of the New York School, was written and published in June of 1943. In that same month, Gottlieb was selected to exhibit a Pictograph (*Pictograph—Symbol*, pl. 5) in the annual invitational exhibition at the Art Institute of Chicago. Gottlieb's *Pictograph #4* (pl. 11) was included in *Abstract and Surrealist Art in America* by Sidney Janis, which was published in early 1944. His painting *Home* (pl. 13) was included in an exhibition organized along with the book and was seen at the Cincinnati Art Museum, the Denver Art Museum, the Seattle Art Museum, the Santa Barbara Art Museum, and the San Francisco Museum of Art. Other New York School artists in this exhibition were Lee Krasner, Byron Browne, Robert Motherwell, Karl Knaths, Ad Reinhardt, Willem de Kooning, Lee Gatch, William Baziotes, Boris Margo, Jackson Pollock, Mark Rothko, and David Hare. Also in that year, Gottlieb had a solo exhibition at the Wakefield Gallery in New York and was included in ten group exhibitions at major New York venues, including the Whitney Museum annual invitational exhibition.

62. Item 3 in the letter Gottlieb and Rothko sent to *The New York Times* in June of 1943 states: "It is our function as artists to make the spectator see the world our way–not his way." (*The New York Times*, June 13, 1943, sec. 2, p. 9.)

63. "I think the similarity [between Pictographs and later work] is in my retaining the concept which is based upon a sort of polarity...." Friedman interview, tape 1A, p. 22.

64. Those who favor Gottlieb's later works usually dismiss the Pictographs as an aberrant beginning. Similarly, some who value the Pictographs think of the later work as a late conversion to forms popularized by other artists. Both views, in their interest to make a point about the importance of one phase of Gottlieb's work, diminish the importance of the entire body of his art.

65. In item 5 of the letter cited above, Gottlieb and Rothko state: "We assert that the subject is crucial and only that subject matter is valid which is tragic and timeless." References to "subject matter" later came into common use among some of Gottlieb's colleagues and has figured in recent reevaluations of the period. Gottlieb asserted, in the 1962 Friedman interview, that the "tragic and timeless" part of the statement was Rothko's addition.

Modern Painters and Sculptors" in May 1942, Rothko showed a figurative work titled *Mother and Child*, while Gottlieb's *Pictograph—Symbol* (pl. 5) was included in the same show.

I raised the question of the dating of these two paintings with David Anfam and Isabel Dervaux, who are compiling the Rothko catalog raisonné. Anfam cites parallels between imagery in *Antigone* and some of Rothko's late figural paintings as indicating a date of 1939. He and Dervaux note that Rothko was working on figural and Mythic paintings at the same time. It is curious that Rothko would have used an unparalleled opportunity, or a show of the artists group of which he and Gottlieb were founding members, to exhibit work that was not his most recent or most advanced.

While it is ultimately not very important to establish which of these two artists launched his new phase first, especially since they worked so closely together, I make this point because Gottlieb's essential contributions to the development of American painting in the early 1940s are usually passed over. Gottlieb's Pictographs, begun in 1941 and produced in significant numbers from that point on, were exhibited frequently beginning in January of 1942. They were formulated and fully developed by 1942. Rothko's Mythic paintings seem to have had a longer development time, and he does not seem to have reached a point at which he was satisfied until about 1943 or 1944.

61. Adolph Gottlieb had been exhibiting in New York since 1929. His work had been reviewed in the major daily newspapers throughout the 1930s, and he was known as a leading figure among younger artists in that decade. In 1939 he was among those who led the secession from the American Artists' Congress and helped form The Federation of Modern Painters and Sculptors.

Gottlieb received major notices in *The New York Times*, *The New York Post*, *Art News*, *The Art Digest*, *The Nation*, and the *New York World Telegram* in May, June, and December of 1942, and January and February 1943. His work was included in the Samuel Kootz book *New Frontiers* in *American Painting*, published in January 1943, and in several shows, and noted in many reviews throughout that year. The letter to the editor of *The New York Times* by Gottlieb and Rothko, which is often cited among the earliest documents of the New York School, was written and published in June of 1943. In that same month, Gottlieb was selected to exhibit a Pictograph (*Pictograph—Symbol*, pl. 5) in the annual invitational exhibition at the Art Institute of Chicago. Gottlieb's *Pictograph #4* (pl. 11) was included in *Abstract and Surrealist Art in America* by Sidney Janis, which was published in early 1944. His painting *Home* (pl. 13) was included in an exhibition organized along with the book and was seen at the Cincinnati Art Museum, the Denver Art Museum, the Seattle Art Museum, the Santa Barbara Art Museum, and the San Francisco Museum of Art. Other New York School artists in this exhibition were Lee Krasner, Byron Browne, Robert Motherwell, Karl Knaths, Ad Reinhardt, Willem de Kooning, Lee Gatch, William Baziotes, Boris Margo, Jackson Pollock, Mark Rothko, and David Hare. Also in that year, Gottlieb had a solo exhibition at the Wakefield Gallery in New York and was included in ten group exhibitions at major New York venues, including the Whitney Museum annual invitational exhibition.

62. Item 3 in the letter Gottlieb and Rothko sent to *The New York Times* in June of 1943 states: "It is our function as artists to make the spectator see the world our way–not his way." (*The New York Times*, June 13, 1943, sec. 2, p. 9.)

63. "I think the similarity [between Pictographs and later work] is in my retaining the concept which is based upon a sort of polarity...." Friedman interview, tape 1A, p. 22.

64. Those who favor Gottlieb's later works usually dismiss the Pictographs as an aberrant beginning. Similarly, some who value the Pictographs think of the later work as a late conversion to forms popularized by other artists. Both views, in their interest to make a point about the importance of one phase of Gottlieb's work, diminish the importance of the entire body of his art.

65. In item 5 of the letter cited above, Gottlieb and Rothko state: "We assert that the subject is crucial and only that subject matter is valid which is tragic and timeless." References to "subject matter" later came into common use among some of Gottlieb's colleagues and has figured in recent reevaluations of the period. Gottlieb asserted, in the 1962 Friedman interview, that the "tragic and timeless" part of the statement was Rothko's addition.

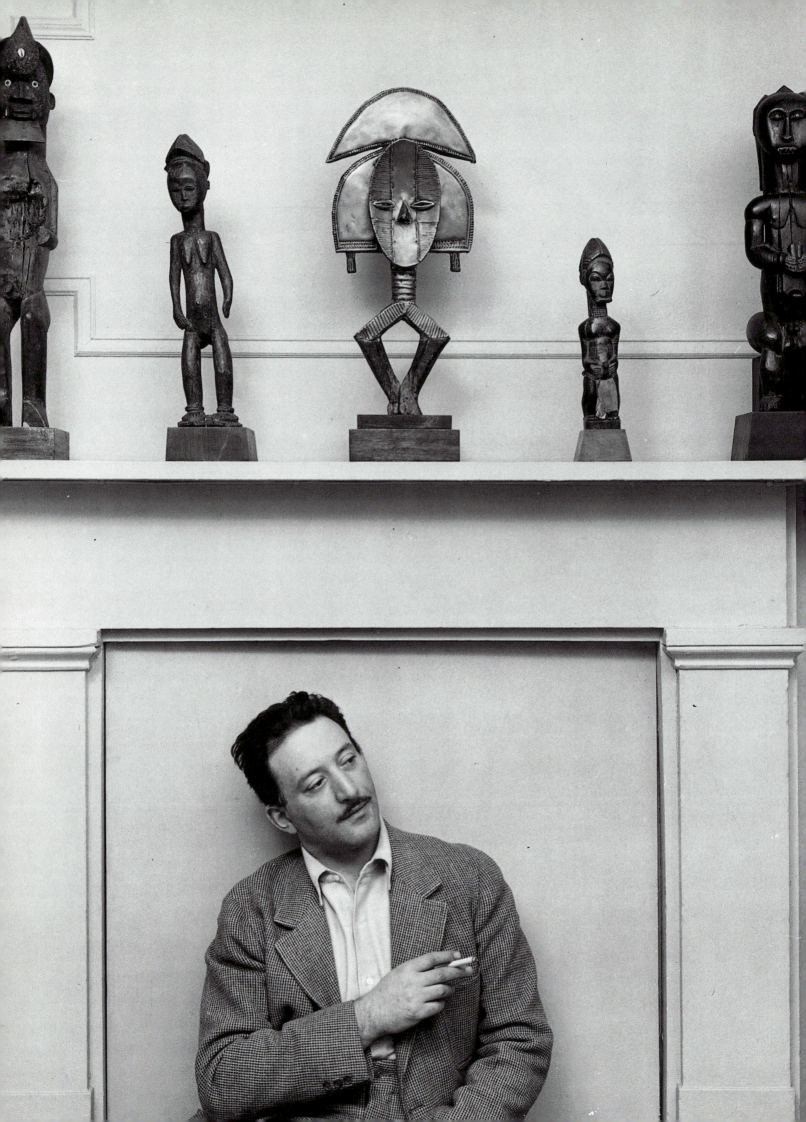

II

ADOLPH GOTTLIEB: PICTOGRAPHS AND PRIMITIVISM

Evan M. Maurer

The decade of the 1940s produced crucial discoveries and achievements for Adolph Gottlieb that established his reputation as one of the most influential and successful artists of his generation. Intellectually acute and inquisitive, Gottlieb was a great reader and museum visitor. He took full advantage of the varied and exciting cultural resources of New York City, where he was born and educated. Coming of age in the 1920s and 30s, Gottlieb was also part of a generation charged by a cultural (and often political) revolutionary spirit that led its members to challenge the artistic and intellectual status quo and seek new definitions and expressions in the arts.

Gottlieb was active in the avant-garde circles of New York and Brooklyn and also sought to broaden his base of experience by traveling to Europe in 1921–1922, following his teacher John Sloan's advice to study the masters. His recognition of the importance of understanding a wide variety of cultural and artistic traditions was a major factor in the development of Gottlieb's art during the 1940s, the decade of his Pictograph series. During the same period, America emerged as an international artistic leader in an environment of change marked by the traumas of the World War II.

In 1939–1940 Gottlieb was at an impasse in his career and uninterested in following any of the current art trends such as regional scene painting, social realism, abstraction, or even surrealism, although he found many aspects of the latter very compelling. Combining different elements of the styles that appealed to him, Gottlieb created a visual expression that was uniquely his own. He was attracted to the work of such artists as Paul Klee and Joan Miró, who had been moving away from the realistic depiction of the visible world to an exploration of flat space, direct painting, and the use of nonspecific, primal signs and gestures to evoke a variety of feelings ranging from joy to mystery and terror. As Gottlieb explored the formal aspects of his art, he also expanded its spiritual foundations and emerged as a stronger, more mature artist. In a 1967 interview he described the process of creating his pictographic paintings.

> I felt that I wanted to make a painting primarily with painterly means. So I flattened out my canvas and made roughly rectilinear divisions...then I would free associate, putting whatever came to my mind freely within these different rectangles. There might by an oval shape that would be an eye or an egg. Or if it was round it might be a Sun or whatever...Now it wasn't just picture writing. I considered myself a painter. I was involved with painting ideas and making things painterly.[1]

The surfaces of Gottlieb's paintings in the Pictograph series bear eloquent witness to his love of the physical act of painting. The varied effects created by layers

II-1. False Door (detail) from the tomb of Akhty-Ir-N
Egypt
5th–6th dynasty, ca. 2750-2475 B.C.
The Minneapolis Institute of Arts, The Lillian Z. Turnblad Fund (52.22)

Aaron Siskind
Adolph Gottlieb photographed in his home with objects from his collection of African art.
ca. 1942
Courtesy of Adolph and Esther Gottlieb Foundation, Inc. New York

II-2. *Horus Eye*
Egypt
19th dynasty, 1297–1185 B.C.
Faience
l: 1 9/16" x w: 1 ¾"
The Minneapolis Institute of Arts, The
 William Hood Dunwoody Fund
 (16.278).

II-3. *Spirit Mask*
Fang Tribe; Gabon (Ogowe River
 District)
Before 1905
carved wood, partly stained
h: 17", w: 11 ½"
The Toledo Museum of Art; Purchased
 with funds from the Libbey
 Endowment, Gift of Edward
 Drummond Libbey (1958.16).

of paint and brushwork patterns give texture, color, and life to the work of art. The built-up layers of paint recall ancient walls that were covered by generations of traditional artists repeating the essential spiritual themes.

In 1955 Gottlieb stated, "I adopted the term pictograph for my paintings out of a feeling of disdain for the accepted notions of what a painting should be."[2] The artist felt that in order to have a new kind of painting one needed to change its formal means and refocus its ability to express emotion and meaning. He felt a need to eliminate the three-dimensional illusionism that had been thoroughly explored by hundreds of years of Western art and replace it with an unself-conscious method of painting; he sought to use the picture plane as a stage for powerful visual signs expressive of human emotions on a primal level.

At this juncture in Gottlieb's career, he wanted his work to be easily accessible, so choice of subject matter was of prime importance. As a painter of strong will and deep intellectual and artistic resources, he developed his own visual vocabulary based on a growing experience of his inner resources. Gottlieb commented that

> ..the external world as far as I was concerned had been totally explored in painting and there was a whole ripe new area in the inner world that we all have...I was trying to focus on what I experienced within my mind, within my feelings rather than on the external world which I can see.[3]

Focusing on the "inner world" led Gottlieb to study the human unconscious and the intense and pioneering research of psychologists Sigmund Freud and Carl Jung. [4] Their theories explained human behavior and personality through analysis of references and symbols from myths, dreams, and other sources–personal and collective. Their studies also showed that the power of myth, dreams, and the unconscious were understood by tribal cultures. These so-called primitive cultures could provide inspiration for reintegrating these principles into modern Western life.

Artists of many persuasions were attracted by these theories, most notably the surrealists, whose celebration and activation of the creative powers of the unconscious and the world of dreams were important elements of the international art world from the mid-1920s through the 1940s. Gottlieb acknowledged this relationship in a discussion of the ways in which he used pictographic symbols in his paintings: "It was a complex process....I thought of it as related to the automatic writing the surrealists were interested in."[5] Gottlieb, like many American artists of his generation had a strong interest in surrealist theory and art that featured automatic techniques, which fostered free expression of the creative unconscious. The surrealists' efforts to encourage an "automatic" flow of words, ideas, and images without the mediating filter of the conscious mind was first developed by André Breton and other writers and poets associated with the movement. In the late 1920s, surrealist artists such as André Masson adapted this approach to the creation of drawings and paintings. Masson would let his pen wander over the paper creating a complex web of overlapping lines. He would then use this freely formed matrix as a stimulus to his imagination, finding within it suggestions of forms which would be emphasized by further drawing. Max Ernst was also very involved with automatic techniques that used random textures and other visual elements dictated by chance as creative irritants that gave birth to an enchanting variety of images. During the early 1940s many of the leading figures in the surrealist movement came from Europe as political refugees, bringing their interest in primitivism and primitive art to the cultural life of New York. Gottlieb, who had been collecting African sculpture for a decade, likewise incorporated this influence in the Pictograph series.[6]

Born out of the revolutionary cultural nihilism of the Dada movement, surrealism offered a positive alternative to those writers, poets, and visual artists who sought a new philosophical center for their lives and art. As it rejected the old values and aesthetics of Europe, surrealism sought to refocus political, moral, and artistic values on the fundamental elements of human nature as expressed in ancient myths, tribal cultures, and the new studies of the human unconscious. At a time of acute world crisis when wars of inconceivable proportions had traumatized millions of people, twentieth-century movements like surrealism searched for sources of strength deep within cultural foundations and the most fundamental roots of the

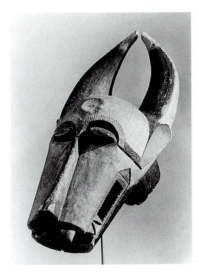

II-4. *Helmet Mask*
Baule; Ivory Coast
19th–20th century
wood
h: 34 ⅝" (88.3 cm)
The Metropolitan Museum of Art, The
 Michael C. Rockefeller Memorial
 Collection, Gift of Mr. and Mrs. Ben
 Heller, 1958 (1978.412.341).

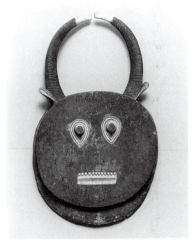

II-5. *Kpele kpele mask*
Baule; Ivory Coast
19th century
wood
h: 44", w: 26 ½", h: 17 ½" (horns)
The Minneapolis Institute of Arts, The
 William Hood Dunwoody Fund (62.37).

individual. Popular books such as Sir James G. Frazer's *The Golden Bough* (first published 1911-15) eloquently demonstrated that many basic forms of mythology were cross-cultural and expressed a fundamental human need to explain and structure basic relationships, emotions, fears, and anxieties.[7] These writings were based on the belief that myths were codified exemplars of human behavior that offered positive metaphorical models of thought and action. Using these studies as one of their models, the surrealists sought a new mythology that would acknowledge the power of a collective, multicultural worldview as a source of strength for a European culture made bankrupt by the dominance of a highly controlled technological society. By defining tribal groups as "primitive," not in a pejorative sense of being crude but rather in the original sense of the word, which denotes an early, pure, or primal state of being, Western scholars and artists of the time felt that people who lived closer to nature in a less technologically diversified environment were still in touch with a primal consciousness that could be a source of strength to a world in process of destroying its human and physical resources.

Through his broad intellectual interests, travels, and friends, Gottlieb also became interested in the study of primitive cultures and especially their varied forms of visual art. Like many avant-garde European artists of the early twentieth century—from André Derain and Pablo Picasso to surrealists such as Breton, Paul Eluard, and Max Ernst—Gottlieb studied and collected examples of tribal art, which were a continuing source of inspiration to his own creative process. This was especially true in the decade of the 1940s, when Gottlieb developed the Pictograph series that became his first mature expression and formed the basis for his continuing artistic development.

Gottlieb was well aware of the tribal arts from a variety of sources available to him since his student years just after World War I and into the early 1920s. Many art books and magazines published illustrations of the art produced by these cultures. The arts of Africa, Oceania, and the Americas were also featured in the well-known collections of New York-area museums such as the American Museum of Natural History and the Brooklyn Museum, which Gottlieb frequently visited. While traveling to Europe in 1921-1922 he saw the great ethnographic museums of Paris, Munich, Berlin, Vienna, and Prague. He shared these interests with artist friends in New York: Edgar Levy, David Smith, and John Graham. Graham was especially attracted to African art and was a forceful advocate of the formal as well as spiritual lessons that African art could offer to Western artists. Graham acknowledged the ancient roots and spiritual power of many African cultures in the catalogue of a 1936 exhibition of African art:

> These sculptured objects spring, therefore, from one of the oldest art traditions in the world...Its postulates were all based on wholly different principles–on spirit–and on spiritual emotions–or the expansion of the unconscious mind, as opposed to the expansion of the conscious mind.[8]

Gottlieb's early interest in tribal cultures grew, and with Graham's help he began to collect African art and later Oceanic and Native American art. When he visited Europe again in 1935 with his wife Esther, Gottlieb made a special excursion to Belgium to visit the world-famous collections of art from the Congo (now Zaire), which are housed in the Musée Royale d'Afrique Centrale at Tervuren. On that same trip he began his collection of non-Western art with the purchase of five African sculptures from Parisian dealers whose names were probably provided by Graham.[9] Gottlieb was also influenced by an important group of special exhibitions presented on African, Pacific, and Native American art by the Museum of Modern Art and other New York museums. These first serious investigations of African, Oceanic, and Native American art by the American museum world had a profound effect on their audiences.[10]

In the extensive literature on the Pictograph series, authors Martin Friedman, Sanford Hirsch, Diane Waldman, and Mary Davis MacNaughton have emphasized the crucial role that tribal art played in the development of Gottlieb's pictorial style and imagery.[11] The artist himself expressed the importance of the art of tribal cultures in 1943 when he wrote about his vital interest in its relationship to modern history and art:

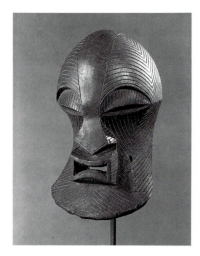

II-6. *Mask*
Songye/Luba; Zaire
wood
h: 16" (40.6 cm)
The University of Iowa Museum of Art,
 The Stanley Collection (CMS551).

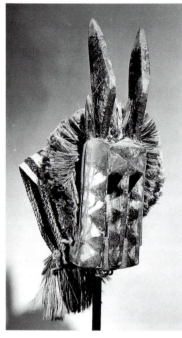

II-7. *Antelope Mask*
Dogon; Mali
19th–20th century
wood, fiber, cloth h: 20 ⅜", w: 6 ⅛"
The Metropolitan Museum of Art,
The Michael C. Rockefeller Memorial
 Collection, Bequest of Nelson A.
 Rockefeller, 1979. (1979.206.48).

While modern art got its first impetus through discovering the forms of primitive art, we feel that its true significance lies not merely in formal arrangements, but in the spiritual meaning underlying all archaic works.

That these demonic and brutal images fascinate us today is not because they are exotic, nor do they make us nostalgic for a past which seems enchanting because of its remoteness. On the contrary, it is the immediacy of their images that draws us irresistibly to the fancies, the superstitions, the fables of savages and the strange beliefs that were so vividly articulated by primitive man.

If we profess a kinship to the art of primitive men, it is because the feelings they expressed have a particular pertinence today. In times of violence, personal predilections for niceties of color and form seem irrelevant. A primitive expression reveals the constant awareness of powerful forces, the immediate presence of terror and fear, a recognition and acceptance of the brutality of the natural world as well as the eternal insecurity of life.

That these feelings are being experienced by many people throughout the world today is an unfortunate fact, and to us an art that glosses over or erodes these feelings, is superficial or meaningless. That is why we insist on subject matter, a subject matter that embraces these feelings and permits them to be expressed.[12]

Although Gottlieb's references to "superstitions" and "savages" grate on our contemporary sensibilities, they must be put into a historical framework. Much of the material written about African and other tribal arts at this time was very general in its descriptions. The act of perception is grounded in the reality of the viewer. Westerners, traumatized by the violence of World War II, emphasized (almost exclusively) the role of tribal art in addressing people's fears and needs for protection and control in the face of powerful forces of destruction and death. Given this critical and sociological context, it is not surprising that artists like Gottlieb turned to what they considered to be the spiritually and visually effective arts of primitive cultures for guidance and inspiration in the creation of an art applicable to their own historic period.

In his comments on the close relationship of modern art to the primitive, Gottlieb began with a description of the spiritual as well as formal power of tribal art. He paid homage to ancient and contemporary tribal cultures because their arts were important cultural expressions recognized as being essential to the fabric of life. If their masks and statues expressed terror, fear, and brutality, that was because those elements had to be acknowledged and dealt with as a part of the life of groups as well as individuals. This was one of the major aspects of primitive art that attracted Gottlieb, who was searching for a visual idiom that could be used to express his own artistic and ethical concerns. He recommended the visual immediacy and emotional power of tribal art to his contemporaries because they too were preoccupied by the powerful forces that must be expressed in art as well as in political rhetoric. In 1947 Gottlieb wrote:

The role of the artist, of course, has always been that of an image maker. Different times require different images. Today when our aspirations have been reduced to a desperate attempt to escape from evil, and times are out of joint, our obsessive, subterranean and pictographic images are the expression of the neurosis which is our reality.[13]

As he developed the pictorial vocabulary of the Pictographs, Gottlieb was trying to maintain a sense of free association that would bring images out from the unconscious without prejudged, intellectual controls. Gottlieb understood the Jungian theory of the "collective unconscious"—a great matrix of intuitive understanding that forms a primal base that unites all human beings. Like many others, Gottlieb felt that art could function as a means of expressing basic human fears and desires without the necessity of factual, verbal information. In 1943 Gottlieb explained his belief in the universality of art as an effective means of communication:

The artistically literate person has no difficulty in grasping the meaning of Chinese, Egyptian, African, Eskimo, Early Christian, Archaic Greek or even Pre-historic art, even though he has but a slight acquaintance with religious or superstitious beliefs of any of these peoples. The reason for this is simply, that all genuine art forms utilize images that can be readily apprehended by anyone acquainted with the global language of art. That is why we use images that are directly communicable to all who accept art as the language of the spirit, but which appear as private symbols to those who wish to be provided with information or commentary.[14]

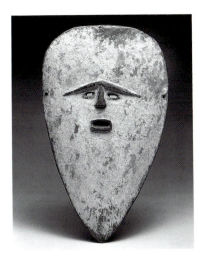

II-8. *Mask*
Vuvi; Gabon
20th century
wood, carved, polychromed paint, kaolin
h: 16 ¾" (43 cm)
©The Detroit Institute of Arts,
 Gift of Mr. and Mrs. Max J. Pincus
 (81.913)

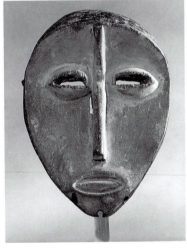

II-9. *Mask*
Lega peoples; Zaire
early 20th century
wood, pigment
h: 7 ½"
The Brooklyn Museum, Gift of Mr.
 and Mrs. John A. Friede (74.121.6).

Gottlieb understood artistic communication to take place on an intuitive, emotional level rather than as rational, intellectual information to be strictly decoded and understood within absolute boundaries. As Lawrence Alloway noted, "Gottlieb told me that when he happened to learn of preexisting meanings attached to any of his pictographs, they became unusable. The signs needed to be evocative, but unassigned."[15]

Gottlieb intended the language of his pictographic images to be mysterious and obscure, like the record of an ancient oracle whose pronouncements remain a familiar yet unresolved riddle. In 1947 the artist wrote:

> I did have certain symbols that were repeated and carried over from one painting to another. But my favorite symbols were those which I didn't understand. If I knew too well what the symbol signified, then I would eliminate it because then it got to be boring. I wanted these symbols to have, in juxtaposition, a certain kind of ambiguity and mystery.[16]

Because of his desire not to use immediately recognizable symbols and references, Gottlieb had to avoid directly copying an image or motif from some other source, whether that be another Western artist or a piece of tribal art. In this process he developed a broad vocabulary of generic images, many of whose origins can be found in the arts of Africa, Oceania, and the Americas.

The word "pictograph" refers to an image that defines an idea, or a form of picture-writing such as the hieroglyphic writing used by the ancient Egyptians. Gottlieb's broad experience of world art, including the extensive collections of ancient Egyptian art on display at the Brooklyn Museum and the Metropolitan Museum of Art, formed a library of pictographic images that could be used in his own creative process. Egyptian hieroglyphic inscriptions—eyes, hands, or simplified images of animals—were one of the sources for his pictographic images. The horizontal or vertical linear system that structures the presentation of hieroglyphic writing must also be counted as a source of inspiration for Gottlieb's grid patterns, which created space cells for individual pictographic images (fig. II-1). An example of an image related to Egyptian hieroglyphs can be identified in *Oedipus* (pl. 1), an early pictographic painting of 1941. The eye and heavy curved eyebrow in the upper right corner have a direct relationship to eye imagery used in ancient Egyptian art where it was used as a symbol of life (ankh) (fig. II-2). The mysterious hieroglyphs of ancient Egypt were the earliest forms of art from the African continent to interest Gottlieb. The sculpture of sub-Saharan Africa also provided the artist with another range of images and forms that influenced him throughout the decade of the Pictograph series.

Gottlieb was attracted to the sculpture of Africa as a collector and as an artist searching for powerful visual statements to express the essence of things from our world. His extensive collection of African and other tribal arts was eventually donated to the Brooklyn Museum. As John Graham, his friend, fellow artist, and mentor in appreciating and collecting African art, wrote in 1936,

> African artists were never seduced by the desire to imitate or compete with nature, as they had, more than a thousand years before, travelled the long road from realism and exact representation to abstraction–a journey which we ourselves are only just ending.[17]

The formal abstraction in African and other non-Western art would continue to inspire Gottlieb as he explored new territories opened by his work on the Pictographs.

An early influence of African art can be seen in Gottlieb's Oedipus series, which were the earliest Pictographs. The 1941 canvas *Oedipus* demonstrates this with its curved pattern of eyes connected to a long, straight nose that is a stylistic convention found in many types of African art, such as the face masks of the Fang people of Gabon and many other tribal styles in Zaire (fig. II-3). The placement of this eye-nose matrix in the center of a rectilinear grid section of the painting also transforms that geometric shape into a mask—one of the principal object types in African sculpture. Gottlieb repeated variations of this conventionalized form in related works such as *Eyes of Oedipus,* 1941 (pl. 2), *Phoenix,* 1941 (pl. 3), and many other works throughout the 1940s.[18]

In *Pictograph* of 1942 (pl. 4), the artist extended this theme in the center of the top row of his grid by basing this image on a recognizable mask. The rounded horns, hemispherical eyes, strong nose and flat mouth are inspired by a type of buffalo mask used by the Baule people of the Ivory Coast (fig. II-4). This form was used as a dance mask and was also frequently carved in smaller scale on a variety of ritual objects.

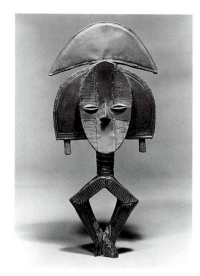

II-10. *Reliquary Figure*
Kota; Gabon
 19th or 20th century
wood, copper, brass
h: 20 ¼", w: 8 ¾", d: 2 ¼"
The Brooklyn Museum, Adolph and
 Esther Gottlieb Collection, Gift of
 Esther D. Gottlieb (1989.51.2).

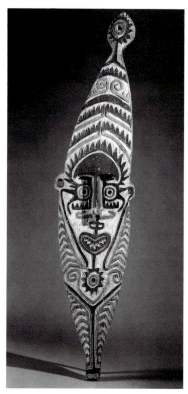

II-11. *Ancestor Tablet*
Elema people; Papuan Gulf
wood; red, black and white paint
l: 58 ¼" (148 cm)
The Saint Louis Art Museum,
 Gift of Morton D. May.

Gottlieb owned several works by Baule artists and would have been able to see many examples of buffalo masks through his avid collecting and museum activities. The staring eyes just below the mask form can also be shown to have a precedent in Baule sculpture. The large, vertical ovals with wide circular pupils are clearly related to the eyes used on the Goli mask, another common type of Baule mask frequently found in Western collections that Gottlieb knew (fig. II-5).

Gottlieb made another strong visual reference to African art in the painting entitled *Augury* of 1945 (pl. 25). The large mask form in the lower right section of the canvas is a reference to a Kifwebe mask (fig. II-6) made by the Songye people of Zaire. These powerful facial abstractions are marked by a domed forehead, prominent nose and mouth, and boldly painted facial patterns—features that may also be identified in Gottlieb's painting. Even in these few instances of Gottlieb's more literal references to African sculpture he is clearly adapting designs, not copying them. Gottlieb's greatest debt to African sculpture lies not in these or other specific visual affinities but rather in the more generic abstractions that the artist used consistently throughout the Pictograph series.

These influences fall into two basic categories: rectilinear masks and ovoid masks. Rectilinear facial abstraction was used frequently by Gottlieb because it is so directly related to the formal elements of the grid pattern that provide the underlying structure for the Pictograph series and continued to play a vital role in Gottlieb's paintings of the early 1950s, such as *Hidden Image*, 1953. There are many precedents for this form in mask designs from a wide variety of African tribal styles that would have been familiar to the artist. Chief among these are the masks made by the Dogon people of Mali (fig. II-7), whose architectonic forms reflect the towers of their village homes.

The abstraction of the human face into a flat oval is one of the most common forms found in African art, where it is consistently used to delineate the faces of statues as well as masks (fig. II-8). Gottlieb's oval mask forms range from the elegant simplicity of the two very abstracted designs used in the upper left section of *Expectation of Evil*, 1945 (pl. 21), which resemble the Bwami society masks and figures of the Lega people of Zaire (fig. II-9), to the generic horned animal mask that the artist used in the top section of *Divisions of Darkness*, 1945 (pl. 26). The oval face painted in the center of the top grid of *Voyager's Return* of 1946 (pl. 34) recalls such objects in Gottlieb's own collection as the brass-covered Kota reliquary figure from Gabon (fig. II-10) and the elegantly carved wooden masks of the Dan people of the Ivory Coast.

Gottlieb was also familiar with the arts of Oceania, whose Pacific Island cultures produced a wide variety of sculptural forms that depended on boldly patterned designs for their visual power. He collected several figures from New Guinea. Large, staring eyes with a pattern of concentric circles is a very common element found in many Oceanic art styles but especially in the arts of New Guinea. Another frequently used graphic feature of New Guinean sculpture depicts a ragged, saw-toothed edge that adds an aggressive element to the figures (fig. II-11). Gottlieb's 1942 painting entitled *Pictograph —Symbol* (pl. 5) features sharp-toothed outlines and open, staring eyes that recall the heightened emotional presence of the arts of New Guinea.

The traditional arts of Native American cultures also had a profound effect on the development of both specific images and general motives in Gottlieb's pictographic paintings. During his formative years in New York, Gottlieb was first introduced to a wide variety of ancient and historic American Indian art at two of his favorite local museums. Both the Brooklyn Museum and the American Museum of Natural History had excellent collections that represented a wide range of object types and geographic styles. Among their rich holdings from the Americas, displays featuring the Northwest Coast Indian at the American Museum of Natural History are extraordinary in scale, number of objects, and aesthetic quality. Since the 1920s the Brooklyn Museum also has exhibited very fine works of art from ancient Peru and Mexico; a noteworthy collection of ceramics, sculpture, and weaving from the American Southwest; an extensive hall of Northwest Coast Indian art; and broad selections from other regions as well.[19] The Museum of the American Indian developed by George Heye added another rich venue where an interested individual like Gottlieb could see a fine

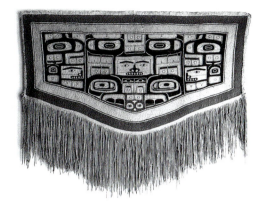

II-12. *Chilkat Blanket*
Tlingit, Northwest Coast, North America
20th century
wool, cedar
h: 53" (incl. fringe), w: 68"
The Brooklyn Museum. Adolph and
Esther Gottlieb Collection, Gift of
Esther D. Gottlieb.

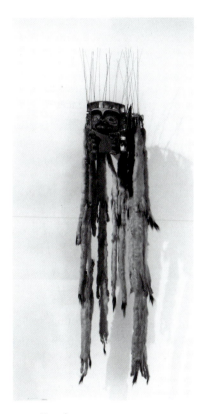

II-13. *Frontlet*
Tsimshian; Northwest Coast, British
Columbia
wood, abalone shell, ermine skins, sea-
lion whiskers, flicker feathers, cord,
felt, pigment
frontlet only: h: 14 ¼", w: 7 ½", d: 9 ¼"
The Brooklyn Museum. Museum
Expedition 1905, Museum Collection
Fund (05.588.7413).

collection of American Indian art. In fact, New York's museums offered the best representation of Native American art available to any public audience.

Because of his wife Esther's health, the Gottliebs spent the winter and spring season of 1937–1938 living in the dry desert climate of Tucson, Arizona. At this time he began to move away from landscape painting and concentrated on making still lifes, whose isolated shapes were precursors of the Pictograph imagery of the next decade. Correspondence from this period suggests that although Gottlieb enjoyed the desert environment, he felt isolated from the cultural stimulation of New York. He wrote to a friend that the only art that interested him in the area was the collection of ancient Southwestern Indian ceramics in the Arizona State Museum.[20] Seeing these ancient pictographs in their original setting was a powerful and affective experience for Gottlieb. These and an exhibition entitled "Prehistoric Rock Pictures of Europe and Africa," which he saw at the Museum of Modern Art in 1937, provided him with examples of a primal, culturally integrated form of painting that effectively communicated meaning and emotion. The fact that their messages were no longer understood made these works mysterious as well as beautiful or even more attractive as a source of inspiration.

After returning to New York in 1939, Gottlieb had another special opportunity to further his developing interest in Native American art when in 1941 the Museum of Modern Art presented its famous survey exhibition "Indian Art of the United States." Accompanied by a large and well-illustrated catalogue, this exhibition was a landmark effort in the presentation and understanding of the beauty and spiritual qualities of Native American art to non-Indian audiences. It was also a sympathetic and historically accurate description of Native American history and the continuing role of art in their lives.

Significantly, sections of the exhibition and the catalogue were devoted to the Native American rock painting tradition, which the authors called "Pictographs." That Gottlieb would adopt this word as the title for his decade-long series is a sign of the profound effect they must have had on him. Gottlieb's form of pictographic imagery was so close to Native American works that Frederick H. Douglas and René D'Harnoncourt's catalogue description of the range of Native American picto-graphic images could also be used to describe the variety of forms that Gottlieb would later develop: "Some are entirely abstract, some have highly conventionalized natural forms, and others are remarkably realistic. Occasionally, combinations of all three styles may be found."[21] The exhibition organizers also emphasized that the meaning of most of these Indian pictographs had been lost, so that like Gottlieb's images they remain visually powerful yet mysterious.

The influence of many types of American Indian art can be seen throughout the Pictograph series, starting with the canvases devoted to the myth of Oedipus. The principal image used to fill these early grid paintings was that of eyes, a motif that corresponds directly to the story of the blinding of Oedipus. While the theme of the eye originates in the Greek myth, a strong visual precedent for the use of eyes scattered across a pictorial design is found in the arts of the indigenous Northwest Coast peoples, which also illustrate mythic themes. In *Eyes of Oedipus* (pl. 2), 1941, Gottlieb's images strongly resemble those on a fine Chilkat dancing blanket made by the Tlingit people of Alaska from his own collection (fig. II-12). Following a wide-spread Northwest Coast artistic convention, the Tlingit artist not only used the eye motif to indicate the features of the central face but also placed them at other locations to articulate their complicated, abstract two-dimensional designs, which represent animals, humans, and mythological creatures. In the whale motif woven into the blanket, a variety of eye forms animate the entire design area just as the eyes do in Gottlieb's Oedipus painting.

Other Northwest Coast influences can be seen in *Altar* of 1947, which features a column of abstracted figures strongly reminiscent of carved totem poles. Another reference to this style of Native American art can be seen in the painting entitled *Vigil* (pl. 46), which he completed the next year. The figure in the second column from the left has a squarish head and a set of eyebrows that are clearly inspired by those found in Northwest Coast art, such as the carved and painted Tsimshian chief's frontlet from the Brooklyn Museum (fig. II-13).

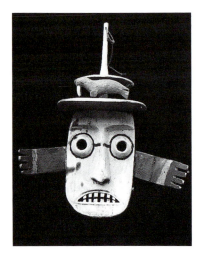

II-14. *Wooden Mask*
probably Kuskwogmiut Tribe, Eskimo;
 Good News Bay, Alaska
h: 18"
Courtesy of the National Museum of
 the American Indian, Smithsonian
 Institution (12/925).

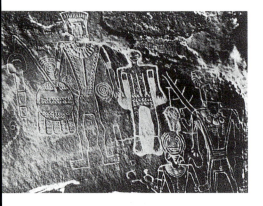

II-15. *Basketmaker Pictograph from
 Southern Utah*
fig. 31, p.98 in *Indian Art of the United
States* by Frederic H. Douglas and
Rene D'Harnoncourt. New York: The
Museum of Modern Art, 1941.

The imaginative masking tradition of the Eskimo peoples of the Arctic was a favorite of the surrealists.[22] Gottlieb's interest in these forms can be seen in *The Enchanted Ones*, 1945 (pl. 17). The mask design in the second row of the grid in the top left corner features large, round staring eyes, a downturned mouth, and a pair of curved hands, or flippers, that extend to the sides of the face. This intensely focused face with hands relates to a common type of Eskimo dance mask, such as one that was in the 1941 Museum of Modern Art exhibition and illustrated in its catalogue (fig. II-14).

Like the influences of African art on Gottlieb's Pictographs, the artist's inspiration from Native American art was more general than in one-to-one affinities with specific works of tribal art. A survey of the Pictograph paintings shows that two of Gottlieb's most frequently used symbols are the spiral and various designs based on the zigzag line. The spiral is one of the most commonly found designs in all of world art. That it was used as an essential element of symbolic visual communication by so many cultures both ancient and historic was of great importance to Gottlieb, who was searching for universally understood images and designs. The spiral can be found in many cultural areas of Native American art, but it is especially prevalent in the arts of the Southwest that Gottlieb favored. The exhibition catalogue of the Museum of Modern Art's 1941 American Indian art exhibition illustrates fifteen works that feature the spiral as a principal design, including a photograph of pictographs from an ancient site in southern Utah (fig. II-15). These and other Indian spiral forms were a major source of inspiration to Gottlieb in such works from 1945 and 1946 as *Masquerade* (pl. 19), *The Enchanted Ones*, *Composition* (pl. 22), and *Enigma*.

Another elemental Southwest design is based on the dynamically angled zigzag line, which represents serpents, lightning, and rain. This type of energized line, like the zigzag bands on some Maidu baskets (fig. II-16), was used throughout the Pictograph series: *Hands of Oedipus*, (pl. 10), *Evil Omen*, (pl. 35), and *Sorceress* (pl. 44).

A design motif native to Southwestern people and related to the zigzag is the repeated curve-counter curve that is said to represent a snake and is associated with the life-giving water that made cultivation and therefore Pueblo civilization possible. The undulating curves of the snakes painted on a Zuni jar (fig. II-17) are another example of a spiritually meaningful and visually effective symbol of Native American art that formed an important source for Gottlieb's Pictographs. Paintings that include variations of the snake design range from *Alkahest of Paracelcus*, 1945 (pl. 18), to *The Seer*, 1950 (pl. 57).

That Adolph Gottlieb admired Native American culture can be seen in many direct and subtle ways as he incorporated its symbols into the visual vocabulary developed in the Pictograph series. The latest painting in this exhibition is *Figuration (Two Pronged)* (pl. 63), finished in 1951. In it the stark geometry of the grid structure has been softened and patches of color and a group of simple line drawings of figures and faces are superimposed over the now-subordinate linear grid system. The drawings are basic abstractions of the human form and closely related to American Indian pictographic images such as figures from the Ojo de Benado site in New Mexico that was published in Garrick Mallery's 1893 study of pictographs entitled *Picture-Writing of the American Indians* (fig. II-18) This influential two-volume work, with more than one thousand illustrations that provide a broad survey of Native American anthropomorphic pictographs, inspired Gottlieb as the spiral and zigzag designs had. Given Adolph Gottlieb's close association with Native American art and its rock-painting tradition, it is fitting that one of his last Pictographs should be so close to the imagery and pictorial surface of ancient Indian paintings. It is an elegant homage to an artistic tradition that the artist admired and respected and a clear example of the close relationship of Gottlieb's Pictographs and his interest in primitive art.

NOTES

1. Adolph Gottlieb, interview with Dorothy Seckler, October 25, 1967, Archives of American Art.

2. Adolph Gottlieb, statement for the 1955 "Annual Exhibition of Contemporary American Painting," University of Illinois.

3. Adolph Gottlieb, interview with Dorothy Seckler, October 25, 1967, Archives of American Art.

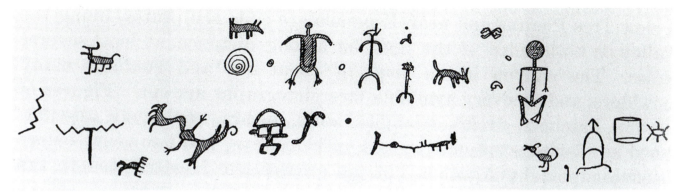

II-18. *Petroglyphs from Ojo de Benado, New Mexico*
fig. 59, p. 98 in *Picture-Writing of the American Indians,* by Garrick Mallery. New York: Dover, 1972 reprint. Originally published as The Tenth Annual Report of the Bureau of Ethnology to the Secretary of the Smithsonian Institution, 1888–89. Published in 1893 by the Government Printing Office, Washington, D.C.

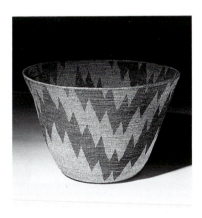

II-16. *Cooking Basket*
Maidu; California
Purchased in 1908
coiled: maple sucker shoots, redbud
bark, willow shoots
h: 10 ½", diam: 16 ¼"
The Brooklyn Museum. Museum
Expedition 1908, Museum Collection
Fund (08.491.8677).

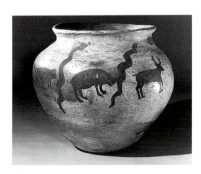

II-17. *Jar Drum*
Zuni; New Mexico
ceramic, slip
h: 17 ¾", d: 21"
The Brooklyn Museum. Purchased in
Zuni, New Mexico, 1903 (03.325.3255).

4. Most studies on surrealism acknowledge the essential tie between the movement and psychoanalytic studies. Freud is mentioned most frequently as the resource most studied and admired by surrealist writers and artists, but the work of Carl Jung is also recognized. For examples see Anna Balakian, *Surrealism, The Road to the Absolute* (New York: Dutton, 1970), pp. 123-133; Anna Balakian, *Andre Breton: Magus of Surrealism* (New York: Oxford University Press, 1971); Elizabeth M. Legge, *Max Ernst: The Psychoanalytic Sources* (Ann Arbor: UMI Research Press, 1989); Evan M. Maurer, "In Quest of the Myth: An Investigation of the Relationships Between Surrealism and Primitivism," Ph.D. dissertation, University of Pennsylvania, 1974.

5. Adolph Gottlieb, interview with Dorothy Seckler, October 25, 1967, Archives of American Art.

6. Evan M. Maurer, "Dada and Surrealism," *Primitivism in Twentieth-Century Art* (New York: The Museum of Modern Art, 1984), pp. 535-593.

7. James G. Frazer, *The Golden Bough* (London: MacMillan Co., 1911-1915), 12 vols.

8. John D. Graham, *Exhibition of Sculptures of Old African Civilizations* (New York: Jacques Seligmann Gallery, 1936), p. 3.

9. Sanford Hirsch, letter to the author, July 23, 1993.

10. *African Negro Art* (New York: The Museum of Modern Art, 1935); *Primitive Art From Africa, Central and South America, Alaska, Asia, and the Pacific Basin* (New York: The American Museum of Natural History, 1939); *Masks* (New York: The Brooklyn Museum, 1939); *Twenty Centuries of Mexican Art* (New York, The Museum of Modern Art, 1940); *Indian Art of the United States* (New York: The Museum of Modern Art, 1941), *The Art of Australia* (New York: The Metropolitan Museum of Art, 1941-42). See also Hirsch essay in this volume.

11. Martin Friedman, *Adolph Gottlieb* (Minneapolis, MN: Walker Art Center, 1963); Lawrence Alloway and Mary Davis MacNaughton, *Adolph Gottlieb: A Retrospective* (New York: The Adolph and Esther Gottlieb Foundation, 1981); Diane Waldman and Robert Doty, *Adolph Gottlieb* (New York: Whitney Museum of American Art, 1968).

12. Clifford Ross, ed., *Abstract Expressionism: Creators and Critics* (New York: Harry Abrams, 1990), pp. 211-212.

13. Ross 1990, p. 52.

14. Ross 1990, p. 210.

15. Lawrence Alloway, "Melpomene and Graffiti," *Art International,* April 1968, p.21.

16. Barbara Rose, ed., *Readings in American Art 1900-1975* (New York: Holt, Rinehart and Winston, 1975), p. 115.

17. John D. Graham, *Exhibition of Sculptures of Old African Civilizations,* (New York: Jacques Seligmann Gallery, 1936), p. 4.

18. Gottlieb's Oedipus series also was influenced by Max Ernst's famous 1922 painting *Oedipus Rex,* especially in *Hands of Oedipus,* 1943, and *Pictograph #4,* 1943, where the large pointing hand can be traced to the large hand emerging from the window in Ernst's painting.

19. Ira Jacknis, "The Road to Beauty: Stewart Culin's Indian Exhibitions at the Brooklyn Museum,"in *Objects of Myth and Memory* (New York: The Brooklyn Museum, 1991), pp. 29-44

20. Mary Davis MacNaughton, "Adolph Gottlieb: His Life and Art,"*Adolph Gottlieb: A Retrospective* (New York: Adolph and Esther Gottlieb Foundation, 1981), p. 22.

21. Frederick H. Douglas and René D'Harnoncourt, *Indian Art of the United States* (New York: The Museum of Modern Art, 1941), p. 97.

22. Kirk Varnedoe, "Abstract Expressionism,"*Primitivism in Twentieth-Century Art* (New York: The Museum of Modern Art, 1984), pp. 615-659; Evan M. Maurer, "Dada and Surrealism, *Primitivism in Twentieth-Century Art,* pp. 535-593.

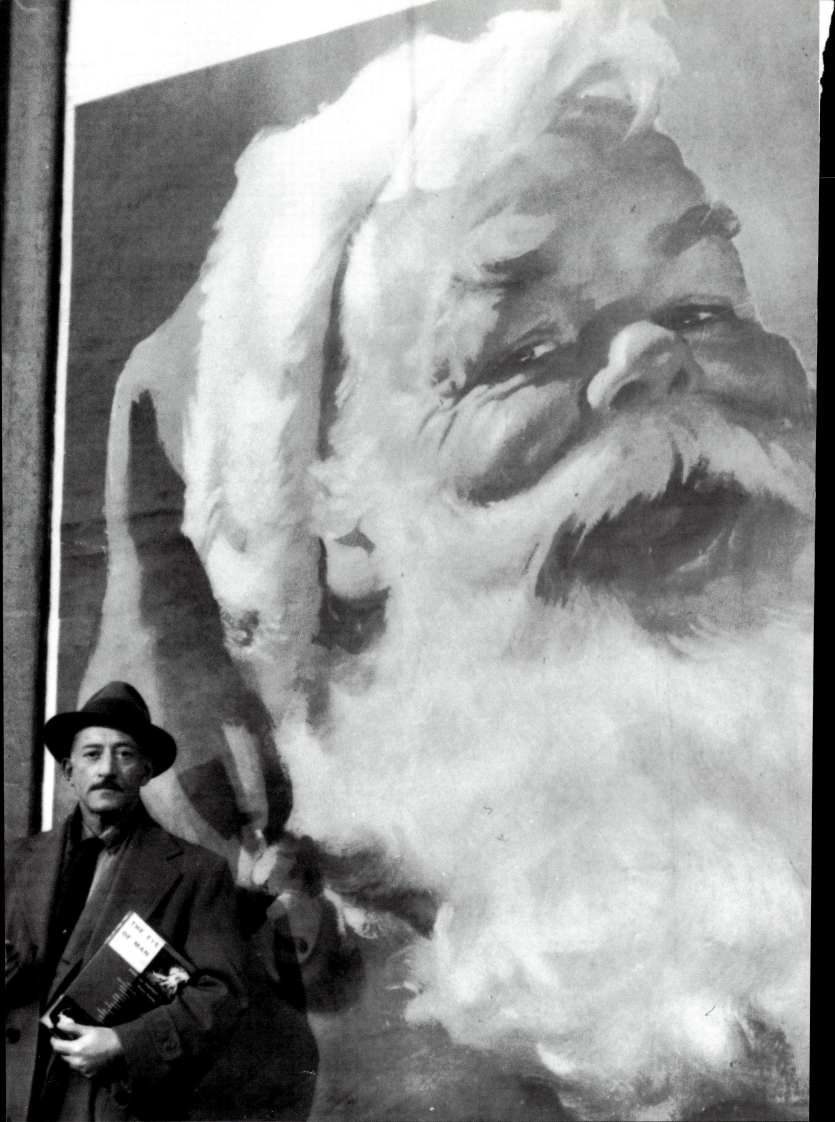

III

MELPOMENE AND GRAFFITI

Lawrence Alloway

This article originally appeared in Art International Magazine (Vol. 12, April 1968), in conjunction with a retrospective exhibition of Adolph Gottlieb's paintings organized jointly by the Whitney Museum of American Art and the Solomon R. Guggenheim Museum in New York, in February 1968. References to the exhibition and catalogue relate to that project.

American painting of the 40s, when first seen as a unit called Abstract Expressionism or Action Painting, was celebrated for its confluence of major talents, and rightly. It has been less frequently remarked that there is one group of artists, working in various styles, who developed in the early 1940s, and another group that does not come on strong until later in the decade. The distinction is worth making, as a step towards replacing the clap-of-thunder theory of New York Painting with a complex and graduated set of real relationships. DeKooning, Gorky, and Pollock are the possessors of strong styles early, and so is Adolph Gottlieb; others, such as Baziotes, Hofmann, Kline, Motherwell, Newman, Rothko do not develop fully characteristic styles until later in the 40s. (I omit Still from either group until his dating has been cleared up.) Rothko's watercolors or Motherwell's collages are not of fundamental consequence compared to their later work; Gottlieb's Pictographs, however, though different from his later work, are no less purposeful and developed. The Pictographs of the 40s, along with some later work, are on view at the Guggenheim Museum and his later work is at the Whitney Museum of American Art.

Gottlieb remembers[1] how Rothko and himself, discussing the impasse of American Painting in 1941, were considering alternatives. What to do instead of subway scenes with *Pittura Metafisica* hints, like Rothko, or still lifes on the beach, derived from object pictures like Pierre Roy's, as in Gottlieb's case? They decided that a change of subject matter was needed and they concurred on their *next* subject: classical mythology. Rothko began his Aeschylus watercolors and Gottlieb painted *The Eyes of Oedipus* (pl. 2), his first Pictograph. This way of arriving at a new subject may seem arbitrary, but, in fact, was not. Mythology was being approached, by one route or another, by various American artists, including Gorky and Pollock. The personal experience of psychoanalysis or its cultural influence, a mythologizing phase of literary criticism, and late Surrealism all contributed to a revival of the value of myth.

Diane Waldman, in the catalogue of the earlier half of the present [1968] exhibition, writes: "It is interesting to speculate that the introduction of primitive forms at this time was required (like Dubuffet's) primarily for pictorial reasons (automatism) rather than for the interest in myth as such."[2] Mrs. Waldman's phrasing implies a separation where I can't see one. She is right to insist, as she does later in the catalogue, that the myths are decontextualized and deracinated, but this is what gave them their new meaning. It does not give them no meaning, which is what the phrase "primarily pictorial" implies. Open-ended mythological subject matter, combined with a repertory of biomorphic forms, solved a problem that Gottlieb shared with other artists of his generation in New York. How to train flatness in painting, without resorting to the existing forms of abstract art; or, to put it another

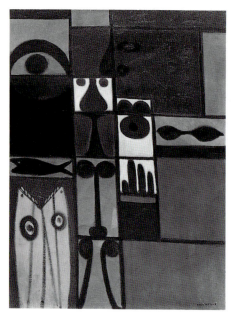

III-1. Adolph Gottlieb
Pictograph
1942
48 x 36"
Aaron I. Fleischman Collection.

way, how to convey the presence of momentous content without using an imagery of spatial illusion? Pictographs, a simulated language system, were used by Gottlieb to appropriate the plane of the picture, without losing the appearance of two dimensions. (Incidentally, despite the European origin of Maurice Dénis and other theorists of painting's essential flatness, all the later developments of the idea occur in the U.S.) In 1942 Gottlieb used the word *Pictograph* (fig. III-1) as a title and also *Pictograph—Symbol* (pl. 5), making clear the significative intention of his closed surfaces.

The "literary" versus "pictorial" antithesis which accompanied the American revival of flat-painting esthetics has blurred the nature of the achievement of the 1903–13 generation of painters in New York. They asserted subject matter while operating within a tradition more sensitive than anywhere else to consistency of convention. Gottlieb, for example, undoubtedly generates the atmosphere of meaning but, in fact, his sets of Pictographs are not transcribable. What he is doing is asserting the human by declaring his art, or Art, to be a symbolizing activity, but the basis of the combinations of signs is his own free associations or painterly improvisation. Gottlieb told me that when he happened to learn of preexisting meanings attached to any of his Pictographs, they became unusable. The signs needed to be evocative, but unassigned. On the other hand, in retrospect, we can see that the Pictographs belong to a definite area of human experience. The forms that recur are sexy, apparitional, tribal, decidedly part of the heritage of Freud and Frazer, who set everybody loose in an underworld of common, mysterious symbols.

The main early quotation from Gottlieb reprinted in the Guggenheim-Whitney catalogue is the statement of 1943 to *The New York Times,* signed jointly with Rothko. Six years ago Gottlieb remembered the composition of the letter, thus: Barnett Newman did the introduction and Gottlieb drafted four of the succeeding propositions.[3] The proposition that stressed art's "timeless and tragic" subject matter was Rothko's. It is curious that this statement, probably the first document of the period to become a cliché through overquotation, is presented once again, in preference to other texts fully authored by Gottlieb and not well known at all. In 1944 Gottlieb wrote: "I disinterred some relics from the secret crypt of Melpomene to unite them through the pictograph, which has its own internal logic. Like those early painters, who placed their images on the grounds of rectangular compartments, I juxtaposed my pictographic images, each self-contained within the painter's rectangle, to be ultimately fused within the mind of the beholder."[4] Here are several clues to the Pictographs: archaism, in which cultural artifacts are emblems of the unconscious; a reference to mythology so explicit that Gottlieb must have looked it up, or come across a reference to the Muse of Tragedy at just the right moment. In addition, there is the notion of the work's "logic" completed by the spectator's perception. The assumption is that the relics with which the painter works are not specialized formal items, but subjects of a common humanity. Thus, the evocative imagery did not have to mean the same, point by point, to Gottlieb and the spectator for it to work. Myth, as the term was used in the 40s, was not a network of one-to-one references, but an oceanic sharing of the imagery of birth and death, desire and terror. On this basis, the spectator's area of legitimate interpretation was somewhat expanded.

The combination of art as human evidence and art as formal structure is expressed admirably in a statement of Gottlieb's in 1951. "I am like a man with a large family and must have many rooms. The children of my imagination occupy the various compartments of my painting, each independent and occupying its own space. One can say that my paintings are like a house, in which each occupant has a room of his own."[5] Artists' statements of the past twenty-five years contain numerous when-I'm-in-my-art type statements, and Gottlieb's is surely a classic for the completeness with which he uses the topics of art as making (the house image) and art as sexual creativity (my "children").

The Pictograph period enabled Gottlieb to stay as flat as he wanted but, at the same time, for his signs to range between the hieratic and the rawly human. What Gottlieb did, it seems, was to pick up a latent possibility in painting as it existed by the end of the 30s and extend it brilliantly. Paul Klee has been both brought on and put down so often as an influence on the art of the 40s, that it is hard to see his influence objectively at present. The basic point is that Klee's work combined painterly and

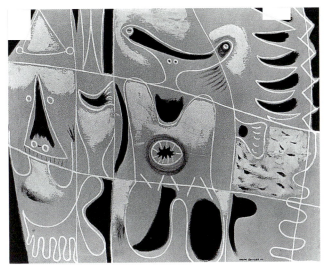

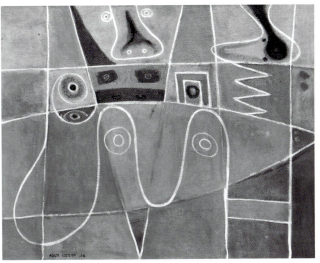

III-2. Adolph Gottlieb
The Couple
1946
25 x 32"
The Fred Jones Jr. Museum of Art
 at the University of Oklahoma, State
 Department Collection.

III-3. Adolph Gottlieb
Pendant Image
1946
25 x 32"
Collection unknown

graphic forms, spatial fusion and sequential ordering, in forms that opened up painting mainly in the direction of mysterious writing (including some interpretation of gesture). It was a third term, because his art was neither abstract nor descriptive. It is Klee's role, as a mixer of sign conventions, that gave him his importance in the 40s, to Gottlieb among others. The Pictographs come with a grid, the uniform divisions of which reduce recessive space and distribute forms equally all over the picture surface. More definitely present than Klee, in terms of physical reminiscences, is Miró; his influence is clear in *The Couple* (fig. III-2), in the treatment of the central figure and in the general scatter of teeth, nostrils, horns, and floating color. (This is one of a group of bright Miró-esque paintings and drawings of the mid-40s incidentally.)

The term Pictograph is appropriate for Gottlieb's work, inasmuch as his signs usually stand for objects (eyes, arm, crown, teeth, fish, head). Barnett Newman, on a couple of occasions, opted for the term ideograph in relation to American painting of the 40s, out of a comparable sense of the usefulness of sign systems as an alternative to abstract art and realism.[6] The term Ideograph means signs for ideas and qualities not directly depictable. However, Gottlieb's emphasis on specific objects, of which his paintings of the 40s almost always grittily consist, is a distinction worth preserving. Newman's sense of the ideograph led into his immediately subsequent formulation of the Sublime. Gottlieb, on the contrary, did not produce "objectless" paintings stylistically relatable to the American Sublime until 1957, when the "Burst" series began.

Eyes of Oedipus (pl. 2), where it all started, has a single ground, milk chocolate in color, crossed by a spare armature bearing laconic and repetitive signs. The eye or eye-and-nose form and hand of the first work persist in *Pictograph* (fig. III-1) of the following year, but diversified in grouping. *Expectation of Evil* (pl. 21) repeats some of the earlier motifs, including the fish with a barbed mouth, but Gottlieb alternates linear signs with details in tonal modeling. *Pendant Image* (fig. III-3), one of a dozen that belongs to the Guggenheim Museum owing to the Baroness Hilla Rebay, continues Gottlieb's invention of heads in terms of anatomical and biomorphic details, but also, in its wide flowing contours, resembles graffiti. The theme of eyes is stressed in both *Mutable Objects* (fig. III-4) and *Home of the Magician* (fig. III-5), as a single dominant in the former, numerous and scattered in the latter. The eye is a popular multivalent sign: it combines hostility (being watched) and curiosity (identifying with the image); male (investigative) and female (by vaginal analogy). Any of these accessible but amorphous meanings abound in Gottlieb's use of the eye image. If *Home of the Magician* rests, basically, on humour, *Equinoctial Rite* (fig. III-6) has no ironies about its mythic tone which is derived in part from

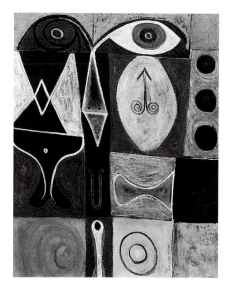

III-4. Adolph Gottlieb
Mutable Objects
1946
30 x 24"
Collection unknown

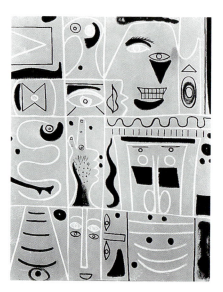

III-5. Adolph Gottlieb
Home of the Magician
1946
38 x 30"
Collection unknown

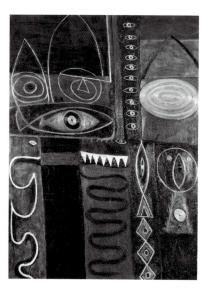

III-6. Adolph Gottlieb
Equinoctial Rite
1947
57 x 40"
Collection unknown

primitive art, as in the columns of eyes and magic fish. *Pursuer and Pursued* (pl. 45) reveals clearly how Gottlieb has preserved freshness, after seven years' work in the style. Though his paint, in this case, is nuanced, the marks take on animal or vegetal life with the unquenchable vitality of graffiti. (Note the head with feet in the top row and the Modigliani mushroom, second down on the right, as typical of Gottlieb's biomorphic cast.) The Pictographs of 1949–51 tend to be either rich and textured as in *T* (pl. 58), or hard and bright. In the latter the human drama of the earlier Pictographs relaxes, as in *Man Looking at Woman* or *Bent Arrow* (not illustrated), to become an unaffective extension of the clean, hard Miró-esque references of the mid-40s. In retrospect it becomes clear that these years are the end of a period; otherwise extremes of ripeness and crispness could not alternate with such aplomb.

Gottlieb's development has three main phases: the Pictographs, 1941–51; what I propose to call, for the present, his middle period, 1951–57; and his later work, relatable to the Sublime, possibly, from 1957 to date. This rough scheme is not meant to wipe out earlier periods or ancillary groups of work (such as the interesting pastels of 1943, for example, which are omitted from the exhibition), but to indicate a main line. Gottlieb was quoted by Milton Esterow in *The New York Times* as denying that his exhibitions amounted to a retrospective; however, the Guggenheim is showing 1941–1956 and the Whitney 1951–1966. About forty Pictographs were shown (that is, four for each year he was working in the style), but they were not an adequate sample of the decade. It is a pity, given the scale of the enterprise, that the Gottlieb build-up should have fallen short at this critical point. On the other hand, the period that got doubled up at both museums (1951–56) is his weakest. This is the time when Gottlieb, legitimately bored with ten years' concentration and restraint, opened up flamboyantly into big scale and luxurious color, as in the *Unstill Lifes* and *Imaginary Landscapes*. This period includes, too, the overlapping grids in which layered scaffolding rips up the surface and minces the space created, with excessive animation (as in *Labyrinth III, Trajectory,* and *Blue at Noon*).

For a work to be a Pictograph the imagery must be significative and the whole must be compartmented; from 1949 on, these qualities become respectively lighter

and looser, until in works like *Archer* (pl. 64) and *Tournament* (pl. 61)(both 1951) we are in the presence of pseudo-Pictographs. These are large works partaking of the textures and colors of the middle period, examples of hedonistic texture and monumentality of form which pulverizes the small scale and momentous content of the main 1941–50 paintings.

NOTES

1. Adolph Gottlieb, in conversation with the author. Whitney Museum of American Art, February 13, 1968.

2. Robert Doty and Diane Waldman, *Adolph Gottlieb* (New York: Whitney Museum of American Art and the Solomon R. Guggenheim Museum, 1968).

3. Adolph Gottlieb, in conversation with the author, 1962.

4. Caption, in Sidney Janis, *Abstract and Surrealist Art in America,* New York, 1944.

5. Adolph Gottlieb, *Arts and Architecture* Vol. 68, no. 9. Los Angeles, 1951.

6. *The Ideographic Picture.* Introduction by Barnett Newman. (New York: Betty Parsons Gallery, 1947).

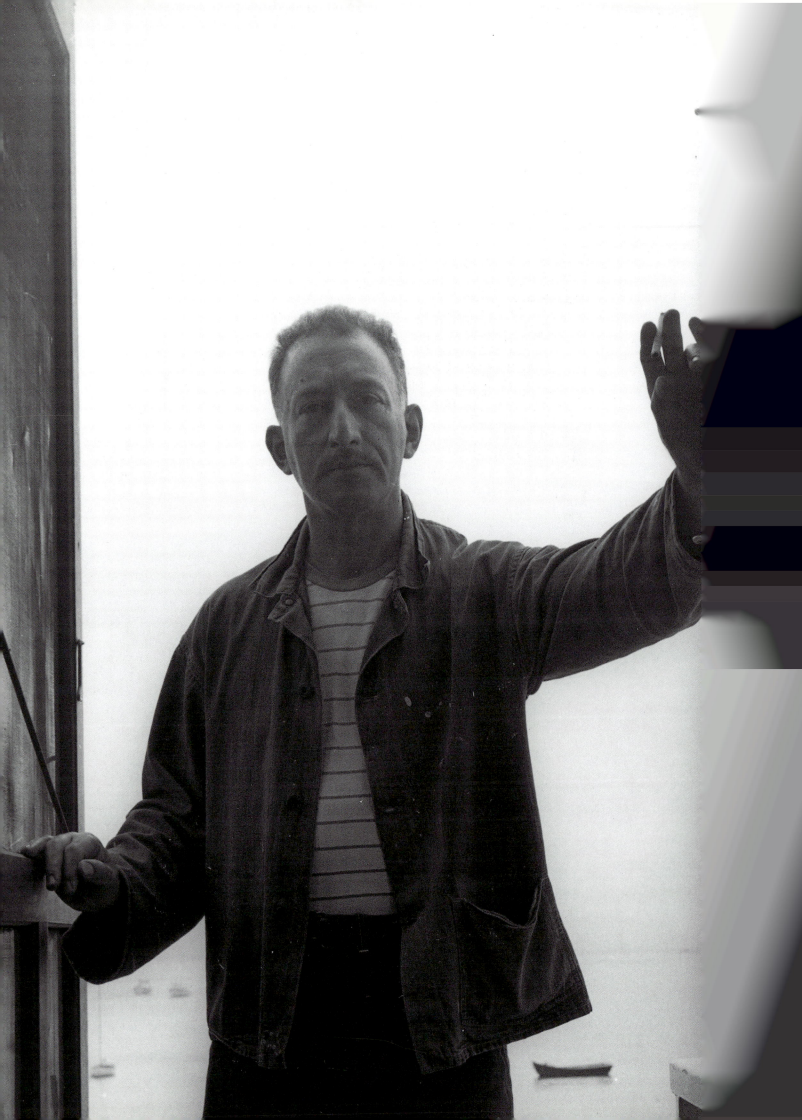

IV

THE GRAPHIC SOURCES OF GOTTLIEB'S PICTOGRAPHS

Linda Konheim Kramer

Between 1941 and 1952 Adolph Gottlieb focused on a series of works that he called Pictographs. The theory behind these works was developed in 1940 when Gottlieb and Mark Rothko were looking for an alternative to regionalism and social realism, the current popular forms of American art, and one that would also be an American alternative to European modernism. They selected "myth" as a subject that concerned itself with the violence they were experiencing in their war-torn world and as one they felt held the key to a universal language. Following the European modernists, who had found new art forms in African art, they looked to ancient and tribal art, with an emphasis on Native American, as a vehicle for this subject. Unlike the Europeans, who borrowed only the forms of primitive art, Gottlieb and Rothko sought a deeper significance in tribal art "not merely in formal arrangements but in the spiritual meaning underlying all archaic works."[1]

In formulating the style of his Pictographs, Gottlieb looked to modern European sources, examining the ways in which artists, including Paul Klee, Picasso, and Miró, had reinterpreted ancient art forms in their own work. Gottlieb did not, however, borrow his symbols or signs directly from any source. His content was nonspecific. The symbols he used were his own, appropriated from his own experience. He believed that these images, of personal significance to him, would have meaning to others because of their roots in a common humanity. He organized his symbolic figurations in flat, nonspatial arrangements in compartmentalized grids, a format he claims to have derived out of an admiration for Native American picture writing and totem poles as well as the way the Italian primitives arranged episodes in boxes.[2] He was also undoubtedly familiar with the abstract, horizontally and vertically divided canvases of Piet Mondrian's constructivist paintings, and it is likely that Gottlieb had seen the work of the Uruguayan Joaquin Torres-Garcia, who also put "things" into the compartments into which he divided his canvases. Although their works are visually related, Torres-Garcia used his pictograph-and-grid constructions entirely for their formal significance, whereas Gottlieb was seeking a way to present the "isolation" and "simultaneity of disparate images" in order to create a sense of time that was neither three-dimensional nor chronological.[3]

The Pictograph series, whether on paper or canvas, is made up of essentially graphic works: the compositions are flat and linear; the images are calligraphic ideographs. Gottlieb did not make preparatory drawings for his Pictographs, so that whether executed in oil on canvas or gouache on paper or as prints, the Pictographs, when most successful, have the directness and spontaneity of sketches. The pictographic notations have sources in his past experiences. They are drawn from the

Adolph Gottlieb in his Provincetown studio, summer 1952. Photo by Maurice Berezov.

IV-1.Adolph Gottlieb
Portrait of Moe
1921
pastel and pencil on paper
7 ½ x 9 ½"
© 1979 Adolph and Esther Gottlieb
Foundation, Inc., New York

IV-2. John Sloan
Turning Out the Light
1905
etching
4 ⅞ x 6 ⅞" plate
Print collection
Miriam and Ira D. Wallach Division of
Art, Prints and PhotographsThe New
York Public Library Astor, Lenox and
Tilden Foundations.

artist's subconscious, recalled through the kind of intuitive gesture associated with the act of drawing.

An examination of Gottlieb's creative evolution, early training and interests, especially as they pertain to drawing and printmaking, reveals the germs of those aesthetic concepts and visual images out of which the style of the Pictographs evolved. In Gottlieb's stylistic development throughout the 1920s and 1930s, concepts and forms gradually build one upon the other, ultimately coalescing in the Pictographs.

His understanding of the power of the quick sketch goes back to his earliest training. Robert Henri, whose lectures at the Art Students League Gottlieb attended in 1921 when he was eighteen years old, instructed him in the expressive powers of the sketch. Henri, rejecting the mechanical polish of the finished product, claimed that "the greatest expression of life itself, however roughly it may be expressed, is in reality the most finished work of art," including even very slight sketches.[4]

This attitude toward drawing was reinforced for Gottlieb by an illustration course he took at the League from January through April that same year, from Henri's disciple, John Sloan.[5] Sloan, who had begun his career as a newspaper illustrator in Philadelphia in the last decade of the nineteenth century, had become highly skilled at capturing subjects in quick sketches, a skill he attempted to pass on to his students.[6] Although Gottlieb's drawing with pastel, *Portrait of Moe* (fig. IV-1), is tentative and unskilled, it is related in subject and quality of line to John Sloan's early etchings of life in the furnished rooms that he could see from his window, such as *Turning out the Light*, 1905 (fig. IV-2).[7] Moe (whose full name is not known), the friend with whom Adolph traveled to Europe later that year, is sitting naked on the bed with one knee up, smoking a pipe. The small bedroom with a simple metal bed, a plain wooden table, a chair, and an open window is compositionally related to the famous painting, *Bedroom at Arles*, by one of the heroes of Gottlieb's youth, the master draftsman, Vincent van Gogh.[8]

Whether by chance or design, Gottlieb's early training continued to be centered around drawing. Upon his arrival in Paris, probably in the summer of 1921, where he remained for six months before traveling around Europe, he spent most of his time acquainting himself with the masters, both old and modern.[9] Although he dedicated most of his time in Europe to looking at art rather than making paintings, he did attend life drawing classes at the Academie de la Grande Chaumière where he drew from the model, but he avoided the instructor because he did not have enough money to enroll officially.[10] It is true that the drawings he made in Paris, some of which are in the collection of the Adolph and Esther Gottlieb Foundation, were typical student works and that the formative experience of this trip lay in what he saw in the museums and galleries by contemporary Europeans like Picasso and Klee. These works left an indelible impression on the young artist. A pencil self-portrait from around 1923 indicates how much his command of the medium had improved since *Portrait of Moe*, but even more significantly, this self-portrait appears to reflect the influence of Picasso's drawing rather than Sloan's. It is described by a strong contour line that gives dimension to the forms by varying in intensity, rather than by shading, as in Picasso's 1917 pencil self-portrait (Musée Picasso, Paris). Both artists focus on the power of their intense eyes, a feature which fascinated Gottlieb throughout his early career. A simplified and stylized self-portrait in ink of around 1938 highlights the large rounded eyes, and another drawing of that same period depicts a fish head with one circular eye surrounded by long lashes. Eyes, of central significance in the myth of Oedipus (which was the first subject of Gottlieb's Pictographs), were prominently featured throughout the entire series in the many configurations including those discussed above.

Around the beginning of 1922, Adolph Gottlieb left Paris to travel in Europe for another year, going to Prague, where he had relatives, Budapest, Vienna, Berlin, Dresden, Munich, and England. He continued to visit many museums and galleries, studying the old masters and modern German Expressionists.[11] He appears to have been especially impressed with the drawings of Rembrandt and Klee, as evidenced by books published in 1920 and 1921 on each of these artists that were in Gottlieb's library, which were most likely purchased on this trip.[12] Gottlieb's appreciation of

IV-3. Milton Avery
Gaspé Beach
1938
pencil on paper
11 x 8 ½"
Collection of Sally M. Avery, New York
 (TL 1990.41.24)
Courtesy The Brooklyn Museum.

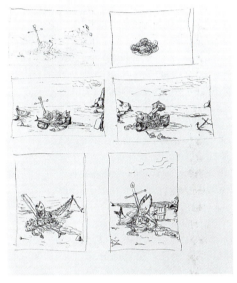

IV-4. Adolph Gottlieb
Untitled (Fish and Anchor)
ca. 1934
ink on paper
11 ⅞ x 9"
© 1979 Adolph and Esther Gottlieb
 Foundation, Inc., New York

Rembrandt's extraordinary skill as a draftsman, his ability to capture a moment with a minimum of line, can probably be attributed to John Sloan's teachings. Later the work of Klee was to have stylistic relevance to Gottlieb's Pictographs, but in the twenties he must have been attracted to Klee's charming graphic notations.

In 1923, back in New York, other experiences built on these. Stream-of-consciousness writing, which is related to the free association that Gottlieb chose for the marking of the signs he used in the Pictographs, was popular among the avant-garde writers of the day. Gottlieb participated in a literary society called Clionia at City College (although he was not a student there), where he read contemporary literature by such writers as T. S. Eliot, James Joyce, and Ezra Pound.[13] Along with classes at Parson's School of Design and John Sloan's painting class at the Art Students League, he also took a still life course in 1924 at the League, according to the registrar's records.

Although he studied painting with Richard Lahey, who had studied with Henri, for a few months in 1926 at the Art Students League, Gottlieb continued to draw. He attended sketch classes for the next few years at the Educational Alliance, where he developed friendships with Barnett Newman and Mark Rothko, which probably influenced the direction of all of their careers. Sign painting, one of the odd jobs he held at this time, entails a manner of working that might also have suggested the flat graphic style he used in the Pictographs.

Some of the ideas that Gottlieb used in the formulation of these works were shaped by his friendship with the artist Milton Avery. Gottlieb and Rothko met Milton Avery for the first time at an opening of an exhibition at the Opportunity Gallery in 1928, and they subsequently became close friends. Gottlieb admired Avery, who was eighteen years his senior, and respected him for taking an esthetic stand against regional subject matter.[14] He paid tribute to Avery in 1965, recalling that "since he was 10 years my senior [sic] and an artist I respected, his attitude helped to reinforce me in my chosen direction. I always regarded him as a brilliant colorist and draftsman, a solitary figure working against the stream."[15]

During the 1930s, Gottlieb's paintings very closely resembled those of Avery, but it was Avery's ideas about, and love for, drawing that probably had the greatest influence on the younger artist. Avery, like Henri and Sloan, recognized the expressive capability of the sketch. He drew every day for most of his life, recording his friends, family, and natural surroundings in ink or pencil. From these drawings he selected the subjects of his paintings.

Gottlieb married Esther Dick in 1932. Following their marriage the Gottliebs visited or spent summers near Milton and Sally Avery (also an artist) from 1932 through 1935 in Gloucester or East Rockport, Massachusetts, and in 1937 in Bonneville, Vermont. Gottlieb's ink sketches of beach and waterfront scenes at Gloucester or Rockport and the Vermont landscapes he made while in the company of Milton Avery are virtually indistinguishable from those of the older artist (figs. IV-3 and VI-4). Both artists frequently divided up the sheet into rectangles so that several small sketches could be included on the same page. The visual result of these sheets of studies is a compartmentalized organization not unlike that used by Gottlieb almost a decade later in the Pictographs. In New York in the winters, both Gottlieb and Rothko continued to sketch with the Averys. Portrait studies of each other and their drawings from the model reflect Avery's tutelage.

Despite Avery's importance to him in the mid-1930s, Gottlieb did not feel that this relationship had any permanent effect on his style. "I was influenced by him but I can't say it did me any good because in a way it was sort of a weak period," he later recalled. "I finally broke away from that and I started going to much better things."[16] In fact, ultimately, more than the style of the drawings themselves, it was Avery's attitude toward drawing that Gottlieb translated for his own purposes in his Pictographs. Avery felt that in his drawings he could record a totally personal experience, which he believed to contain a statement of universal significance. It was this statement that he hoped to convey later in his paintings through the use of abstract forms and colors.[17] Following a similar theory, Gottlieb assumed that his own graphic notations drawn from his subconscious would communicate through a common human experience.

While Milton Avery's style, rooted in the American landscape and portrait

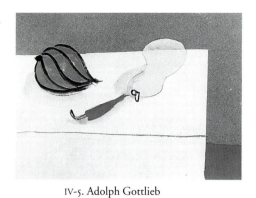

IV-5. Adolph Gottlieb
Untitled (Arizona Still Life)
ca. 1938
gouache and collage on colored
 construction paper
4 ⅜ x 6"
© 1979 Adolph and Esther Gottlieb
 Foundation, Inc., New York

tradition and the contemporary work of Matisse and Picasso, was central to Gottlieb's artistic vision during this period, other artistic directions were acquiring significance for the young artist. His friend, the artist and writer John Graham, was a link for the American artists in his circle with the European avant-garde, both intellectually and artistically. Graham encouraged Gottlieb's interest in cubism, surrealism, and African sculpture, which seemed to be part of the impetus for a second trip to Europe in the summer of 1935. Representative of these new and developing interests, which played a substantial role in the formation of the Pictographs, are his purchases of several pieces of African sculpture, the start of a substantial personal collection, and a book by Jean Cocteau entitled *Mythology*, which contained ten lithographs by Giorgio de Chirico.[18]

It was not, however, until he was on his own in Arizona for eight months in the winter and spring of 1937-38 (where the Gottliebs went for Esther's health) that Adolph Gottlieb was able to break away from the Avery-like style in which he had been working. Living in the outskirts of Tucson, Gottlieb was overwhelmed by the desert landscape. Finding this vast and strange landscape difficult to paint, he began making still lifes.[19] By focusing on still life, a subject that is not particularly prevalent in Avery's work, Gottlieb began to branch out in a new direction, but one that was not unprecedented in his personal experience. He had taken a course in still-life painting at the Art Students League in 1924, possibly because of an early affinity for Cézanne's work, and had recently been exposed to the possibilities of abstraction from still life by the work of cubists that he had just seen in Europe in 1935 and then in the Museum of Modern Art's landmark exhibition "Cubism and Abstract Art" of 1936. The first still lifes he made—for instance, a 1937 watercolor with Native American pottery—were traditional in format but utilized new subject matter of the Southwest. Numerous small gouaches, drawings, and a few prints of these Arizona still lifes show his progress toward abstraction (fig. IV-5). Gradually he incorporated gourds and vegetables found in the local markets and tipped up the table to flatten the space in the manner of Cézanne and the cubists. As he became more acquainted with his surroundings, Gottlieb enlarged his subject matter to include such desert objects as dried cacti, petrified wood, sun-bleached bones, and a chessboard. (While in Arizona, Gottlieb was playing chess by mail with two different people in New York, accounting for the presence of a chessboard in a number of his still lifes.)[20] These gouaches, brightly colored at first, gradually take on the tans and dusty rose tones of the desert that were to inform the early Pictographs. The same composition often appears in a drawing, a gouache, and a print.

While in Arizona, Gottlieb made several tiny woodcuts (white line on black background), sometimes based on compositions found in the drawings and/or gouaches. These experimental prints may also have inspired his later use of sgraffito in his Pictographs or, in any case, the frequent occurrence of white lines on dark backgrounds.

The source for a number of recurrent signs in the Pictographs are found in the drawings and prints that he made in Arizona. Clearly recognizable examples include the gourd shape and certain dried remains of desert life. The angular forms and sharply pointed tips of the dancing cacti and the linear, flamelike desert bush are first found in a tiny woodcut of the corner of a house and a woman (Esther) in a chair looking out on the desert. Somewhat farfetched, although worthy of mention, is the relationship of the chessboard to his later use of the grid.

Most of the visual material on which Gottlieb drew in his Pictographs had sources in his own work, especially his prints and drawings. A crayon drawing done after Gottlieb's return to New York in the summer of 1938, *Box with Sea Objects*, was a subject that clearly fascinated him. He used this composition in a painting colored in the strong oranges, blues, browns, and white associated with De Chirico's work and then in an etching in which the composition is reversed. It has been discussed often as a transitional work because of the gridlike compartments created by the box. April Kingsley compared it to De Chirico's *Great Metaphysical Interior or Duo* and Salvador Dali's *Illuminated Pleasures*.[21] These and other works containing boxes, or forms of a similar category, were included in another groundbreaking exhibition shown at the Museum of Modern Art in 1936, "Fantastic Art, Dada and Surrealism." The composition, however, is related to some of Gottlieb's own Arizona paintings as well. In these paintings a still life was placed on a table in front

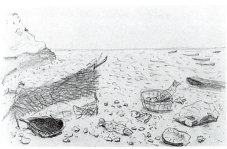

IV-3. Milton Avery
Gaspé Beach
1938
pencil on paper
11 x 8 ½"
Collection of Sally M. Avery, New York
(TL 1990.41.24)
Courtesy The Brooklyn Museum.

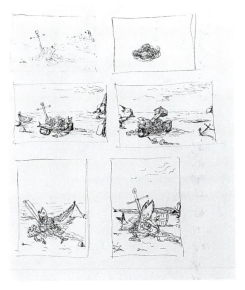

IV-4. Adolph Gottlieb
Untitled (Fish and Anchor)
ca. 1934
ink on paper
11 ⅞ x 9"
© 1979 Adolph and Esther Gottlieb
Foundation, Inc., New York

Rembrandt's extraordinary skill as a draftsman, his ability to capture a moment with a minimum of line, can probably be attributed to John Sloan's teachings. Later the work of Klee was to have stylistic relevance to Gottlieb's Pictographs, but in the twenties he must have been attracted to Klee's charming graphic notations.

In 1923, back in New York, other experiences built on these. Stream-of-consciousness writing, which is related to the free association that Gottlieb chose for the marking of the signs he used in the Pictographs, was popular among the avant-garde writers of the day. Gottlieb participated in a literary society called Clionia at City College (although he was not a student there), where he read contemporary literature by such writers as T. S. Eliot, James Joyce, and Ezra Pound.[13] Along with classes at Parson's School of Design and John Sloan's painting class at the Art Students League, he also took a still life course in 1924 at the League, according to the registrar's records.

Although he studied painting with Richard Lahey, who had studied with Henri, for a few months in 1926 at the Art Students League, Gottlieb continued to draw. He attended sketch classes for the next few years at the Educational Alliance, where he developed friendships with Barnett Newman and Mark Rothko, which probably influenced the direction of all of their careers. Sign painting, one of the odd jobs he held at this time, entails a manner of working that might also have suggested the flat graphic style he used in the Pictographs.

Some of the ideas that Gottlieb used in the formulation of these works were shaped by his friendship with the artist Milton Avery. Gottlieb and Rothko met Milton Avery for the first time at an opening of an exhibition at the Opportunity Gallery in 1928, and they subsequently became close friends. Gottlieb admired Avery, who was eighteen years his senior, and respected him for taking an esthetic stand against regional subject matter.[14] He paid tribute to Avery in 1965, recalling that "since he was 10 years my senior [sic] and an artist I respected, his attitude helped to reinforce me in my chosen direction. I always regarded him as a brilliant colorist and draftsman, a solitary figure working against the stream."[15]

During the 1930s, Gottlieb's paintings very closely resembled those of Avery, but it was Avery's ideas about, and love for, drawing that probably had the greatest influence on the younger artist. Avery, like Henri and Sloan, recognized the expressive capability of the sketch. He drew every day for most of his life, recording his friends, family, and natural surroundings in ink or pencil. From these drawings he selected the subjects of his paintings.

Gottlieb married Esther Dick in 1932. Following their marriage the Gottliebs visited or spent summers near Milton and Sally Avery (also an artist) from 1932 through 1935 in Gloucester or East Rockport, Massachusetts, and in 1937 in Bonneville, Vermont. Gottlieb's ink sketches of beach and waterfront scenes at Gloucester or Rockport and the Vermont landscapes he made while in the company of Milton Avery are virtually indistinguishable from those of the older artist (figs. IV-3 and VI-4). Both artists frequently divided up the sheet into rectangles so that several small sketches could be included on the same page. The visual result of these sheets of studies is a compartmentalized organization not unlike that used by Gottlieb almost a decade later in the Pictographs. In New York in the winters, both Gottlieb and Rothko continued to sketch with the Averys. Portrait studies of each other and their drawings from the model reflect Avery's tutelage.

Despite Avery's importance to him in the mid-1930s, Gottlieb did not feel that this relationship had any permanent effect on his style. "I was influenced by him but I can't say it did me any good because in a way it was sort of a weak period," he later recalled. "I finally broke away from that and I started going to much better things."[16] In fact, ultimately, more than the style of the drawings themselves, it was Avery's attitude toward drawing that Gottlieb translated for his own purposes in his Pictographs. Avery felt that in his drawings he could record a totally personal experience, which he believed to contain a statement of universal significance. It was this statement that he hoped to convey later in his paintings through the use of abstract forms and colors.[17] Following a similar theory, Gottlieb assumed that his own graphic notations drawn from his subconscious would communicate through a common human experience.

While Milton Avery's style, rooted in the American landscape and portrait

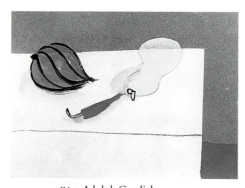

IV-5. Adolph Gottlieb
Untitled (Arizona Still Life)
ca. 1938
gouache and collage on colored
 construction paper
4 ³⁄₈ x 6"
© 1979 Adolph and Esther Gottlieb
 Foundation, Inc., New York

tradition and the contemporary work of Matisse and Picasso, was central to Gottlieb's artistic vision during this period, other artistic directions were acquiring significance for the young artist. His friend, the artist and writer John Graham, was a link for the American artists in his circle with the European avant-garde, both intellectually and artistically. Graham encouraged Gottlieb's interest in cubism, surrealism, and African sculpture, which seemed to be part of the impetus for a second trip to Europe in the summer of 1935. Representative of these new and developing interests, which played a substantial role in the formation of the Pictographs, are his purchases of several pieces of African sculpture, the start of a substantial personal collection, and a book by Jean Cocteau entitled *Mythology*, which contained ten lithographs by Giorgio de Chirico.[18]

It was not, however, until he was on his own in Arizona for eight months in the winter and spring of 1937-38 (where the Gottliebs went for Esther's health) that Adolph Gottlieb was able to break away from the Avery-like style in which he had been working. Living in the outskirts of Tucson, Gottlieb was overwhelmed by the desert landscape. Finding this vast and strange landscape difficult to paint, he began making still lifes.[19] By focusing on still life, a subject that is not particularly prevalent in Avery's work, Gottlieb began to branch out in a new direction, but one that was not unprecedented in his personal experience. He had taken a course in still-life painting at the Art Students League in 1924, possibly because of an early affinity for Cézanne's work, and had recently been exposed to the possibilities of abstraction from still life by the work of cubists that he had just seen in Europe in 1935 and then in the Museum of Modern Art's landmark exhibition "Cubism and Abstract Art" of 1936. The first still lifes he made—for instance, a 1937 watercolor with Native American pottery—were traditional in format but utilized new subject matter of the Southwest. Numerous small gouaches, drawings, and a few prints of these Arizona still lifes show his progress toward abstraction (fig. IV-5). Gradually he incorporated gourds and vegetables found in the local markets and tipped up the table to flatten the space in the manner of Cézanne and the cubists. As he became more acquainted with his surroundings, Gottlieb enlarged his subject matter to include such desert objects as dried cacti, petrified wood, sun-bleached bones, and a chessboard. (While in Arizona, Gottlieb was playing chess by mail with two different people in New York, accounting for the presence of a chessboard in a number of his still lifes.)[20] These gouaches, brightly colored at first, gradually take on the tans and dusty rose tones of the desert that were to inform the early Pictographs. The same composition often appears in a drawing, a gouache, and a print.

While in Arizona, Gottlieb made several tiny woodcuts (white line on black background), sometimes based on compositions found in the drawings and/or gouaches. These experimental prints may also have inspired his later use of sgraffito in his Pictographs or, in any case, the frequent occurrence of white lines on dark backgrounds.

The source for a number of recurrent signs in the Pictographs are found in the drawings and prints that he made in Arizona. Clearly recognizable examples include the gourd shape and certain dried remains of desert life. The angular forms and sharply pointed tips of the dancing cacti and the linear, flamelike desert bush are first found in a tiny woodcut of the corner of a house and a woman (Esther) in a chair looking out on the desert. Somewhat farfetched, although worthy of mention, is the relationship of the chessboard to his later use of the grid.

Most of the visual material on which Gottlieb drew in his Pictographs had sources in his own work, especially his prints and drawings. A crayon drawing done after Gottlieb's return to New York in the summer of 1938, *Box with Sea Objects*, was a subject that clearly fascinated him. He used this composition in a painting colored in the strong oranges, blues, browns, and white associated with De Chirico's work and then in an etching in which the composition is reversed. It has been discussed often as a transitional work because of the gridlike compartments created by the box. April Kingsley compared it to De Chirico's *Great Metaphysical Interior or Duo* and Salvador Dali's *Illuminated Pleasures*.[21] These and other works containing boxes, or forms of a similar category, were included in another groundbreaking exhibition shown at the Museum of Modern Art in 1936, "Fantastic Art, Dada and Surrealism." The composition, however, is related to some of Gottlieb's own Arizona paintings as well. In these paintings a still life was placed on a table in front

IV-6. Adolph Gottlieb
Untitled
ca. 1940
etching
6 x 7 ⅝" plate
© 1979 Adolph and Esther Gottlieb
 Foundation, Inc., New York

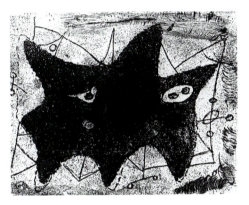

IV-7. Adolph Gottlieb
Untitled
ca. 1940
etching
2 ⅞ x 3 ⅞" plate
© 1979 Adolph and Esther Gottlieb
 Foundation, Inc., New York

IV-8. Adolph Gottlieb
Untitled
ca. 1944
etching
3 ⅞ x 3" plate
© 1979 Adolph and Esther Gottlieb
 Foundation, Inc., New York

of a window, which opened onto the broad vista of a desert landscape. In *Box with Sea Objects* (fig. V-2) the desert landscape has been replaced by a seascape, and the gourds, cacti, and bones of the desert have been translated into shells, driftwood, and seaweed. The wooden bookcase, which is surrealistically placed on the sandy shore, was actually an object he found on the beach.[22]

Gottlieb had been interested in etching since the early 1930s, when he purchased an etching press in a junk shop. Beaches had a special meaning for him since his summers with Avery (who made his first drypoint in 1933) on the Massachusetts shore; it is not surprising therefore to find another small etching from the late 1930s of a pile of debris including a fish head, an anchor, a barrel, and a fishnet, which is closely related in subject and style to a drawing by Avery. Finally Gottlieb actually incorporated this whole print into the etching of the box with sea objects (fig. IV-6). This combined etching contains the germ of a number of ideas and images that he built on in the coming years. The background of cliffs, stylized waves, and boat with fishermen, which he added in this version (fig. IV-6), seems to make direct reference to De Chirico's metaphysical surrealism. In accord with a working method utilized for the Pictographs, he appropriated his own imagery and incorporated it in another context, thereby giving it new meaning. The upright fish head in this print, as well as some of the other sea forms like the spiral shell, handlike seaweed and driftwood, contained special meaning for the artist and turn up again and again in different permutations in the Pictographs.

The abstracted image of a gourd, mentioned above, is another symbol that recurs in the Pictographs. A small etching from 1940 (fig. IV- 7), which looks at first to be entirely abstract, is on further consideration probably an abstraction of an upturned table with gourds on it, in which the table takes on the shape of the gourds. Gottlieb also made several versions of this print. He began with an etching on a 4 by 5 inch plate; then after adding aquatint to tone the etching, he cut the plate down to enclose the image more tightly within the borders, as if it were one sign in a compartment of a Pictograph painting; finally, he reused the etched image in a woodcut, which he printed in red for a Christmas card in 1940. It was this kind of image that seems to be the basis for one of his first Pictograph paintings, *Pictograph–Tablet Form*, a year later.

During this period Gottlieb seemed to be experimenting with new ideas most aggressively in the medium of printmaking. He made some figurative prints in the early 1940s, around the same time that he made a group of drawings of heads and figures. (Most of these drawings, recorded in a brochure for an exhibition at the Wakefield Gallery, New York, in 1944, were lost in a studio fire of 1965.) The hand, eye, and nose forms that became significant features in the vocabulary of the Pictographs are found in an etching of about 1944 of a weirdly distorted head with big eyes (fig. IV-8). Eyes, as mentioned above, played an especially important role in Gottlieb's personal iconography. The image of the eye occurs in many permutations in the Pictographs, with reference to Egyptian, Greek, tribal, and modern sources. As a symbol it contains infinite layers of meaning, all of which are implicit in Gottlieb's use of the sign. This etched head of 1944 also brings to mind Klee's etching of 1904, *Perseus–The Triumph of Brain over Body*, a rendition of a mythological figure. Although Gottlieb had been sufficiently impressed by Klee's work when he first saw it in Europe in the early 1920s to acquire a book on the artist, he could more recently have seen Klee's Perseus print in "Fantastic Art, Dada and Surrealism" exhibition at the Museum of Modern Art. Lawrence Alloway articulated the importance of Klee's essentially graphic and calligraphic style to the formation of Gottlieb's Pictographs: "Klee's work combined painterly and graphic forms, spatial fusion and sequential ordering, in forms that opened up painting mainly in the direction of mysterious writing…his art was neither abstract nor descriptive."[23] Gottlieb did learn from Klee's manner of working but used it to his own ends.

A drypoint from the early 1940s, *Untitled* (fig. IV-9), depicting an abstracted female figure, has close affinities to surrealist works of artists like Ernst, Matta, Masson, Miró, and Dali. Gottlieb's already established interest in this style, about which he had learned from John Graham and then seen firsthand in Paris in 1935, must have been reinforced by the exhibition "Fantastic Art, Dada and Surrealism." Although drawn in a single line by only one hand, the drypoint is divided into three

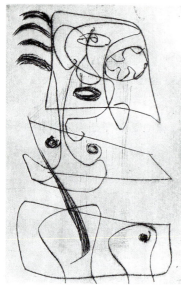

IV-9. Adolph Gottlieb
Untitled
1943
etching
5 ⅞ x 3 ⅞" plate
© 1979 Adolph and Esther Gottlieb
 Foundation, Inc., New York

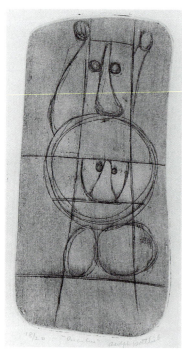

IV-10. Adolph Gottlieb
Incubus
ca. 1946
etching
9 ⅜ x 4 ¾" plate
© 1979 Adolph and Esther Gottlieb
 Foundation, Inc., New York

disconnected sections, very much like one of the Exquisite Corpse drawings of the surrealists. It seems to emerge from his unconscious as in the surrealists' automatic drawings. Gottlieb certainly responded to the surrealist's exploration of the subconscious through psychic automatism, in which conscious reason is intended to be eliminated. The unpremeditated relationships that occurred in the Exquisite Corpse drawings and the expression of the unconscious the surrealists sought in automatic drawing were means Gottlieb explored as he sought a route to the collective unconscious through his own subconscious in the Pictographs. He used their notion of automatic drawing as a means for free association and intuitive gesture to draw forth the signs and symbols embedded in his subconscious. Certain details of this small print also ultimately found their way into the lexicon of the Pictographs—the shapes of the breasts, the eye, the four flying strands of hair.

April Kingsley, in her essay in the catalogue of the exhibition "Adolph Gottlieb, Works on Paper," noted that the prints in a sense had taken the place of drawings and preparatory sketches, which the artist had stopped making in the 1940s.[24] It seems, however, that Gottlieb also reworked ideas from his paintings in the etchings. For instance, the etching *Incubus* of 1944–45 (fig. IV-10), which features a single figurative element, is close in composition to *Pictograph–Tablet Form* of 1941, one of the first paintings in which Gottlieb used the word "pictograph" in a title, but the content has been transformed. *Pictograph–Tablet Form* can be read as an extension of Gottlieb's Arizona still lifes, with the table plane completely vertical and the objects turned into abstract symbols.[25] It also contains a very early reference to the grid, and the shape in the painting, which is virtually abstract, assumes the character of a mythological creature in *Incubus*. This transformation probably occurs through the kind of intuitive association that Gottlieb wished to use in the Pictographs. *Incubus*, an evil male spirit of medieval mythology who descended on women in the night and attacked them sexually, is humorously characterized by the nightmarish, yet rather cheerful demon in this print, a character related to Klee's charming and delicately drawn monster in the watercolor *Dance You Monster to My Soft Song!* of 1922 (fig. IV-11).

Hieroglyph (fig. IV-12), circa 1944, an exploration of other sources for Pictographic ideas, recollects the calligraphic forms and format of hieroglyphs in the vertical layering of the signs, the horizontal and vertical lines that divide them, and the general character of each symbol. The images themselves, although reminiscent of hieroglyphs, are not hieroglyphs but rather signs and symbols drawn from both ancient and modern art as well as Gottlieb's own psyche. The eye, arrow, snake, mask, and geometric shapes all participate in the history of man's imagery. The hand with a tattoo is unique to Gottlieb's work. The image, which he used frequently, derived, according to Esther Gottlieb, from a Syrian woman who lived near the Gottliebs in Brooklyn and whose tattooed hands fascinated the artist.[26]

Untitled (Etching #B), also circa 1944, has the scaffolding of an unevenly structured grid, rather like that of *Hieroglyph*, but the forms, in this case biomorphic shapes recalling prints by Arshile Gorky or Miró, are also reminiscent of Gottlieb's own gourd forms.

In each of the small etchings made before 1945, Gottlieb seems to explore various sources and configurations in order to seek the means by which he could most successfully express the theory he had developed for his Pictographs. Even in 1945 or 1946, when the style of the Pictograph paintings was completely realized, Gottlieb still was trying out new ideas in a group of Pictograph etchings he produced during this period.[27] He was not as interested in etching for its reproductive value as for the possibility it offered of making an image, pulling a proof, and then reworking the plate to make a variation of the image.[28] It was an ideal medium in which to experiment with techniques for portraying visually and technically his concepts for the Pictographs.

Chimera (pl. 39), circa 1946, is a prototype of Gottlieb's initial conception for his Pictographs. The powerful and clearly described figurations in this print are representative of the archetypal and totemic signs with which he hoped to reach the spiritual roots of human nature. Bird, snake, fish, hand, nose, eyes, claw, mask, and curtain are all drawn from personal experience or from those of other cultures and

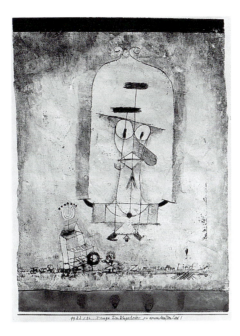

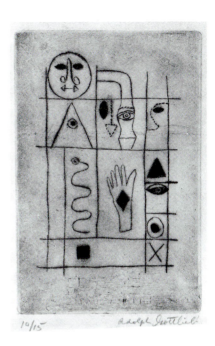

IV-11. Paul Klee
Dance You Monster to My Soft Song!
1922
watercolor and oil transfer drawing on
plaster-primed gauze bordered with
watercolor on the paper mount
gauze: 13 ⅞ x 11 ½"
paper: 17 ⅞ x 12 ⅞"
Solomon R. Guggenheim Museum,
New York, Gift, Solomon R.
Guggenheim, 1938.

<small>Right</small>
IV-12. Adolph Gottlieb
Hieroglyph
1944
etching
5 ⅞ x 3 ⅞"
© 1979 Adolph and Esther Gottlieb
Foundation, Inc., New York

eras that had become part of Gottlieb's own vocabulary. The mythological subject matter is that which Gottlieb originally selected for this series as a route to the collective unconscious. Undoubtedly a reference to all of the creatures in this print, a chimera is a fabulous she-monster in Greek mythology described as having a lion's head, a goat's body, and serpent's or dragon's tail. The almost symmetrical and pronounced grid pattern was the format chosen to contain these ciphers.

Although these ideas continue to occupy him in the etchings produced during this period, as the decade progressed Gottlieb became less rigid in the parameters of his Pictographs. As forms became looser and vaguer, the subject references became more mysterious and psychological—omen, apparition, augury, and voyage.

The print *Voyage* (pl. 36), circa 1946, is particularly adventurous both in its use of new sources, investigation of different formats and icons, and its return to earlier personal imagery. It is formally and stylistically reminiscent of prehistoric rock engravings, which Gottlieb must have seen in an exhibition of facsimiles entitled "Prehistoric Rock Pictures in Europe and Africa" at the Museum of Modern Art in 1937. The images, most of which are unique to this work, are more specific (less symbolic) and descriptive than are commonly found in Gottlieb's Pictographs—house, sun, windmill, acrobat. Instead of placing them within a preset grid pattern, the compartments are tailored to fit each image. The use of white line against a dark background in *Voyage* is unique among this group of etchings but not in Gottlieb's work. In his woodblock *Untitled (Arizona Still Life)* from around 1938, as well as in others of this period, Gottlieb incised the drawing into the block so that it appeared as white line against black background in the print. The medium of aquatint used in *Voyage* allowed for greater range of tone from glowing white to grays to black, a technique in which Goya was a supreme master. Gottlieb was well aware of Goya's prints, having received as a birthday present in 1939 a book of Goya's great series of etchings, *The Disasters of the War*. He might also have seen the superb set of Goya's *Capriccios* that the Brooklyn Museum had acquired in 1937 because he lived in Brooklyn and frequented the museum during this period. His vertical stratification of signlike images, drawn in white line over a dark background, was also used by Klee in *Cosmic Composition* of 1919 (fig. IV-13), work that was included in his retrospectives at the Museum of Modern Art in 1941 and 1945.

The creatures that people the surface in *Untitled (E#E),* another etching of 1946, are related to those hairy microscopic critters found in Miró's paintings of the 1920s and early 1930s.[29] In *Omen* (pl. 37), Gottlieb loosely and lightly draws his signs over abstract tonal patterns of aquatint. *Apparition* (pl. 24), 1945, is an exceptionally large print in which the symbols are much more abstracted and elusive.

Many of the new ideas with which Gottlieb experimented in the Pictograph

<small>THE PICTOGRAPHS OF ADOLPH GOTTLIEB</small>

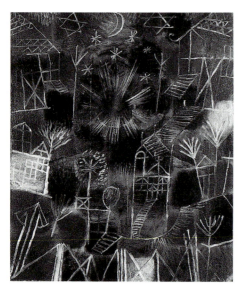

IV-13. Paul Klee
Cosmic Composition
1919
oil on cardboard
18 ⅞ x 16 ⅛"
Courtesy of Kunstsammlung
 Nordrhein-Westfalen, Düsseldorf.

etchings of 1945 and 1946 were paralleled in, or incorporated into the paintings. In the Pictograph oil paintings made before the etchings in this style, such as *Oedipus* (pl. 1) or *Eyes of Oedipus* (pl. 2) of 1941, the heavy and rigid lines that delineate the signs and grid, painted over a uniform ground color, are incompatible with the directness and spontaneity called for by the concept. Possibly in recognition of this, in paintings dated 1942 and 1943, including *Pictograph–Symbol* (pl. 5) and *Pictograph #4* (pl. 11), he used a more painterly approach, consistent with the traditional qualities of oil painting. The compartments of the grid were each painted in different tones rather than defined by lines, and the signs within them were densely painted in a realistic manner rather than in a linear, symbolic one. This was a good painterly solution but lacked the mystery that Gottlieb wanted to convey. By 1943 in *Hands of Oedipus* (pl. 10), which contains many of the same figurations as Pictograph #4, the symbols are drawn in a black calligraphic line in a style closer to that he had developed in the etchings.

This linear and calligraphic quality that seemed to satisfy an aspect of the artist's vision was one with which he experimented in the Pictograph etchings in the mid-1940s. The style of the etchings and the paintings began to merge around 1945 as the paintings became freer, more playful, and more personal, a change that Sanford Hirsch relates to a release from the tensions of the war.[30] Gottlieb abandoned the somewhat rigid mythological subject matter to address more general and more personal issues. A painting in oil and egg tempera of 1945, *Masquerade* (pl. 19), ostensibly a display of tribal masks, is related in subject matter to another etching, *Pictograph,* ca. 1944. These masks, as the play on the word used for the title implies, are not actual masks; they rather make reference to masks as they have been used throughout history by tribal Africans, by Native Americans or Pre-Columbians or to Picasso, Klee and Miró. Hirsch pointed out to the author that this work may in fact refer to an exhibition of masks that was held at the Brooklyn Museum in 1939. The paint is lightly applied on the canvas, thereby reproducing the transparent character of his aquatint, and the quality of the line is closer to his etchings than to the earlier paintings. By drawing in white line on a dark background, a technique similar to one used in the etching *Voyage,* and the early woodcuts, Gottlieb attained in a painting the same sense of spiritual ambiguity that he had achieved in his etchings.

The use of the fast-drying medium of gouache, rather than oil, may have played a part in the loosening of his style around 1945. Gouache, sometimes called poster paint, is a water-based paint that dries quickly and is generally easier to use and more flexible than oil paint. It allows more fluid and immediate application of line over ground and easy transitions between matte and transparent surfaces. Gottlieb, who had learned the technique of painting in gouache on colored paper from Avery in the 1930s, uses the medium in a manner similar to Avery's in *Untitled,* 1946 (Hirshhorn Museum and Sculpture Garden).[31] The entire sheet is covered with a terra cotta background color equivalent to the colored paper Avery had used, and symbols are drawn in line, either black or white, over flat graphic shapes. Although the technique was that used by Avery, the signs recall the drawings on Native American pottery or Greek vases. The colors are those Gottlieb remembered from Arizona, and the images are his private code—fingers, eyes, snake, kelp, faces, gourd.

Gottlieb began to paint with greater freedom, using more intuition than intellect. The grid broke down, the forms crossed over the compartments to join each other, and in some cases they became more calligraphic. Imagery gradually changed. Colors became transparent. As Hirsch observed, the subject of the couple, two figures, one male, one female, was an important area of concentration for Gottlieb in the late 1940s, a subject that recalls his figurative drawings and prints earlier in the decade.[32]

The gouache *Untitled,* circa 1946, still retains some of the lines of the grid and many familiar symbols. As in the etching *E#E* discussed above, the lines of the grid have been transgressed and so the composition reads vertically rather than in the horizontal stratifications typical of earlier works. In the gouache, abstracted male and female figures dominate the imagery, their heads (and eyes) occupying the top level of the composition. The paint, still muted earth tones, is laid down in layers of varying shades, and the images, now human figures, are rendered loosely in line, a major change from the gouache of the same year in the Hirshhorn Museum.

As the grid disintegrated, Gottlieb also began using watered-down gouache, which looks more like watercolor, resulting in less rigid delineations of the forms and lighter colors. Another gouache of 1948, *Figures* (pl. 53), is painted neither in the muted desert tones of the two 1946 gouaches discussed above nor in the dark foreboding colors of certain works around 1945, but in washy pinks, reds and browns with black ink. The composition is still made up of separate signs, recognizable though abstracted, which transgress the horizontal compartments of his original grid pattern. Full-length male and female figures with emphasis on their sexuality, fill the center of the sheet. The vertical compartmentalization of the parts of the figures, recall the divisions in the Exquisite Corpse drawings.

By the end of the decade Gottlieb seems to be moving toward greater abstraction and away from the referential forms of the Pictographs without giving up the grid entirely. Sometimes the grid returns to greater prominence, as in an untitled gouache of 1949, but the forms in this work are delineated in a shorthand manner and the color is reduced to red wash and black line. The images in *Night* of 1950 (pl. 60) are almost indecipherable although remnants of the grid remain. Rendered in ink and wash on paper with hints of yellow and orange, it communicates the same mysterious message, although more abstracted, that Gottlieb had achieved in etchings like *Omen* and *Apparition*. On the other hand, in one especially sketchy and unusual drawing, *Untitled (Study from Man Looking at Woman)* of 1951 (pl. 67), in graphite and gouache, he seems to move in the direction of more geometric simplicity, leaving many areas of unpainted paper. The compartments, a few of which are colored in primary colors, are mostly outlined in pencil over the white ground of blank paper. The more geometric grid, white ground, and primary colors are unusual in Gottlieb's oeuvre of this period but are reminiscent of Mondrian's constructivist paintings. The symbols are basic geometric shapes and letters of the alphabet, not commonly used in Gottlieb's Pictographs; many compartments remain empty. A few of the old signs are hastily sketched in pencil—an arrow, head, breasts, and legs—while the dancing cactus is recognizable, though truncated by the top of the sheet. The drawing *Untitled (Study from Man Looking at Woman)* is a study for, or from, a very similar oil painting on canvas. If Gottlieb developed this painting from a sketch, he abandoned one of the primary premises of the Pictographs. On the other hand, if the sketch is after the painting, it is another indication of Gottlieb's continuing need to rework and reexamine his visual vocabulary.

Gottlieb had received a commission for a stained glass window in 1949, and in 1951 he was working on the proposal for a large stained-glass facade for the Milton Steinberg House in Manhattan, which was constructed in 1953–54. The possibilities suggested by the metal lines that surround the images in a stained-glass window, an art Gottlieb had also examined with great interest when he was in Europe, may have been the inspiration for another almost totally abstract untitled drawing of 1951 in which red, yellow, green, and blue washes covered with heavy black lines form compartments empty of symbols. The colors glow from behind like stained glass. The resulting emphasis on the grid, which may or may not have been influenced by his work in stained glass, led to the formation of the series that followed the Pictographs, which Gottlieb called Labyrinths. He explained that he had arrived at the style of the Labyrinths by obscuring the image and working with a series of overlapping grids so that the images became obscured and the grid ultimately became the image.[33] The resulting works, with which he entered the next phase of his career, were made up of strong linear and ultimately gestural networks, informing the Labyrinths with the same calligraphy associated with the act of drawing that was integral to the Pictographs. In these works Gottlieb moved away from specific subject matter toward greater abstraction.

NOTES

1. Adolph Gottlieb and Mark Rothko, "The Portrait and the Modern Artist," typescript of a broadcast on *Art in New York*, WNYC, October 13, 1943. See Lawrence Alloway and Mary Davis MacNaughton, *Adolph Gottlieb: A Retrospective* (New York: Adolph and Esther Gottlieb Foundation, Inc., 1981), p. 171.

2. Gottlieb, in *Exhibition of Contemporary American Painting and Sculpture* (Urbana: University of Illinois, 1955), p. 202.

3. Ibid.

4. Barbara Rose, ed. *Readings in American Art Since 1900, A Documentary Survey* (New York and Washington: Praeger Publishers, 1968), p. 41.

5. Transcript of Registrar's records from the Art Students League, New York.

6. Gottlieb may have taken an illustration course in search of a practical application for his chosen career as an artist in order to please his parents who were worried about the impracticability of a career in art (MacNaughton 1981, p. 11).

7. The relationship is even more obvious in the quality of line in the tissue for this print. See Peter Morse, *John Sloan's Prints, A Catalogue Raisonné of the Etchings, Lithographs and Posters* (New Haven and London: Yale University Press, 1969), p. 144.

Sloan's teachings and interests have a curious parallel to concepts Gottlieb used in the formulation of the theories that led to his Pictographs. Long before Gottlieb developed the theory behind his Pictographs, he learned from John Sloan that "Art is the evidence of man's understanding, the evidence of civilization. Humanness is what counts. Man doesn't change much over the centuries...." (See Rose 1968, p. 42.)

Sloan may also have been the source for Gottlieb's first introduction to Native American art. He summered in Santa Fe every year between 1928 and 1951 where he was fascinated by the traditions of the local tribes. He studied Native American dances, pottery designs, and blankets and painted the desert forms and spaces. See David Scott, *John Sloan* (New York: Watson-Guptill, 1975), p. 162.

8. Adolph Gottlieb, "Artist and Society, A Brief History," *College Art Journal* 14, no. 2 (Winter, 1955), p. 96. Gottlieb cites Cézanne and van Gogh as the "heroes of my youth."

9. According to the registrar's records at the Art Students League, he took his last class in April 1921 until he resumed in February of 1924. In a manuscript chronology of his life, on file in the archives of the Adolph and Esther Gottlieb Foundation, Gottlieb recalls this trip.

10. David Sylvester, "Adolph Gottlieb, An Interview," *Living Arts*, no. 2, June 1963, p. 4. (The interview was first broadcast on the BBC Third Programme in October 1960.) Gottlieb comments that he did not work in Europe but just looked.

See MacNaughton 1981, p. 12, for discussion of drawing classes in Paris.

11. Gottlieb's manuscript chronology.

12. Carl Neumann, *Rembrandt Handzeichnungen* (Munich: R. Piper & Co., 1921) and H. v. Wedderkop, *Paul Klee, Junge Kunst, Band 13* (Leipzig: Verlag von Klinkhardt & Biermann, 1920) in the archives of the Adolph and Esther Gottlieb Foundation, New York.

13. April Kingsley, *Adolph Gottlieb, Works on Paper* (The Art Museum Association of America, 1985) p. 11.

14. Barbara Haskell, *Milton Avery* (Whitney Museum of American Art, 1982) p. 182, fn. 3. She substantiates a birth date of 1885 rather then 1893, which was the date Avery himself seemed to use. This means that Milton Avery was eighteen years older than Gottlieb rather than ten.

15. Gottlieb statement in Charlotte Willard, "In the Galleries," *New York Post*, January 10, 1965, p. 20, as quoted in MacNaughton 1981, p. 26, fn. 28.

16. Adolph Gottlieb, interview with Dorothy Seckler, October 25, 1967, Archives of American Art.

17. Statement by Milton Avery, *Exhibition of Contemporary American Painting* (Urbana: University of Illinois, 1951) p. 158.

18. Giorgio de Chirico (10 lithographs) and Jean Cocteau (text), *Mythologie* (Paris, 1934) in the collection of the Adolph and Esther Gottlieb Foundation.

19. MacNaughton 1981, p. 21.

20. Told to the author by Sanford Hirsch, Director, the Adolph and Esther Gottlieb Foundation.

21. Kingsley 1985, p. 19.

22. Jeanne Siegel, "Adolph Gottlieb: Two Views," *Arts Magazine* 42 (February 1968).

23. Lawrence Alloway, "Melpomene and Graffiti," *Art International*, April 1968, p. 22; reprinted in this volume, pp. 41-45.

24. Kingsley 1985, p. 23.

25. Stephen Polcari, *Abstract Expressionism and the Modern Experience* (Cambridge: Cambridge University Press, 1991), p. 154.

26. Information told Sanford Hirsch, Director, Adolph and Esther Gottlieb Foundation, and supplied by him to the author.

27. Some of these were shown with a group, put together by Gottlieb, called The Graphics Circle in an exhibition that was held early in 1947.

28. Adolph Gottlieb, "The Ides of Art," *The Tiger's Eye,* no. 2 (December 1947), p. 52.

29. Gottlieb owned a Miró print of this period, which is now in the collection of the Adolph and Esther Gottlieb Foundation.

30. Sanford Hirsch, *Pictograph into Burst: Adolph Gottlieb Paintings in Transition* (New York: Adolph and Esther Gottlieb Foundation, 1992), p. 15.

31. Gottlieb, interview with Dorothy Seckler, October 25, 1967, Archives of American Art.

32. Sanford Hirsch, *Pictograph into Burst: Adolph Gottlieb Paintings in Transition* (New York: Adolph and Esther Gottlieb Foundation, 1992), p. 8.

33. *Exhibition of Contemporary American Painting and Sculpture* (Urbana: University of Illinois, 1955).

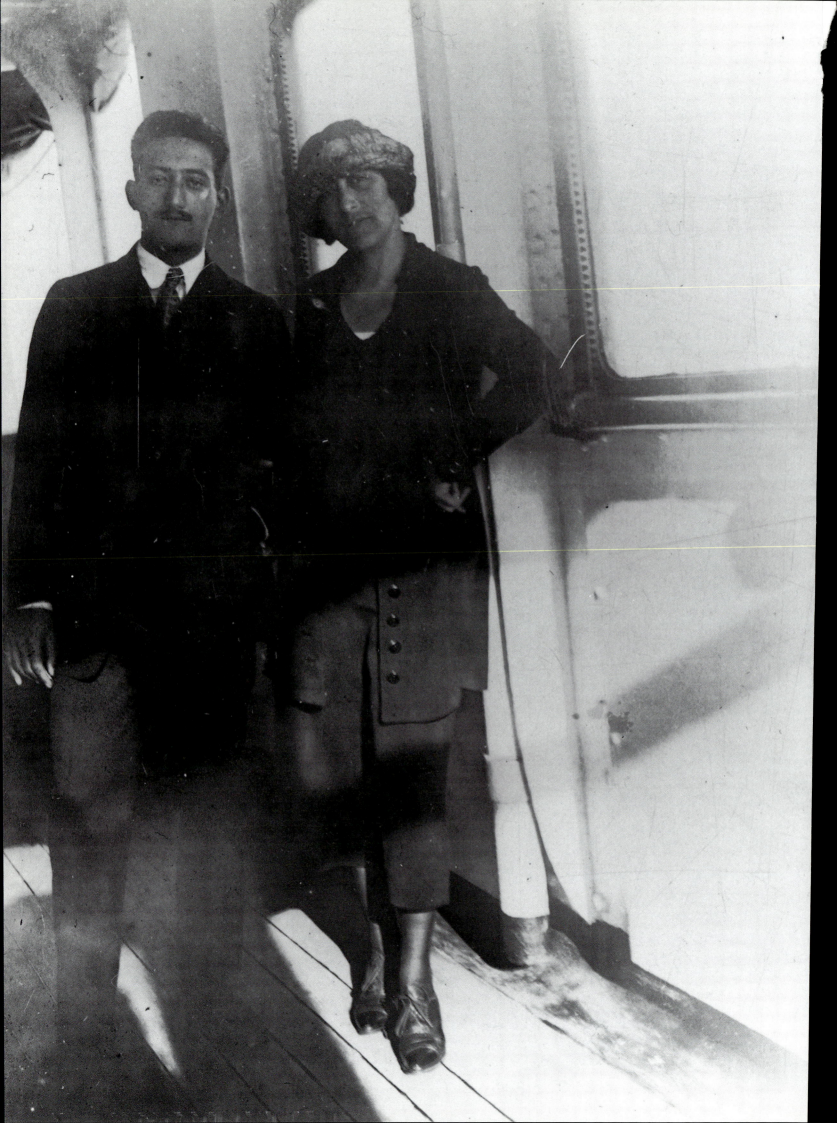

V

THE LEGACY OF SIGNS: REFLECTIONS ON ADOLPH GOTTLIEB'S PICTOGRAPHS

Charlotta Kotik

You have to be able to discover new things in a painting every time you look at it.... More than the painting itself, what counts is what it throws into the air, what it spreads.... The painting must be fertile. It has to give birth to a world. It doesn't matter whether you see flowers in it, figures, horses, as long as it reveals a world, something living.

Two and two don't make four. They only make four for the accountants. But you can't stop there; the painting must make you understand that, it must fertilize the imagination.
—JOAN MIRÓ[1]

The imagination to create a new universe, one wrought from the fragments of fantastic beings and objects as well as everyday reality yet related both to ancient myths and the formal advances of twentieth-century art, was the basis of Gottlieb's Pictographs. This series of paintings is of prime importance within the oeuvre of this eminent abstract expressionist. In this extensive group of works begun in the early 1940s, Gottlieb formulates his unique response to the impasse in American painting that had profoundly disturbed his inquisitive faculties. Equally dissatisfied with the often pious sentiments of regionalism, the aggressive yet uninspiring mode of American social realism, and the mechanistic aspects of geometric abstraction offered by painters of the American Abstract Artists group, Gottlieb felt compelled to find his own voice, one more in tune with the tumultuous events at the outbreak of the World War II.

In the Pictograph series, Gottlieb reconciles the flat planes of geometric abstraction found in Piet Mondrian's painting with the swelling shapes characteristic of synthetic cubism seen in Fernand Léger's work. He also assumed the practice of automatic writing, the exploration of subject matter derived from the subconscious, and the biomorphic forms drawn from surrealism, as expounded by André Breton. At the same time, Gottlieb incorporated certain imagery and techniques from the cultures of the indigenous peoples of the American continents, Africa, and Oceania. Synthesizing the lessons of Western art history with these varied non-Western sources, he forged a new expression, which was uniquely American. With their nonhierarchical composition and their exploration of subconscious subject matter and the spontaneity of automatism, Gottlieb's Pictographs provided a conceptual stepping stone leading toward abstract expressionism and pointing beyond. Moreover, in the Pictographs Gottlieb created a bridge between the paintings of the abstract expressionists and the work of artists of subsequent generations who would react against the all-encompassing hegemony and frequently dogmatic criticism of that very movement.

Adolph Gottlieb meeting his mother, Elsie, in Europe, 1922.

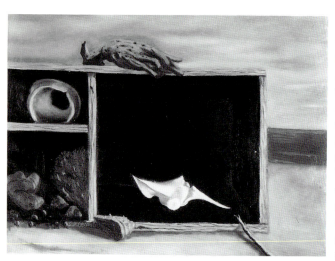

V-1. Adolph Gottlieb
Untitled (Box and Sea Objects)
ca. 1940
oil on linen
25 x 31 ⅞"
© 1979 Adolph and Esther Gottlieb
 Foundation, Inc., New York

Adolph Gottlieb was born in 1903 on New York's Lower East Side. His parents had planned that the young Gottlieb would join the family's thriving stationery business, but early on he demonstrated a special ability and interest in the fine arts. At the age of eighteen, without a passport, Gottlieb traveled to France and witnessed firsthand the artistic innovations and excitement of Paris, the artistic capital of the world at that time. He continued his travels through central Europe and Germany, a much troubled land in 1922 yet one still full of expressionist spirit and the modern masterpieces created before World War I. Gottlieb was interested not only in contemporary art but also in the art of past centuries, especially the work of the Italian primitives and Renaissance masters. In these traditions the drama of Christianity unfolds in narrative scenes that are frequently isolated within the distinct compartments of the painted composition. He also looked at the outstanding German and French public collections of works from non-Western cultures, thus gaining a knowledge of the varied civilizations of the world and their collective cultural heritage. The knowledge acquired during his travels early in life greatly enriched Gottlieb's formal and conceptual solutions during the Pictograph period.

Upon his return from Europe, Gottlieb made peace with his parents and finished high school. He then attended the Art Students League, where he met and befriended the painter Barnett Newman, with whom he visited museums to continue his study of old masters, and the Russian émigré artist John Graham, who further encouraged Gottlieb's interest in modern art and later initiated him into collecting primitive art. At the Art Students League, Gottlieb had the opportunity to study with both Robert Henri and John Sloan, American painters of the Ashcan school. After he trained his students in traditional painting techniques, Sloan, like Henri, also advocated experimentation with applying paint directly onto the canvas, without the use of preliminary sketches, in order to preserve spontaneity of gesture and freshness of idea. This essentially proto-abstract-expressionist approach proved to be invaluable for Gottlieb, who created all of his Pictograph paintings in this manner, often mixing various media on canvas and thereby achieving unique surfaces and color modulations.

In 1932 Adolph Gottlieb married Esther Dick, who was also a painter. For many years Esther supported them both by teaching, and thus enabled Gottlieb to concentrate fully on developing his ideas and to paint without major financial pressures. The Gottliebs moved to Brooklyn in 1933, where they befriended several artists, most notably David Smith and his wife Dorothy Dehner, whose interest in the European avant-garde was similar to Gottlieb's own. Here they also discovered the Brooklyn Museum with its diverse collections and an exhibition program that included major shows devoted to Native American art.[2]

Within the context of today's heightened awareness of cultural pluralism, it is interesting to note how much emphasis there was in New York in the 1930s on exhibiting art and artifacts created by indigenous peoples of the Americas, Asia, Africa, and Oceania, as well as the archaeological finds of Europe. Not only institutions devoted to tribal cultures—the Museum of Natural History and the Museum of the American Indian, for example—but also the recently established Museum of Modern Art delved into the realm outside Western artistic tradition when formulating their exhibition programs. An avid museum-goer, Gottlieb certainly drew inspiration from such groundbreaking exhibitions mounted by the Museum of Modern Art as "African Negro Art" in 1935 and "Prehistoric Rock Painting in Europe and Africa" in 1937. These, together with the grand events such as the Museum of Modern Art's "Cubism and Abstract Art" and "Fantastic Art, Dada and Surrealism," both in 1936, show the diversity of artistic experience offered to the New York public in the 1930s.

For many artists of the twentieth century, an interest in the cultural artifacts of non-Western societies was translated into a desire to own some of these objects and, through their presence, to be continually reminded of the energy and force believed to be inherently present in them. While it is commonly accepted that Gottlieb's interest in non-Western cultural artifacts informed his Pictographs, there was no simple one-to-one relationship between the images in the artist's Pictographs and the shapes of African masks, for example, or the design of a Native American blanket. These objects were not copied to become components in the composition of Gottlieb's paintings but

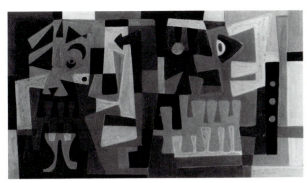

V-2. Steve Wheeler
Untitled (#40)
ca. 1942
gouache on paper
6 ½ x 11"
Private collection. Courtesy of Snyder
Fine Art, New York.

rather served as a source of inspiration. Their influence in the work was spiritual and emotive, not physical or rational.

In 1937 Esther's physician advised her to move from New York, and the Gottliebs relocated to Arizona. During their stay there, Adolph Gottlieb at first concentrated on painting still lifes, which allowed him to work indoors and away from the blinding light of the desert. When Gottlieb had adjusted to his new environment, he began to incorporate landscape elements into his repertory, frequently adding a view from the studio window behind a still-life composition. Gottlieb's use of flattened pictorial space can be credited to the intense desert light, which obliterates shadows and demolishes spatial depth, and to his longstanding interest in cubist still lifes and his fascination with Native American art. He was particularly interested in Georges Braque's compositions as well as those of the Mexican painter Rufino Tamayo. One can envision the horizontal tabletop laden with various objects being tilted upright and becoming a vertically oriented plane marked with shapes of ambiguous meaning, a format that became characteristic of his later Pictograph series (fig. V-1). Gottlieb explains:

> It was 1937. I had been working for a year in Arizona. My work was becoming more abstract and I became interested very much in the curious things that you find in the sands of the desert. And I'd set them up and make a still life. I started doing that in Tucson. Then I went to the ocean and I found similar things on the beaches. I'd collect these things and I'd set them up and paint still lifes. And then I started painting these objects in boxlike arrangements. They were fragmented pieces of things that had been worn and weathered, and they had no connection with each other. So therefore I divided them, and I made boxes—I painted boxes which had compartments, and each one of these things was isolated, so that you saw it by itself. But then there was a total—a sort of a total combination......it led to the idea of the pictographs where instead of having a realistic representation of an object in a box, I had more of a symbolic representation.[3]

The restricted palette of the desert was also important to Gottlieb. He had learned a great deal about the techniques of painting from the writing of Hamilton Easter Field, who advised against the use of primary colors.[4] The subtle earth tones characteristic of his desert paintings and early Pictographs were achieved through the modulation and expert layering of paint. Despite the beauty of the desert and his interest in American Indian ceramics, which he studied at the Arizona State Museum, Tucson, Gottlieb felt isolated in Arizona and in 1938 moved with Esther back to Brooklyn. At that time, his search for new subject matter and style in painting was already well under way.

Once back in New York, Gottlieb reestablished contact with other artists of his generation, who felt that the possibilities of working within traditional styles and themes had been exhausted. The political climate of the time added to the frustrations of these avant-garde artists, who grappled with defining the role and potential of art in times of social and political change. Gottlieb's social consciousness and organizational abilities had led him to become a founding member of the American Artists' Congress in 1936 prior to his move to Arizona. This organization was short-lived but nevertheless important because it initiated numerous projects that increased the political awareness of artists and the general public alike. The Congress organized such projects as the 1937 exhibition entitled "In Defense of World Democracy—Dedicated to the Peoples of Spain and China" and the 1939 showing of Pablo Picasso's *Guernica* in New York. Painted in 1937 in response to the brutal bombing of a Basque town by German pilots acting on behalf of General Franco, *Guernica* deeply moved Gottlieb with its mythical overtones and formal innovations. Derived from his experiments with collage, Picasso's fractured figures exploding across a flattened pictorial field were an important precedent for Gottlieb's own fragmented images in the Pictograph paintings.

The horrors of the Spanish Civil War that were depicted by Picasso signaled the global destruction waiting to strike. Artists responded in many ways, some joining the ranks of the Spanish Republican Army, others reexamining the role of art in society and the responsibility of the artist in times of a threat to the nation. In the United States, the years of the Great Depression had a great impact on artists and their perceived role within society as it at once eroded the traditional client base and offered a possibility of stable employment through the enlightened social programs

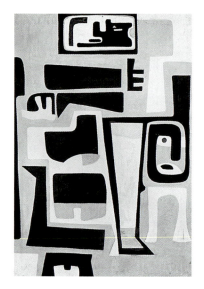

V-3. Peter Busa
Children's Hour
ca. 1948
oil on canvas
72 x 52"
Estate of Peter Busa.

of the New Deal. As veritable employees of the state, artists organized in groups such as the American Artists' Congress and the Artists' Union, forums in which their roles and responsibilities were discussed. Gottlieb was a member of the Artists' Congress from its inception in 1936, and left it later that year to join the Artists' Union. He soon realized, however, that this group was dominated for the most part by social realists. The activities of the Union and the editorial policy of its magazine *Art Front* did not correspond with Gottlieb's ideas. The rift between him and the political activists only deepened when they supported the Nazi-Soviet pact on nonaggression, which was signed in 1939. Enraged by Stalin's treason against humanist ideas in aligning himself with Hitler and by his colleagues' tolerance of this act, Gottlieb was instrumental in organizing the Federation of Modern Painters and Sculptors, a dissent group of former members of the American Artists' Congress, who were equally upset by the Congress's political platform supporting Stalinist doctrine of repression and deceit.[5]

As the impending nightmare of World War II manifested itself into a painful reality, the old themes and genres of European art were insufficient to express the inner tensions present in many artists' minds. Western civilization had been unable to contain the spread of Nazism with the forces of reason and rules of democratic government and had failed miserably in preventing this tragedy of immense proportions. The feeling of emptiness and the need to begin anew was prevalent, and every source leading toward the discovery of a way out from this impasse was being investigated.

The spiritual powers inherent in the form and function of artifacts created by tribal cultures were seen by contemporary artists as an important source of renewal during this turbulent time. The art of Native Americans was identified as a distinctly American aesthetic heritage, as a native source of inspiration for modernity, and as a challenge to European artistic hegemony. The great Mexican muralists Rufino Tamayo and Diego Rivera, whose work was well known in New York, had demonstrated the validity of returning to their native heritage as a source of inspiration and transforming it into a potent artistic and social tool for the twentieth-century artist. Adolph Gottlieb and Barnett Newman were also ardent proponents of Native American art and were particularly interested in tribal art from the Northwest Coast. Searching for context and meaning in their work, they were not only concerned with the majestic formal beauty of the objects but also attracted to their spiritual power and their function within the society. In his catalogue introduction to a 1944 exhibition of pre-Columbian sculpture, Newman eloquently identified the relevance of aboriginal American cultural artifacts to contemporary art:

> While we transcend time and place to participate in the spiritual life of a forgotten people, their art by the same magic illuminates the work of our time. The sense of dignity, the high seriousness of purpose evident in this sculpture, makes clearer to us why our modern sculptors were compelled to discard the mock heroic, the voluptuous, the superficial realism that inhibited the medium for so many European centuries. So great is the reciprocal power of this art that while giving us a greater understanding of the people who produced it, it gives meaning to the strivings of our own artists.[6]

A whole new school—again centered around the progressive Art Students League—was created in the early 1940s with the values of Native American art in mind, particularly the concept of shallow space without perspective, which the artists of this group termed "Indian Space."[7] Although Gottlieb was never formally associated with these much younger artists, who later became known as the Indian Space Painters, he shared many interests with them and was a friend of Steven Wheeler, who together with Peter Busa, was one of the most active and accomplished artists of the movement (fig. V-2 and fig. V-3). They had studied many sources analogous to Gottlieb's and were striving for similar pictorial solutions.[8] As Barbara Hollister explains in the catalogue of the 1991 exhibition "The Indian Space Painters/Native American Sources for American Abstract Art":

> The Indian Space artists found in Northwest Coast ideographic art the basis of a pictorial language in which image, symbol, and myth coalesced, functioning simultaneously as art form, historical narrative, and religious icon. They were thus engaged in one of the seminal issues of early abstraction: the merging of language and image.[9]

Free of Western conventions, tribal art symbolized the universal power of rebirth, and its fusion of conscious and unconscious creative powers pointed toward creativity

in its primal stage. The unconscious—or subconscious—was a realm of intense investigation for the surrealists, who saw it as the only true source of creativity. Gottlieb studied Jung's theory of the collective unconscious. The Swiss psychologist asserted the existence of a "racial memory" filled with the imprints of signs and symbols accumulated through the ages that can be released and become an immense source of inspiration if one escapes the dictates of learned repression and stale conventions. The universal need of various cultures to produce myths that help explain the mysteries of life and creation and guide humans through the trauma of death and devastation was of great interest to Gottlieb and his fellow artists at this critical time in history.

Gottlieb's paintings, which demonstrated his interest in imagery derived from myth and the exploration of the subconscious, were included in the Third Annual Exhibition of the Federation of Modern Painters and Sculptors exhibition in 1943. *The New York Times* art critic Edward Alden Jewell reacted negatively to the work in the exhibition.[10] In their famous letter to *The New York Times*, Gottlieb and Rothko responded to Jewell's review and presented a joint statement that formulated their credo most eloquently.

> ...We do not intend to defend our pictures. They make their own defense. We consider them clear statements. Your failure to dismiss or disparage them is prima facie evidence that they carry some communicative power.
>
> We refuse to defend them because we cannot. It is an easy matter to explain to the befuddled that "The Rape of Persephone" is a poetic expression of the essence of the myth; the presentation of the concept of seed and its earth with all its brutal implications; the impact of elemental truth....
>
> It is just as easy to explain "The Syrian Bull", as a new interpretation of an archaic image, involving unprecedented distortions. Since art is timeless, the significant rendition of a symbol, no matter how archaic, has as full validity today as the archaic symbol had then. Or is the one 3000 years old truer?...
>
> The point at issue, it seems to us, is not an "explanation" of the paintings but whether the intrinsic ideas carried within the frames of these pictures have significance.
>
> We feel that our pictures demonstrate our aesthetic beliefs, some of which we, therefore, list:
>
> 1. To us art is an adventure into an unknown world, which can be explored only by those willing to take the risks.
>
> 2. This world of imagination is fancy free and violently opposed to common sense.
>
> 3. It is our function as artists to make the spectator see the world our way—not his way.
>
> 4. We favor the simple expression of the complex thought. We are for the large shape because it has the impact of the unequivocal. We wish to reassert the picture plane. We are for flat forms because they destroy illusion and reveal truth.
>
> 5. It is a widely accepted notion among painters that it does not matter what one paints as long as it is well painted. This is the essence of academism. There is no such thing as good painting about nothing. We assert that the subject is crucial and only that subject matter is valid which is tragic and timeless. That is why we profess spiritual kinship with primitive and archaic art....[11]

In order to move forward during a time of disillusionment, Gottlieb looked to history for inspiration. He was moved by classical myths, especially those exploring the tragic lot of a hero unable to ward off the destructive forces of fate. Influenced by the ideas expressed in the writings of Sigmund Freud and Carl Jung, which were much discussed among artists at the time, Gottlieb focused on the myth of Oedipus as the subject of his earliest Pictographs.[12]

Oedipus (pl. 1) and *Eyes of Oedipus* (pl. 2), both from 1941 and considered to be among the earliest of the Pictographs, demonstrate the continuous formal logic inherent in Gottlieb's work. The box compartment inspired by Native American objects that first appeared in Gottlieb's work of the late 1930s here grows into a complex structure of a rectilinear grid that divides the pictorial field into multiple compartments holding the arrested objects. These geometric divisions bring to mind the work of Piet Mondrian, whose paintings were much admired by the New York avant-garde when they were displayed in the Gallatin Collection of modern art at New York University from 1927 to 1943. Thus even before his coming to New York in 1940, this shy and reticent Dutchman exerted much influence through his unwavering

adherence to compositional order and balance expressed through the use of principles of strict geometry. Gottlieb's palette was far from Mondrian's primary colors, however; it retained the pink, beige, and brown hues of the desert. The vocabulary of shapes in both paintings is restricted, the most prominent being the image of the eye. Rendered in light and contrasting paint in the *Eyes of Oedipus*, the eye simultaneously suggests blindness and the sexually charged symbol of an egg. It also alludes to rejection, colloquially expressed in the saying "turning a blind eye": first to the rejection of the infant Oedipus by his father and ultimately to the hero's rejection by his compatriots after he unknowingly violates all accepted social norms.

In 1941 the Museum of Modern Art mounted two more of their influential exhibitions—retrospectives of the work of Paul Klee and Joan Miró. Gottlieb had known and admired Klee's work since his trip to Europe in 1921. Independent of any school, this Swiss artist is among the most poetic and sophisticated minds of the twentieth century. Both his work and the paintings of the Catalan Miró demonstrate conceptual and formal affinities with the interests of the New York avant-garde. While they adopted surrealism's method of free association, Klee and Miró nevertheless remained independent of its dogmatism. Each created his own lexicon of whimsically bizarre signs and personages and affected most of the future artists of the New York School with his imagination and energy. These two exhibitions may have been responsible for the loosening of the rectilinear grid in the Pictograph compositions after 1941, allowing for greater freedom and variety in the juxtapositions of associated shapes.

Pictograph—Symbol of 1942 (pl. 5) displays well many of Gottlieb's formal and compositional concerns. Some of the motifs recall the decorations observed on Native American ceramics of the Southwest as well as the earth-tone color scheme associated with the region. The image of the eye is prominent, as it is in most of the Pictographs. Alluding to the tragic fate of Oedipus in the early Gottlieb series, its presence has multiple significances in the later work. Universally seen as a symbol of perception and knowledge, it also symbolizes inner vision for the surrealists, the sun in Egyptian art, and God Almighty in Christianity. The eye may also signify the evil eye, cast to inflict misfortune—an illness, loss of property, or worse—that is one of the most pervasive myths in the history of mankind. Its terrible effects are mentioned in Sumerian texts, the Bible, and Middle Eastern, Semitic and European folk traditions. The universal fear of the evil eye supports Gottlieb's belief in the collective memory and the interconnectedness of myths that appear in various cultures in different guises but with essentially the same meanings.[13] But above all, the image of the eye refers to the vision of the artist whose keen observations constantly reveal new perceptions of our reality.

Although no two compositions are alike within the large group of Pictographs, there are some close relationships between them. Two such works are *Pictograph #4* (pl. 11) and *Hands of Oedipus* (pl. 10), both from 1943. In these works, it is the motif of two heads in profile, facing away from each other and joined in the back, that captures our attention. Surrounded by stylized images of eyes and hands, these two profiles allude to the different states of existence. An open eye in one and a closed eye in the other, as shown in the faces in *Hands of Oedipus*, point to the function of the artist who receives the knowledge of the world through his open vision, transforms it through contemplation in his private and closed inner world, and finally relays it in visible form to be viewed by others. The double profile also alludes to the active-passive duality of our existence, wherein both factors are necessary for the safe conduct of our lives.

In *Pictograph #4*, the dual nature of the profiles is heightened by placing one profile in a field of light, the other into a field of dark color. The opposition of light versus dark has been equated with positive and negative, good and evil, safe and dangerous, for centuries and has a similar connotation in this painting. The profile in the dark field, the hand painted in the dark hue, and the jagged motif underneath—a sign of water in Egyptian hieroglyphs—are all reminders of life's perils. The smaller *Pictograph #4* is executed with energetic brushwork and rich colors, while the artist discarded any reference to his own physical energy in *Hands of Oedipus* and kept the symbolism of colors at a minimum. These two works exemplify the duality present

not only in the Pictographs but also throughout most of Gottlieb's work. His were investigations unsolvable with a single answer; the artist's highly analytical intellect demanded multiple solutions to any posed problem in a firm belief that simplification for the sake of clarity does not lead to the discovery of the hidden truths or essential values.

Masquerade of 1945 (pl. 19) has an ominous feeling, accentuated by its dark tonality. The mysterious personages seem to appear from the depth of the painting as if recalled from the dream world by forces of magic. By relinquishing the idea of flatness and of clear delineation with his customary black line, Gottlieb created one of the most memorable works in the series.

Letter To a Friend of 1948 (pl. 48) has the character of a large tablet densely marked with simulated calligraphic signs. Although many of the signs are familiar from his other Pictographs, the overall impact of this work is unique. Based on the exploration of a thin white line outlining the symbols, the work suggests Gottlieb's interest in creating a private alphabet of symbols.

Two works, both of 1948, point to the less-structured composition of the late Pictographs. In the first, *Sounds at Night* (pl. 47), the forms float in the mysterious darkness of the pictorial field unrestricted by geometric compartments, while in *Running* (pl. 51) the black marks sweep over the white canvas in a dynamic ballet.

By 1951, in works such as *Figuration (Two Pronged)* (pl. 63), the geometry of compartmentalization is almost dissolved. Here the stylized figures of a man and a woman remind us of petroglyphs from ancient times, while the patches of color dispersed through the painting are the first signs of the "bursts" that would occupy Gottlieb's paintings from the 1950s to the 1970s.

Throughout the period of Pictographs, which span more than a decade, the artist used a distinct vocabulary of shapes. Some are more abstract than others; most are nevertheless based on the manipulation of the observed. Many of the most prominent figures featured through the whole series—a hand, an eye, teeth, a mask, a spiral, or a jagged-edged motif—were sustained from his earlier representational works. Gottlieb states,

> I decided to restrict myself to those shapes which I felt had a personal significance to me. And I wanted to do something figurative. Well I could not visualize the whole man on canvas. I could not see him in a flat space. I felt that I wanted to make a painting primarily by painterly means. So I flattened out my canvas and made these roughly rectangular divisions, with lines going out in four directions. That is vertically and horizontally. Running right out to the edge of the canvas. And then I would free associate, putting whatever came to my mind very freely within these different rectangles. There might be an oval shape that would be an eye or an egg. Or if it was round it might be sun...It could be a wriggley shape and that would be a snake...There would be very little editing or revision. [14]

An image maker at heart, Gottlieb used the grid filled with the fragments of various objects in a manner that allowed him to incorporate these figurative elements within a modernist format.

By randomly arranging numerous objects, Gottlieb created compositions without a focal point and without built-in hierarchy, clear progression, or implied narrative. The images were meant to be viewed simultaneously so that the impact would be instantaneous. "There was no chronology," Gottlieb explains, "there was no rational order, the images appeared at random, they then established themselves in a new system. That was why all those years I was able to use very similar images, but by having different juxtapositions there will always be a different significance to them." [15]

Gottlieb's development of a lexicon of signs and symbols that he used repeatedly in constantly changing configurations occurred at a time when the theory of semiotics—the science of signs—was widely studied both in United States and in Europe. Building upon the work of Swiss theorist Ferdinand de Saussure, the philosopher and founder of American semiology, C. S. Peirce outlined a rather complex system in which there exists a triad of signs—icon, index, and symbol. [16] A closer look at his definitions of icon and symbol will illuminate some of the aspects of Gottlieb's work. In the icon, the relationship between the sign (the signifier) and the object (the signified) manifests a visual resemblance to the real-life object that has been selected to become a sign. This resemblance is initially necessary so that it can be identified, i.e., recognized by the viewer (the receiver). Thus, a drawn or painted

eye—present in nearly all of Gottlieb's Pictographs—becomes an icon of real-life anatomy. The active participation of the viewer, or interpreter, endows the icon with the symbolic meaning, and the context in which the sign appears transforms the icon into a symbol. In the Pictographs devoted to Oedipus, for example, the eye image ceases to be only an icon as it becomes a symbol of the tragedy of the hero, whose terrible, albeit unwitting, deeds drove him to self-inflicted blindness. The iconic symbols, or symbolic icons, are the signs that Gottlieb selected for his Pictographs. The cognitive nature of perception and the forms that invite the multiple interpretations make the Pictographs meaningful and fresh despite the frequent repetition of signs. "Common artistic experience," writes the Italian philosopher Umberto Eco, "teaches us that art not only elicits feelings but also produces knowledge. The moment that the game of intertwined interpretations gets under way, the text compels one to reconsider the usual codes and their possibilities."[17] These words apply not only to linguistic relationships but to those in the visual arts as well.

Gottlieb himself did not refer directly to the theory of semiotics—as did the Indian Space Painters—yet it is highly probable that he was aware of it. Always interested in literature, poetry especially—his cousin Cecil Hemley was a poet and Gottlieb is known to have written poems in the 1930s himself—his work was influenced by the imagery drawn from literature, such as T. S. Eliot's "The Waste Land." Although Gottlieb was not interested in developing a visual vocabulary that would be comprehensible as part of a universal language of signs—such as that of Joaquin Torres-Garcia, whose compartmentalized compositions are often mentioned in discussions of Gottlieb's work—he nevertheless created a private system of symbols, which require an extensive knowledge of his work to decode. Our efforts, if we undertake the challenge, are rewarded not only by a rich cultural experience but also by a greatly expanded worldview through a new look at some very old parts of our cultural heritage.

The series of Pictographs proved important not only for Gottlieb's own work but also for American painting, for we see in these works the first concentrated effort to draw truly innovative solutions from the ideas suggested both by cubism and surrealism, with indigenous American and tribal art acting as a catalyst in setting the whole process in motion. In the history of American art, Gottlieb is a singular figure. He occupies that special place in the art world accorded to the independents—simultaneously revered and neglected. In essence he was a maverick working on his own terms according to his own timing. With the other abstract expressionists, Gottlieb began a revolution that ultimately liberated American art. His accomplishments, however, reached beyond any particular movement because of his unwillingness to conform to the dictums of regionalism before World War II, of surrealism during the war, or of abstract expressionism immediately afterwards. He provided a unique link with the European modernism exemplified in the work of Picasso and Henri Matisse. Gottlieb admired Matisse not only for his feelings for color but also for his superb draftsmanship and steadfast adherence to object. At the same time, Gottlieb connected the cultural heritage of Native American art with that of Western modernism, incorporating an extraordinary feeling for both and an ability to keep the elements distinctly present while according them proper recognition. His was an approach of understanding, of plurality, and of maintaining the specific features of the forms.

Gottlieb continued to concentrate on Pictographs well into the 1950s. However, he gradually discarded the pictographic compartments, thus simplifying the composition by ultimately keeping only one frame—that of the whole pictorial field itself. This frame eventually held two essentially opposing forms—the dynamic, open, and seemingly ever-expanding "bursts" and their counterpart, the hermetic form of a clearly delineated disc. Never yielding to total abstraction but always maintaining the presence of an object through its manipulated image, Gottlieb's Pictographs point to the iconic vision of Jasper Johns and the compartmentalized imagery of the early work of Robert Rauschenberg.

The work of Adolph Gottlieb has not been exhibited widely in recent years. As in previous decades, his work did not conform to the dominant values of the 1980s with its demand for glamour and easy consumption. There is no single biography of the artist and only an occasional magazine article about his work. But despite this sparse showing and scholarship, young contemporary artists are aware of Gottlieb's ideas and seeking to

learn more. The fragmented figure and the ideographic sign are explored by artists both in the United States and around the globe. Painters of various ages, backgrounds, and prominence, such as A.R. Penck and Gert Sonntag in Germany, Carlos Alfonzo of Cuba, or Donna Nelson, Robin Winters, Matt Mullican, and Jonathan Lasker in New York, each recall Gottlieb in their work. Yet much as Adolph Gottlieb himself did not imitate the features of the works he admired, these artists do not follow the ideas set forth in Gottlieb's painting literally but instead recognize kinship with his work. In a time when content in art is once again seriously debated, when the ideas of cross-cultural fertilization are central to understanding the wide scope of art currently being created, the legacy of Adolph Gottlieb once again comes into focus.

NOTES

1. Joan Miró, "Two and Two Don't Make Four," *Joan Miró: 1893-1993* (Barcelona: Fundació Joan Miró, 1993), p. 426.

2. Adolph and Esther Gottlieb's collection of African, Oceanic, pre-Columbian, and Native American objects was bequeathed to the Brooklyn Museum in 1989.

3. Jeanne Siegel, "Adolph Gottlieb: Two Views," *Arts Magazine* 42 (February 1968), p. 30.

4. Mary Davis MacNaughton, "Adolph Gottlieb: His Life and Art," *Adolph Gottlieb: A Retrospective* (New York: Adolph and Esther Gottlieb Foundation, Inc., 1981), p. 11. MacNaughton suggests that Gottlieb read Hamilton Easter Field's *The Technique of Oil Painting and Other Essays* (1913).

5. Sanford Hirsch, "Introduction," *Adolph Gottlieb: A Retrospective* (New York: Adolph and Esther Gottlieb Foundation, Inc., 1981), pp. 9-10.

6. Barnett Newman, *Pre-Columbian Stone Sculpture* (New York: Wakefield Gallery, 1944), p. 1.

7. Barbara Hollister, "Indian Space: History and Iconography," *The Indian Space Painters: Native American Sources for American Art* (New York: The Sidney Mishkin Gallery, Baruch College, The City University of New York, 1991), p. 31.

8. For further information about Peter Busa, see Sandra Kraskin, *Life Colors Art: Fifty Years of Painting by Peter Busa*, exhibition catalogue (Provincetown, Mass.: Provincetown Art Association and Museum, 1992).

9. Hollister 1991, p. 31.

10. Edward Alden Jewell, "End-of-the-Season Melange," *The New York Times*, June 6, 1943, Section II, p. x9.

11. Adolph Gottlieb and Mark Rothko, in Edward Alden Jewell, "The Realm of Art," *The New York Times*, June 13, 1943, p. x9. Reprinted as Appendix A in *Adolph Gottlieb: A Retrospective* (New York: Adolph and Esther Gottlieb Foundation, Inc., 1981), p. 169.

12. Abandoned by his royal parents at birth on the advice of a prophet who foresaw a threat to the king, Oedipus was rescued and raised by foster parents. As an adult, he met and was challenged by a man on a road, whom he kills. Unbeknownst to Oedipus, the man was his father. By solving the riddle of the Sphinx, he proceeds to take his father's place as king and husband of the queen, his mother. After many years and several children, the nature of Oedipus's deeds are revealed, at which time his wife and mother Jocasta hangs herself and Oedipus blinds and exiles himself.

13. For more information on the symbol of the eye in various world cultures, see *The Evil Eye: A Casebook*, Alan Dundes, ed. (Madison: The University of Wisconsin Press, 1992).

14. Adolph Gottlieb, interview with Dorothy Seckler, October 25, 1967, archives of Adolph and Esther Gottlieb Foundation, New York.

15. Ibid.

16. For a summary of Peirce's theory, see Terence Hawkes, *Structuralism and Semiotics* (Berkeley and Los Angeles: University of California Press, 1977), pp. 126-130; for further reading, see *C.S. Peirce, Collected Papers* (8 vols.), Charles S. Hartshorne, Paul Weiss, and Arthur W. Burks, eds. (Cambridge, Mass.: Harvard University Press, 1931-58).

17. Umberto Eco, *A Theory of Semiotics*, (Bloomington and London: Indiana University Press, 1976), p. 274; quoted in Hawkes 1977, p. 142.

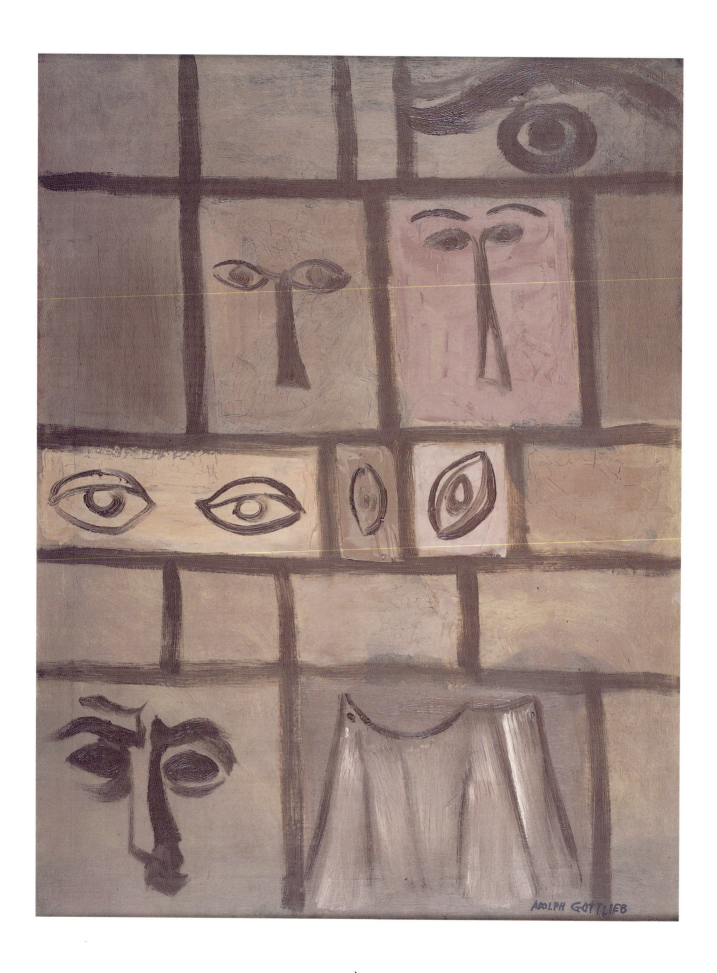

I

Oedipus

1941
oil on canvas
34 x 26"

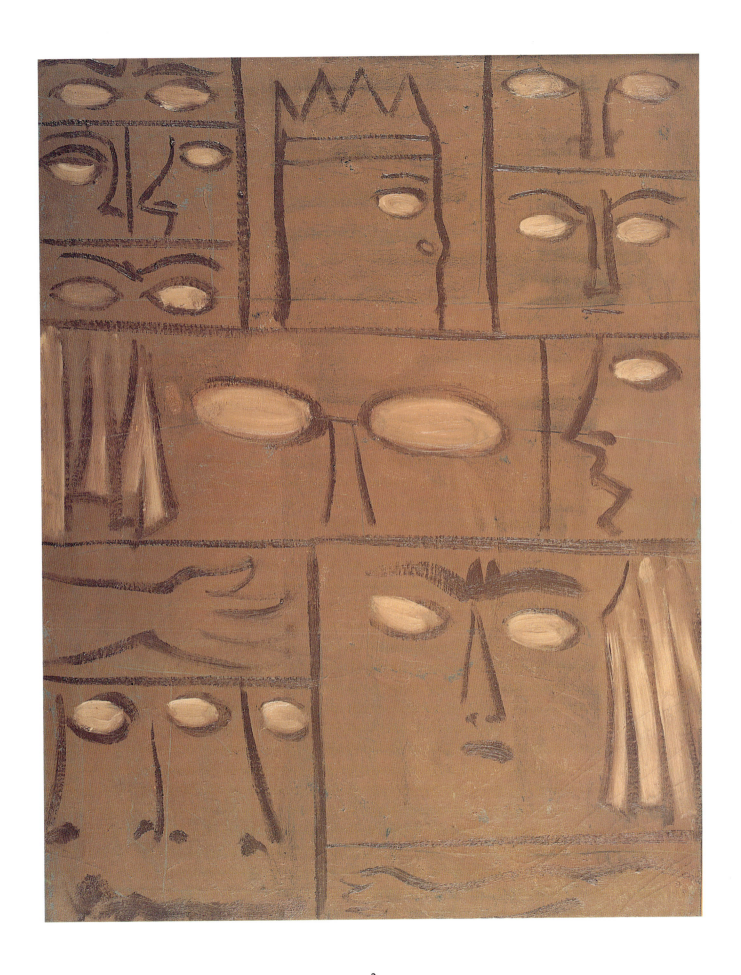

2

Eyes of Oedipus
1941
oil on canvas
32 ¼ x 25"

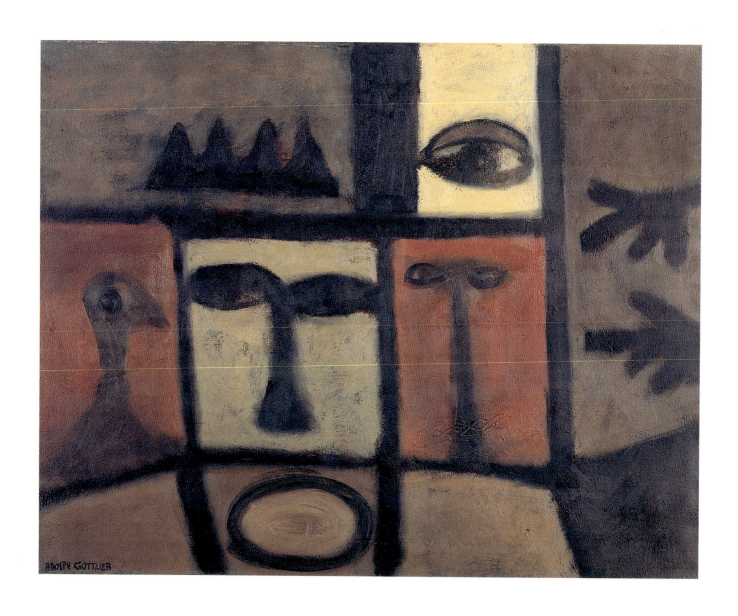

3

Phoenix

1941

oil on canvas

24¾ x 32"

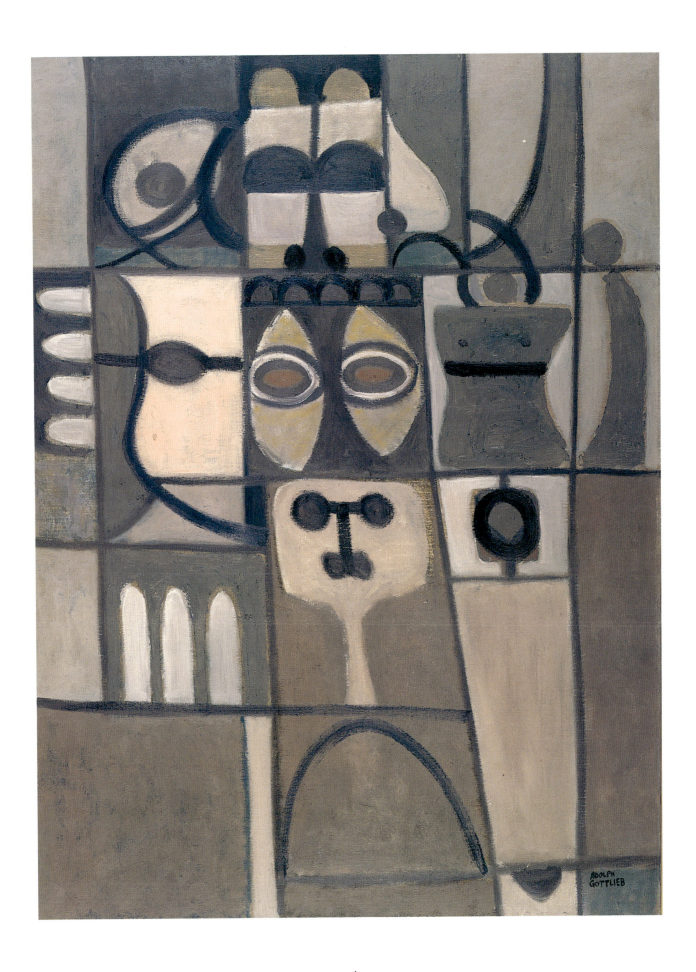

4

Pictograph
1942
oil on canvas
48 x 36"

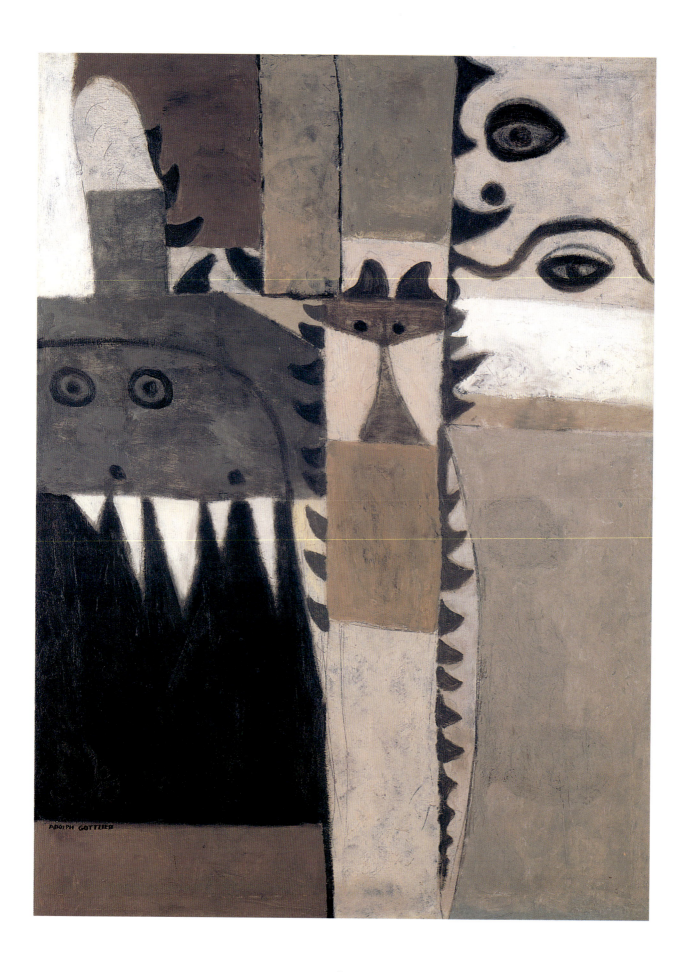

5

Pictograph–Symbol

1942

oil on canvas

54 x 40″

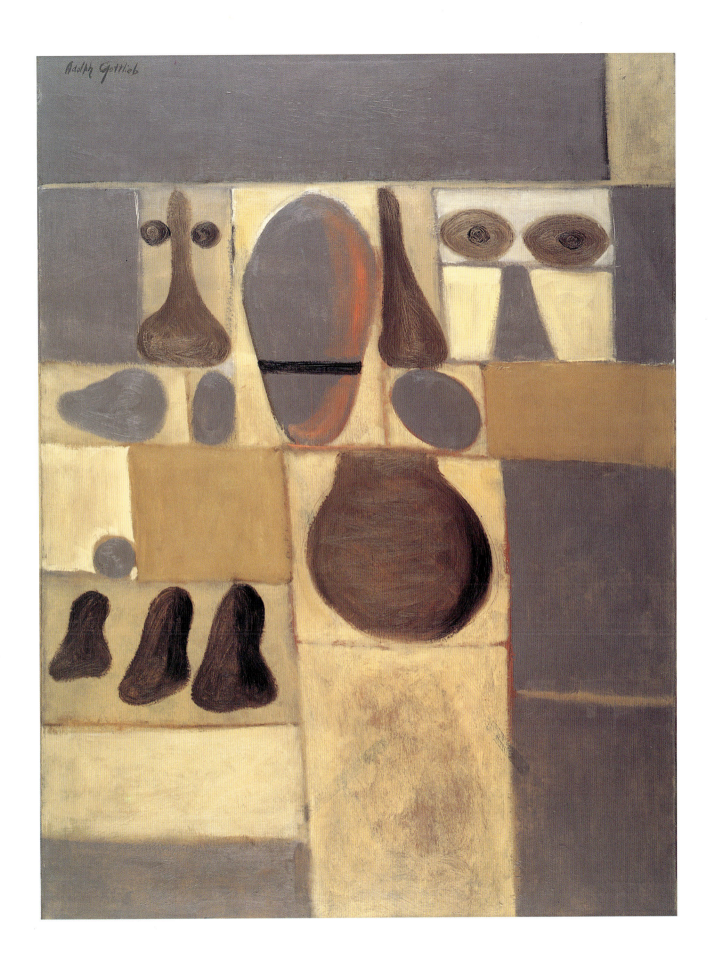

6

Pictograph (Yellow and Purple)

1942
oil on linen
48 x 36"

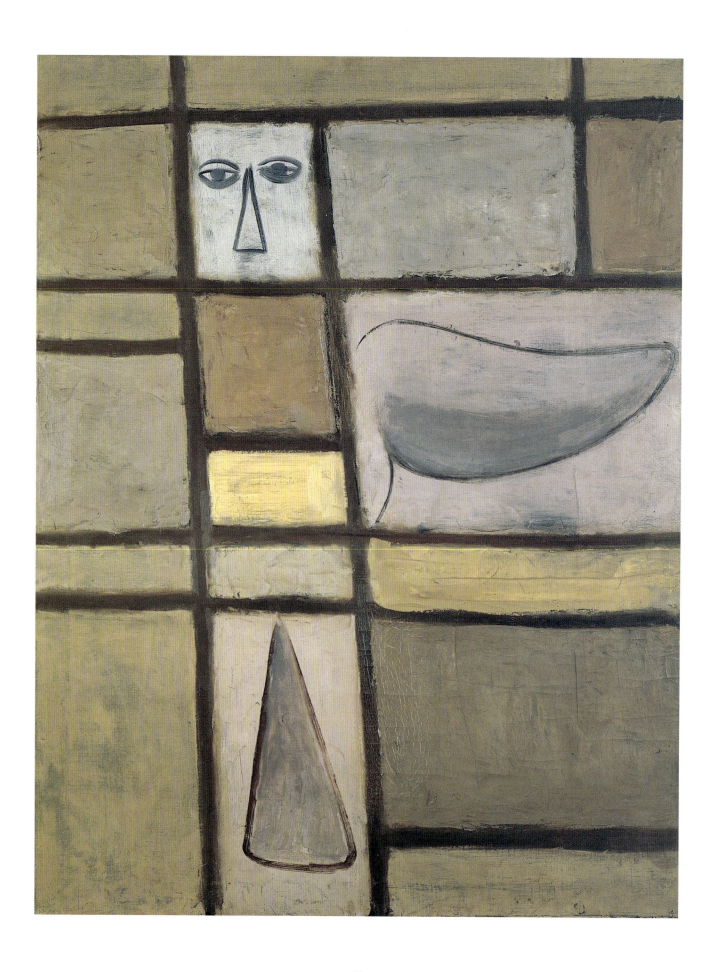

7

Minotaur

1942
oil on linen
35 ¾ x 27 ¾"

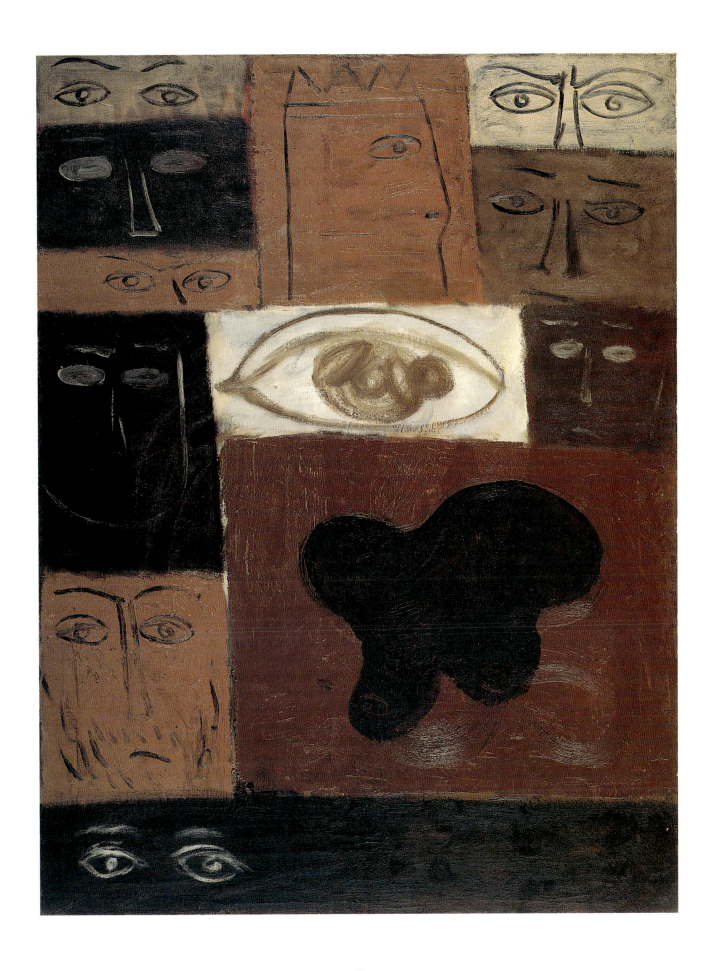

8

Oedipus
1942
oil and sand on linen
33 15/16 x 25 7/8"

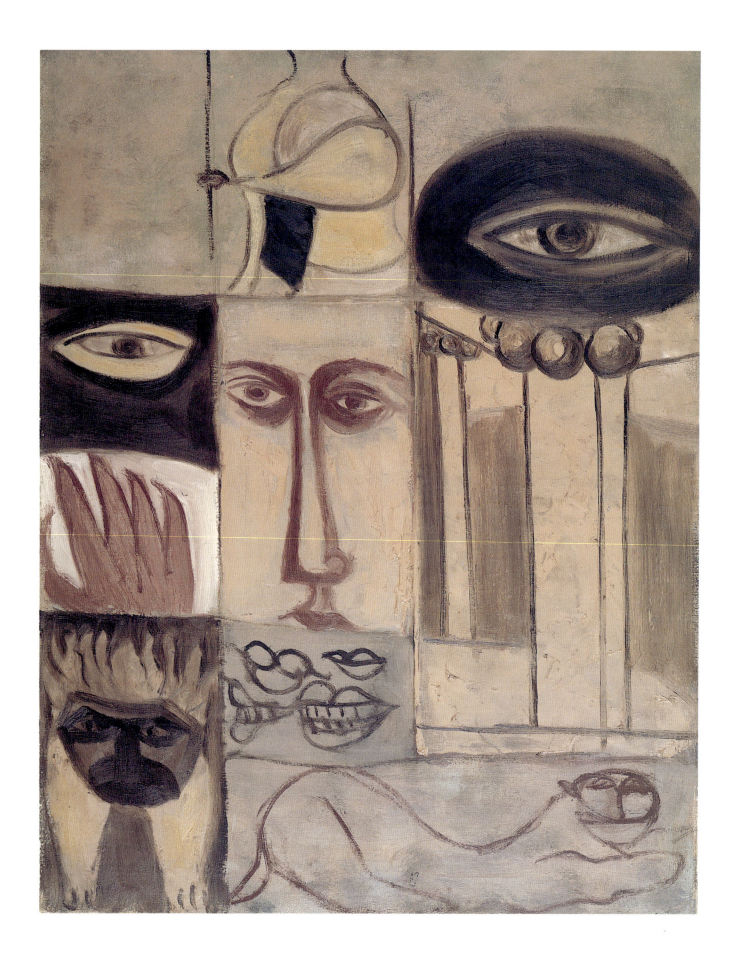

9

Palace

1942
oil on canvas
32 x 24 ⅞"

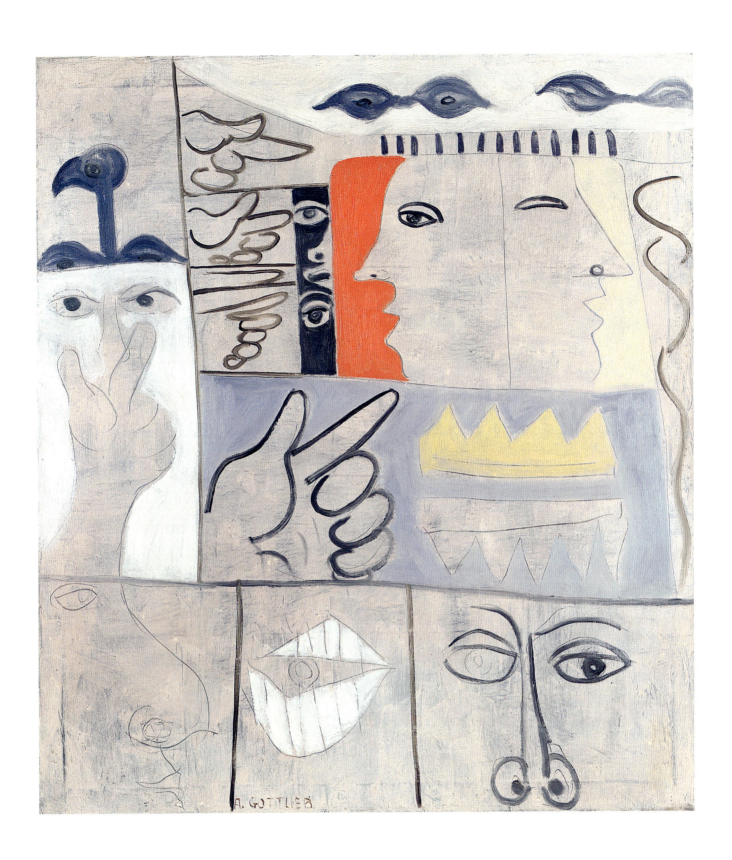

10

Hands of Oedipus
1943
oil on canvas
40 ¼ x 35 ¹⁵/₁₆"
Private Collection

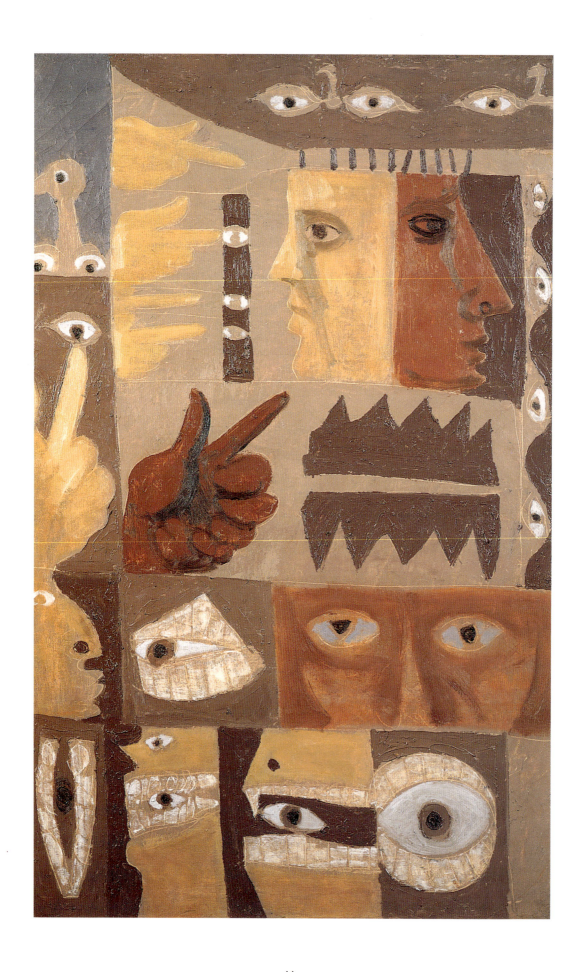

11

Pictograph #4
1943
oil on canvas
35 ¼ x 22⅞"

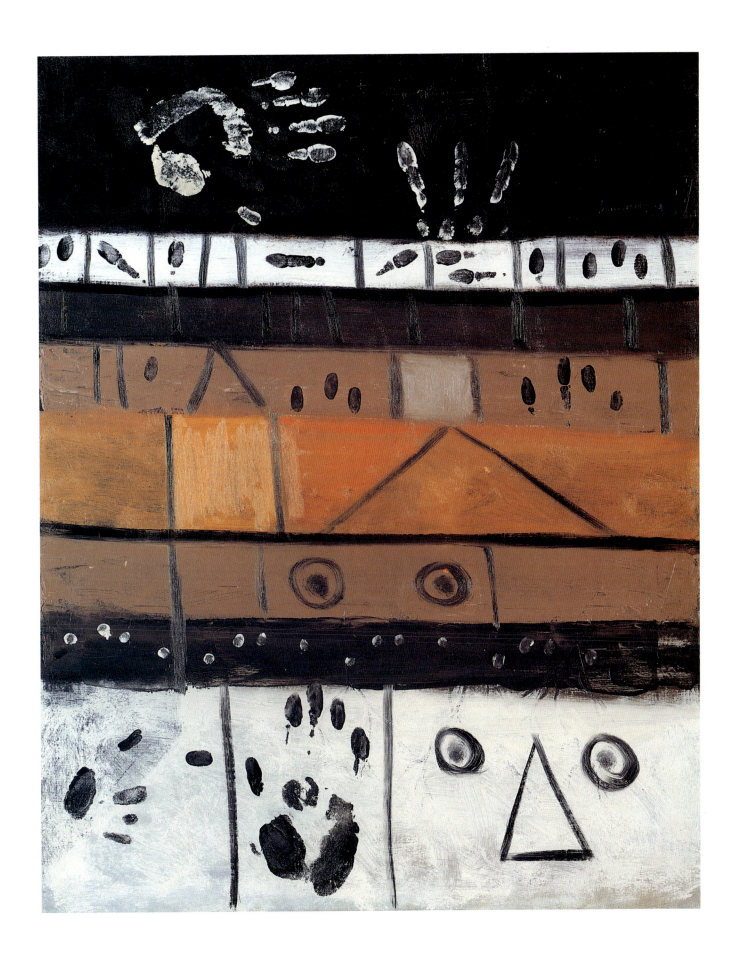

12

Black Hand

1943
oil on linen
30 x 24"

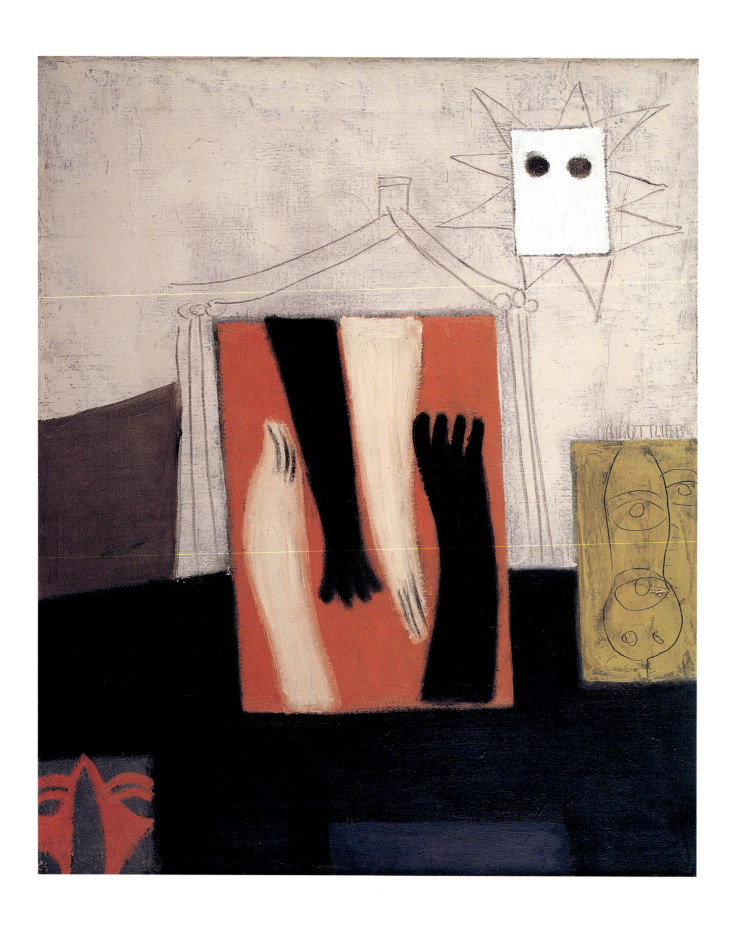

13

Home

1943
oil and pencil on canvas
23 ⅞ x 19 ⅞"

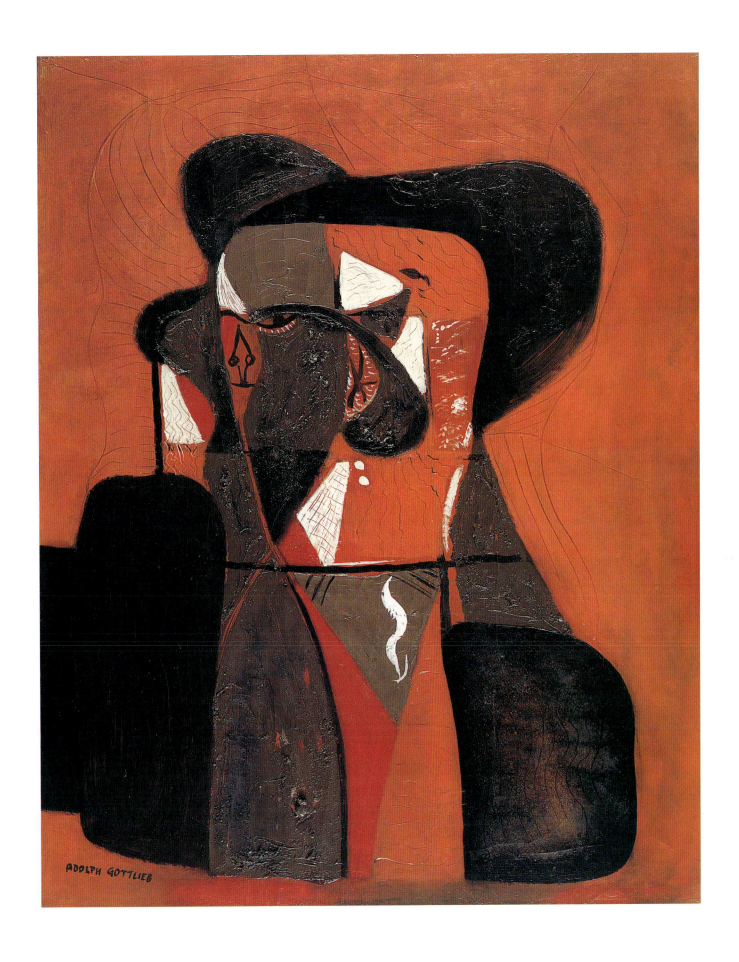

14

Red Portrait

1944

oil with cotton waste on canvas

29 ½ x 23 ½"

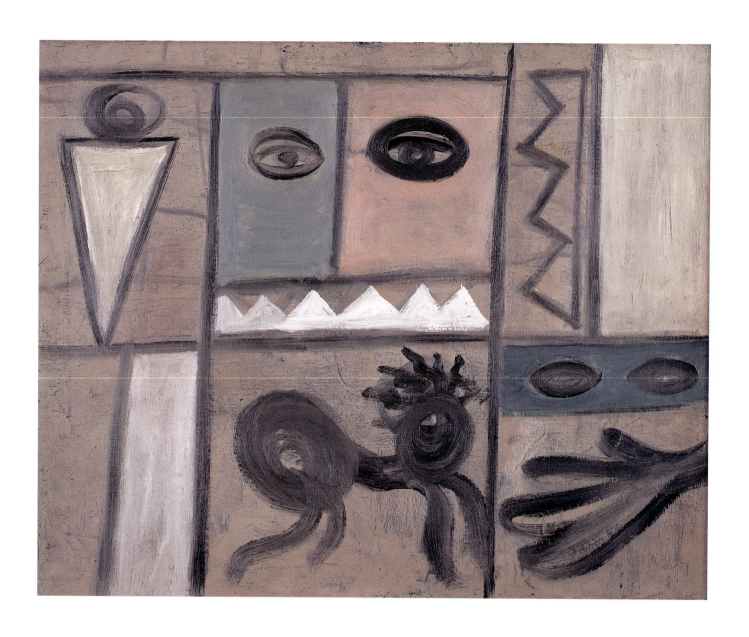

15

Lion

1944
oil on linen
24 x 29⅞"
Colin J. Adair, Montreal

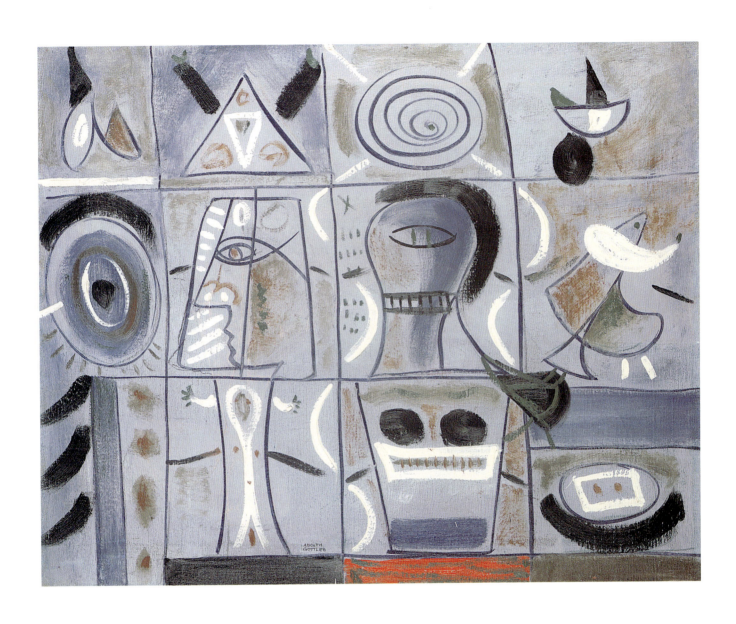

16

Nostalgia for Atlantis

1944

oil on canvas

20 x 25"

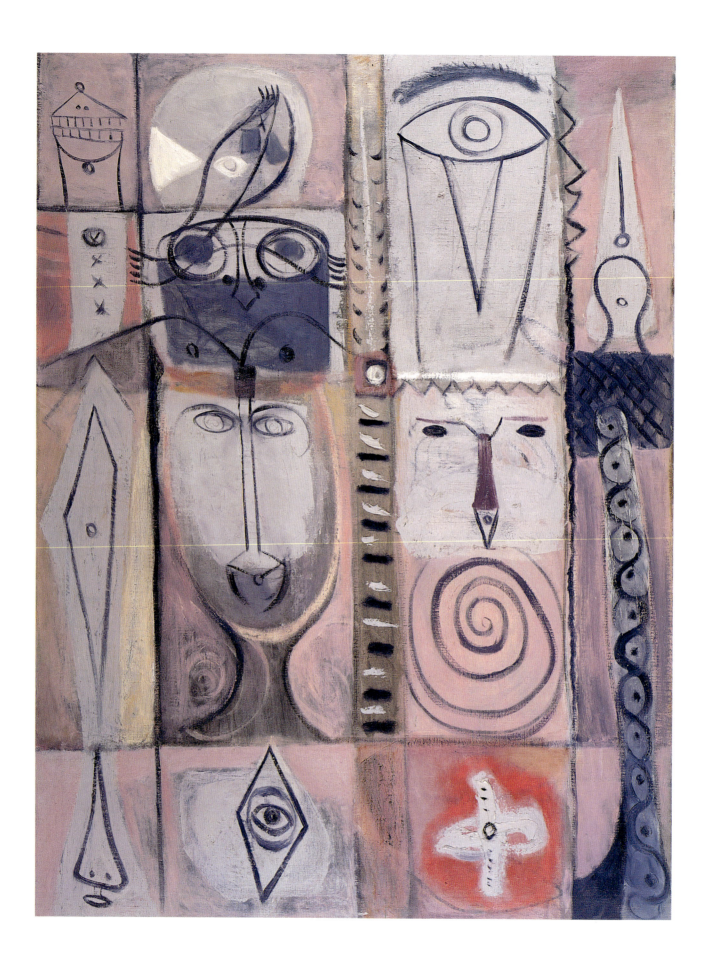

17

The Enchanted Ones

1945
oil on linen
48 x 36"

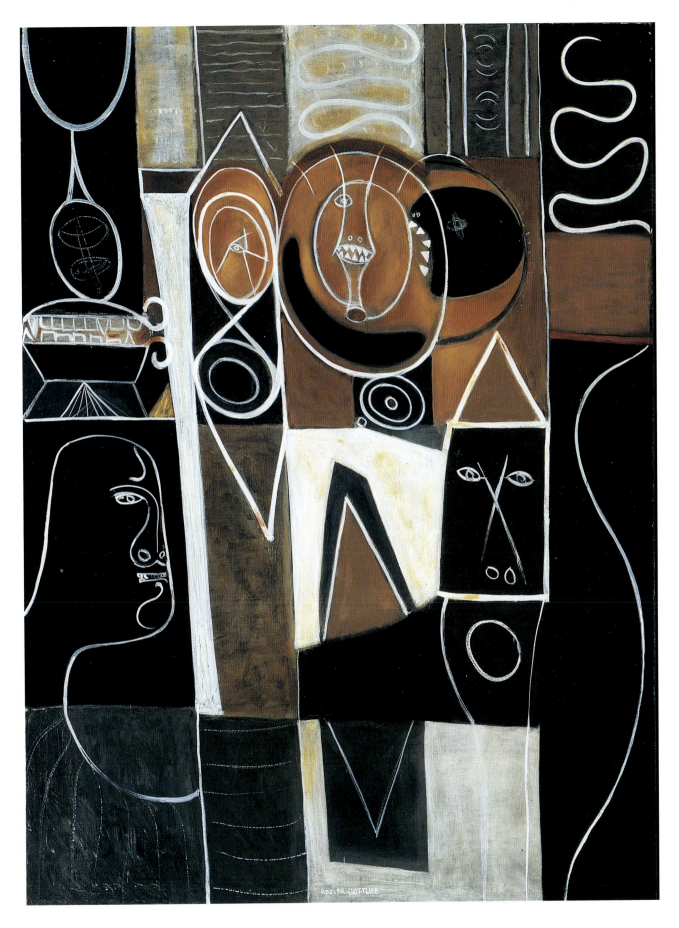

18

Alkahest of Paracelsus
1945
oil on canvas
60 x 44"
Museum of Fine Arts, Boston. The Tompkins Collection. 1973.599

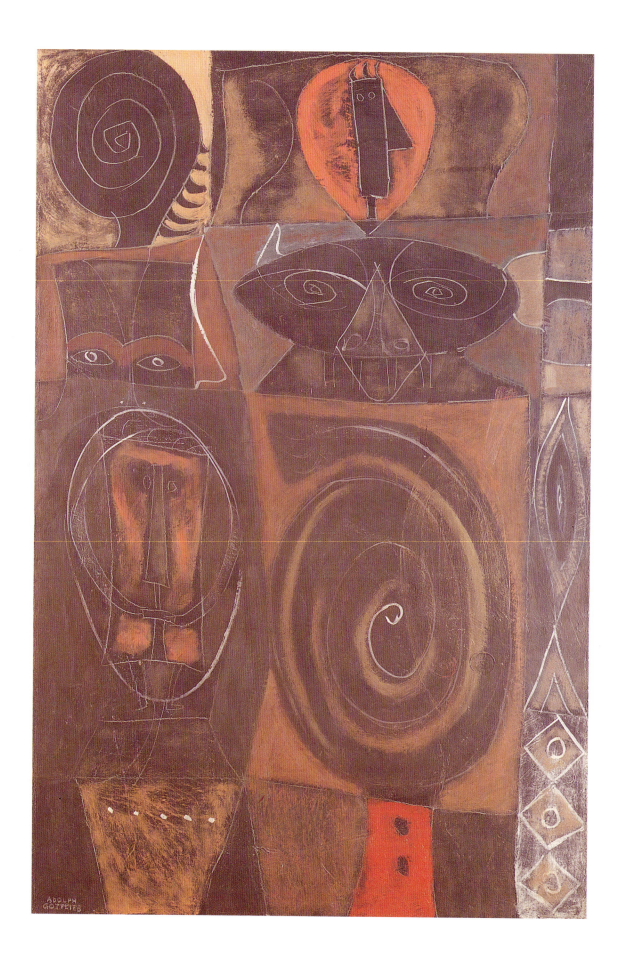

19

Masquerade
1945
oil and tempera on canvas
36 x 24"

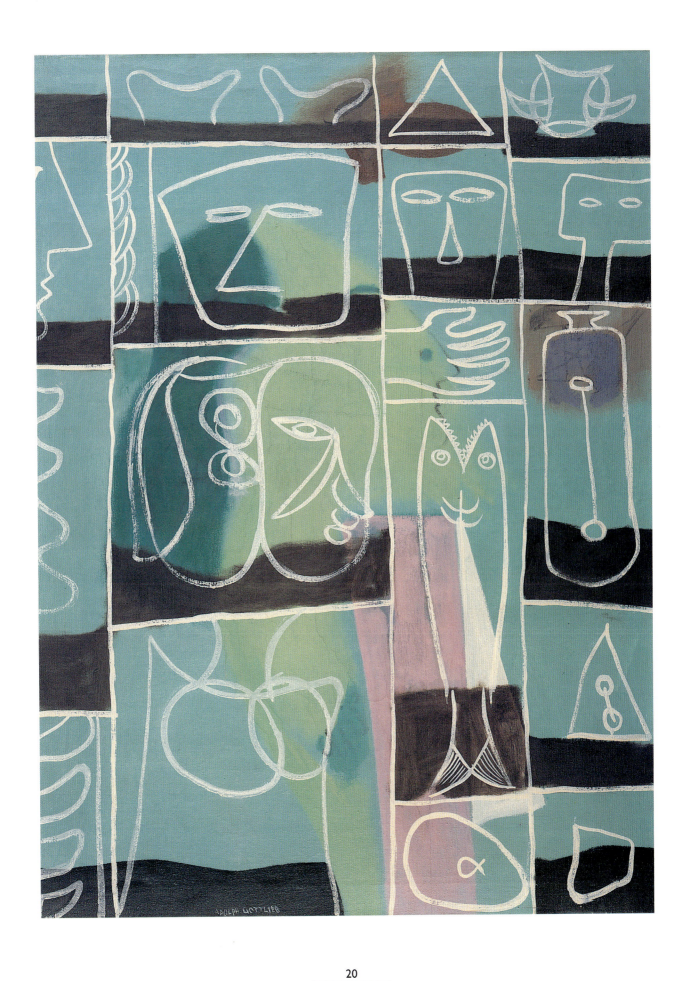

20

Mariner's Incantation

1945

oil, gouache, tempera and casein on canvas

39 ¹³/₁₆ x 29 ⅞"

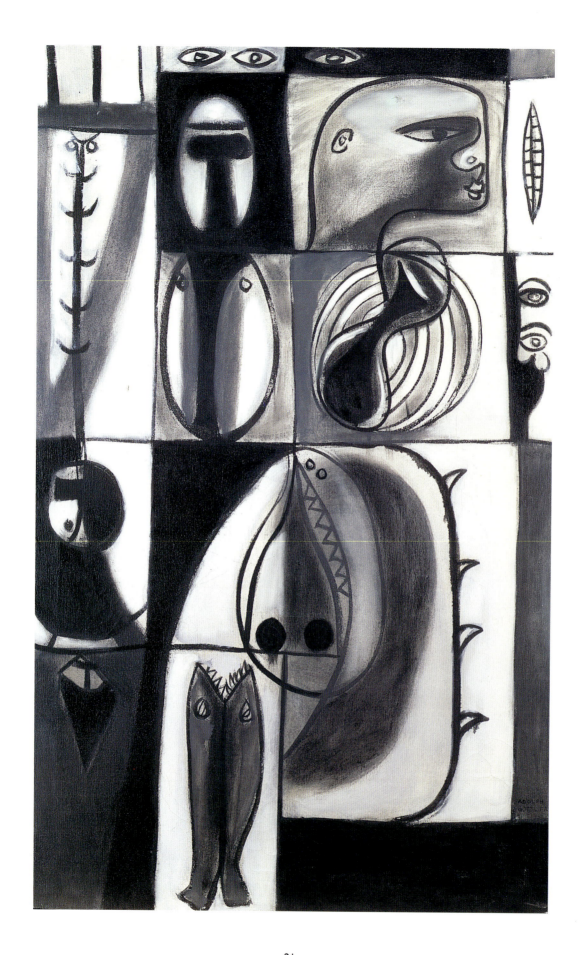

21

Expectation of Evil

1945

oil, gouache and tempera on canvas

43 ⅛ x 27 ⅛"

Los Angeles County Museum of Art, purchased with funds provided by Burt Kleiner and Merle Oberon (M.89.4)

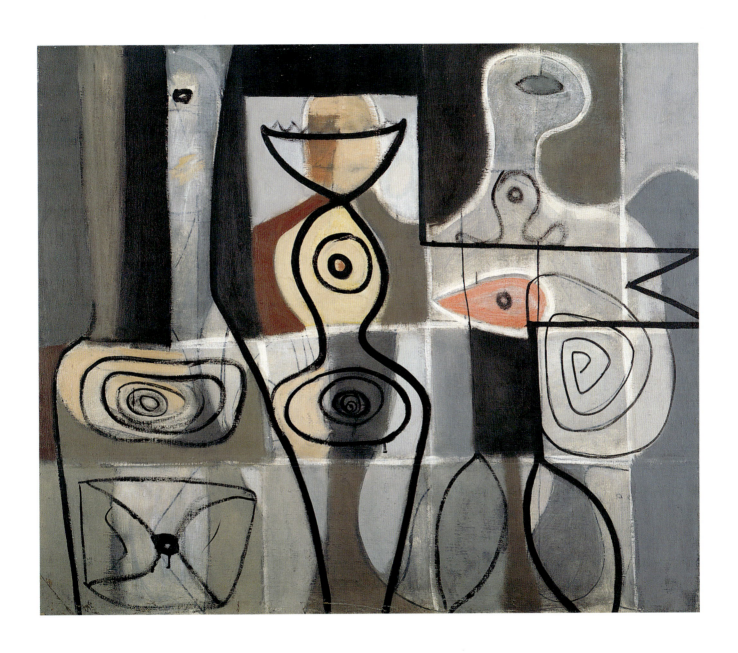

22

Composition

1945

oil, gouache, tempera and casein on linen

29 $^{13}/_{16}$ x 35 $^{7}/_{8}$"

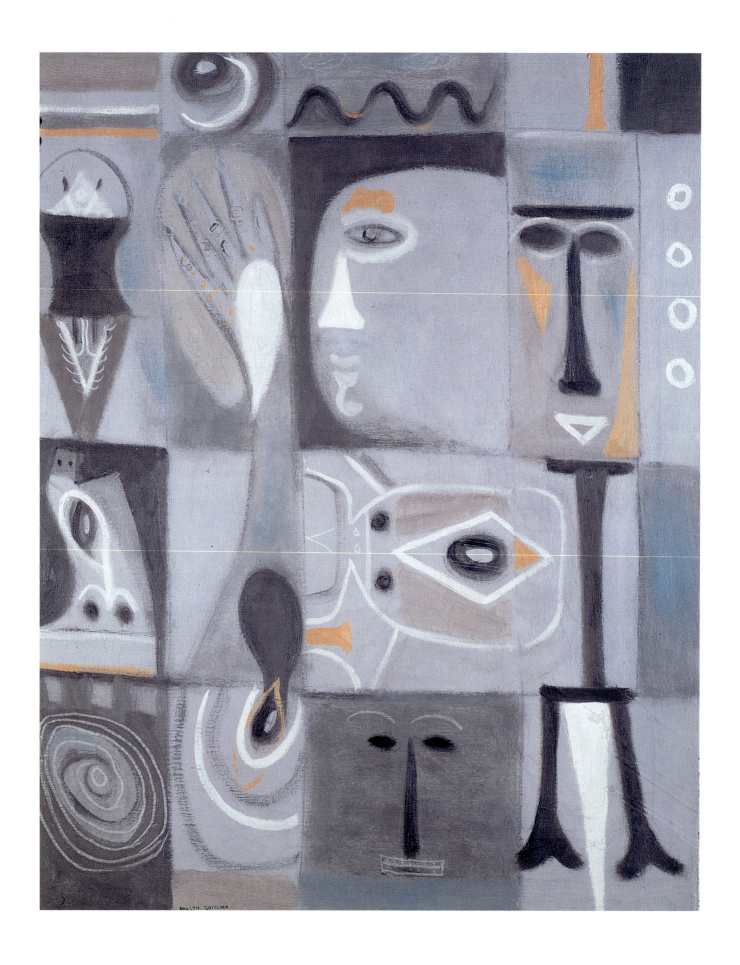

23

The Token

1945
oil, tempera and casein on canvas
31 ⅞ x 24 ⅞"

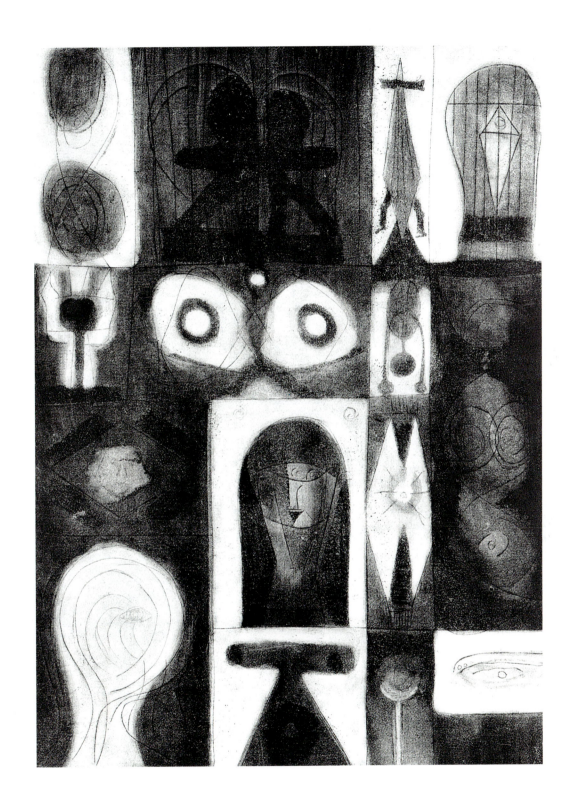

24

Apparition

1945
etching and aquatint
20 x 15" plate

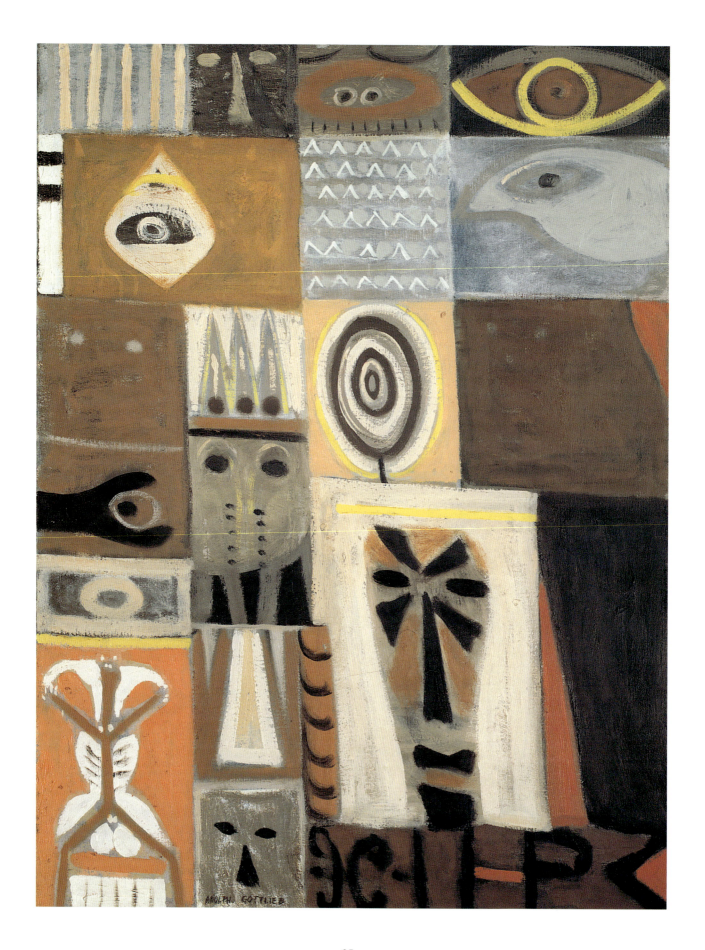

25

Augury

1945

oil on canvas

40 x 30"

Solomon R. Guggenheim Museum, New York

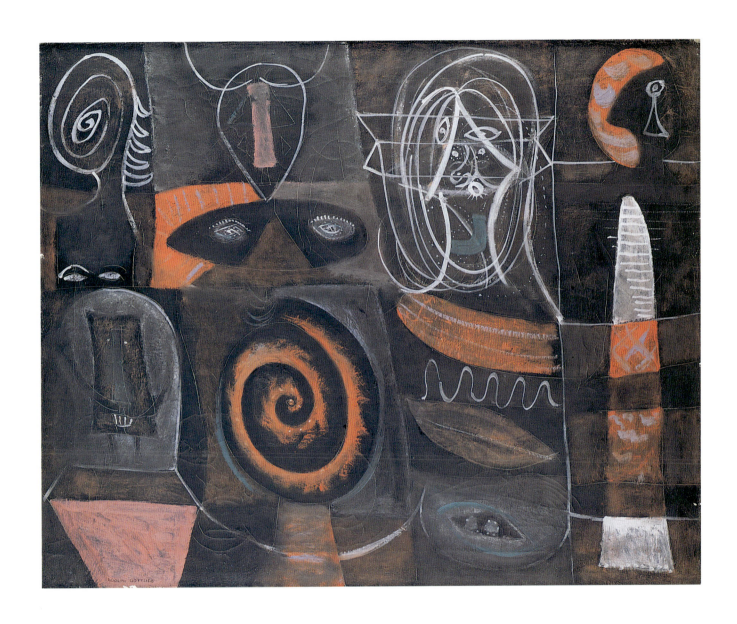

26

Divisions of Darkness

1945

oil on canvas

24 x 30"

The Everest Group, Ltd., St. Paul, Minnesota

Photography © 1990 Sothebys, Inc.

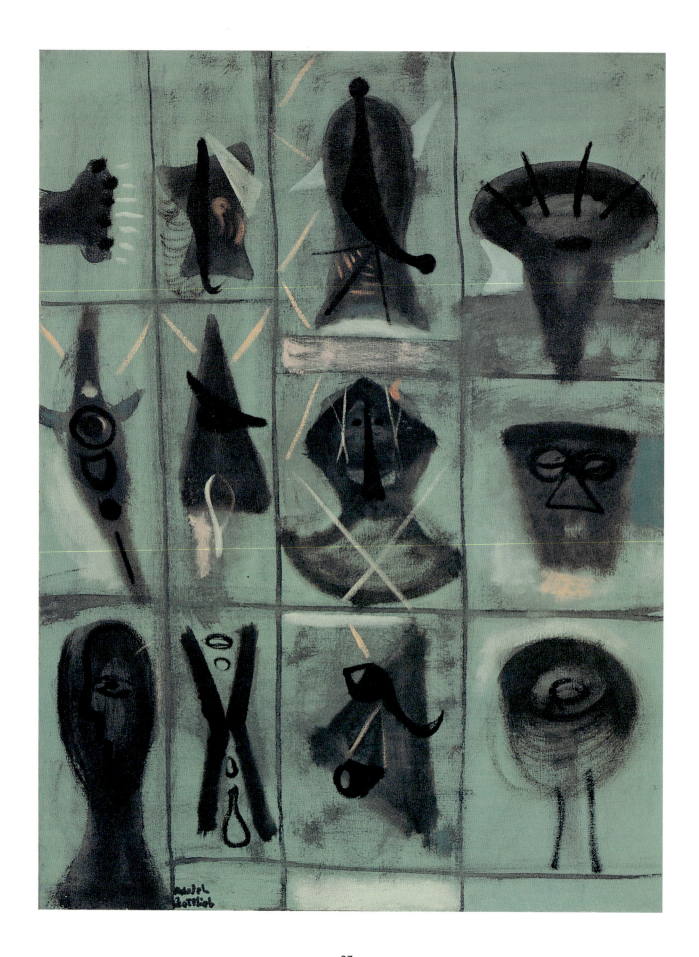

27

Jury of Three

1945
oil on canvas
34 x 26"
Marlborough International Fine Art

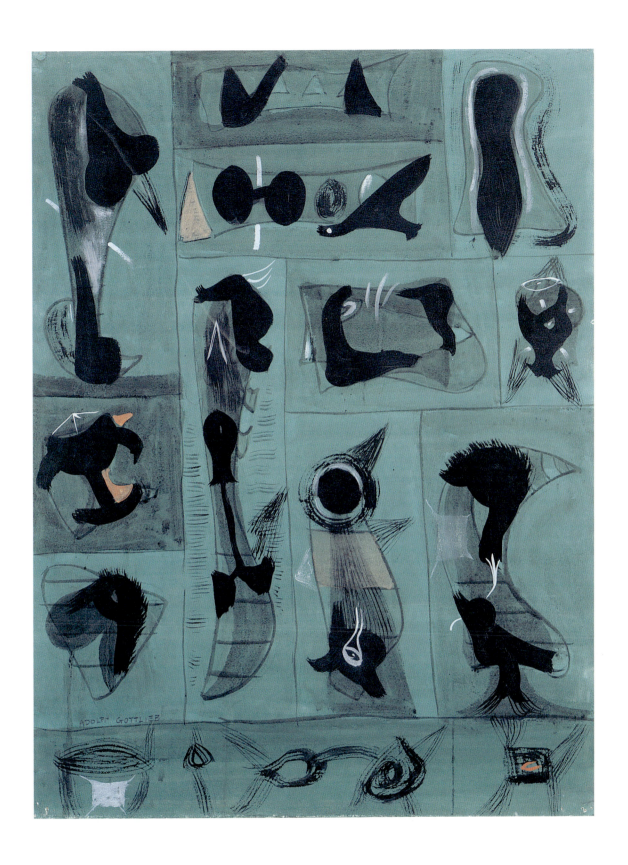

28

Birds

ca. 1945
gouache on paper
26 x 20"

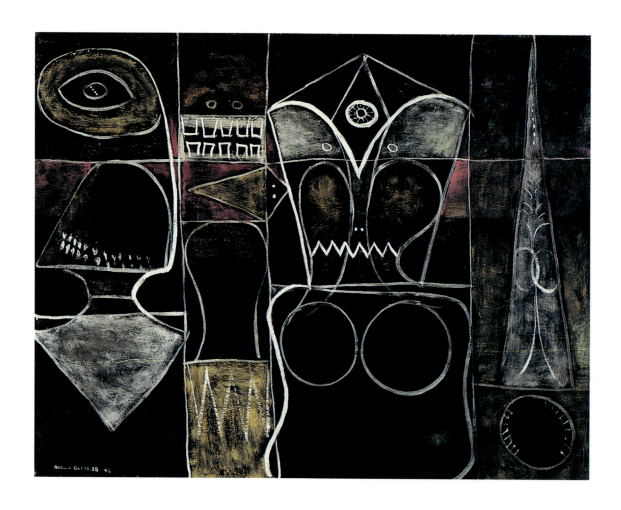

29

Black Enigma

1946

oil on canvas

25 x 32"

Hood Museum of Art, Dartmouth College, Hanover, N.H.;

Bequest of Lawrence Richmond, Class of 1930

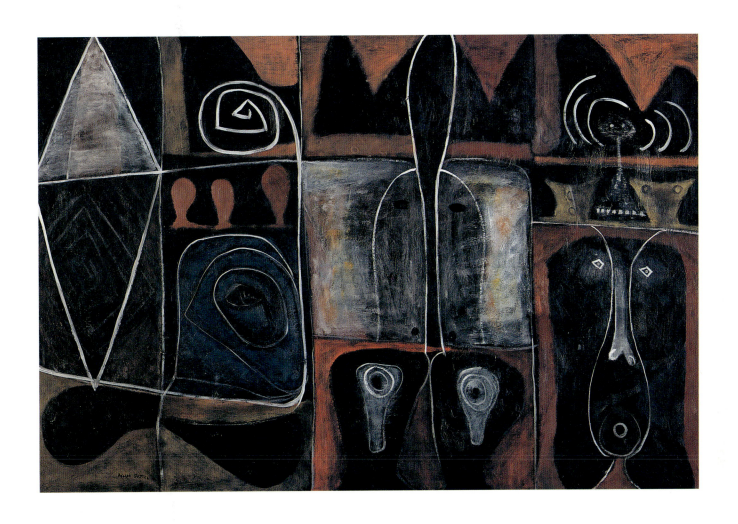

30

Recurrent Apparition

1946

oil on canvas

35 ½ x 53 ½"

Elvehjem Museum of Art, University of Wisconsin - Madison.

Elvehjem Associates Fund, Friends of the Elvehjem Fund, Emily Baldwin Bell Fund and Tenth Anniversary Fund purchase, 1980.56.

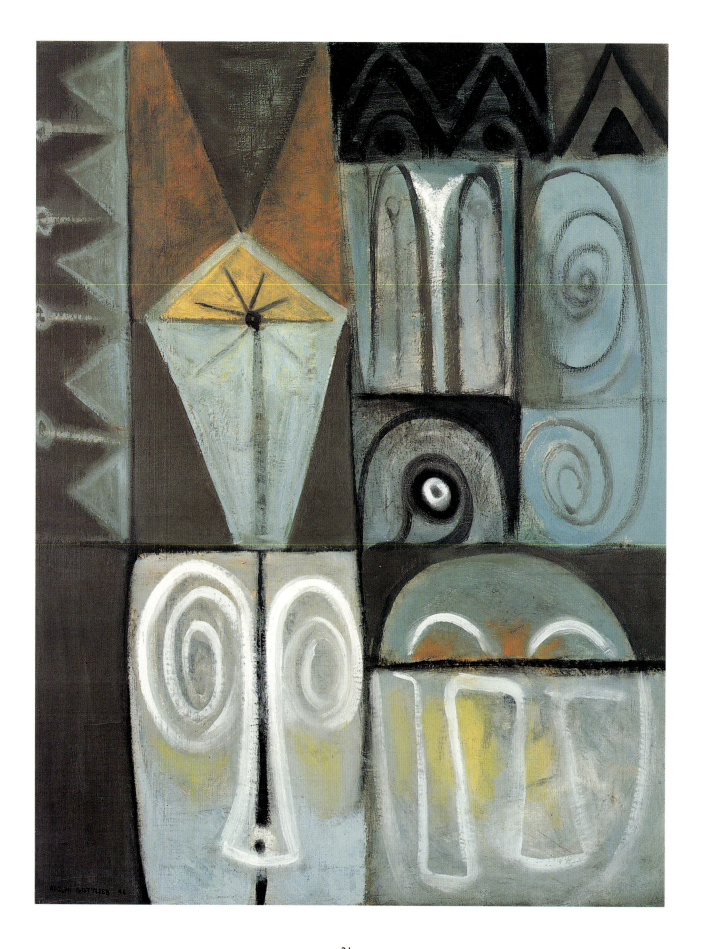

31

The Spectre

1946

oil and gouache on canvas

33 ¹⁵/₁₆ x 26"

Fayez Sarofim Collection

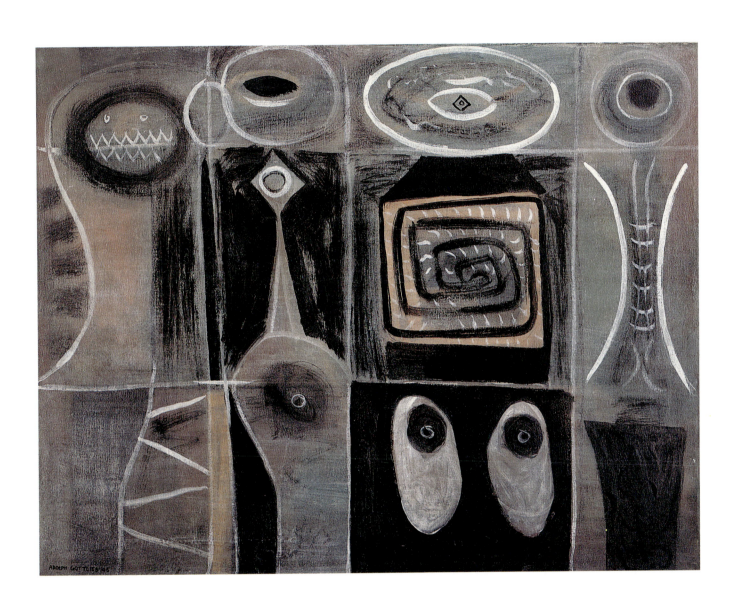

32

The Prisoners

1946

oil, gouache and tempera on canvas

24 ⅞ x 31¹⁵/₁₆ "

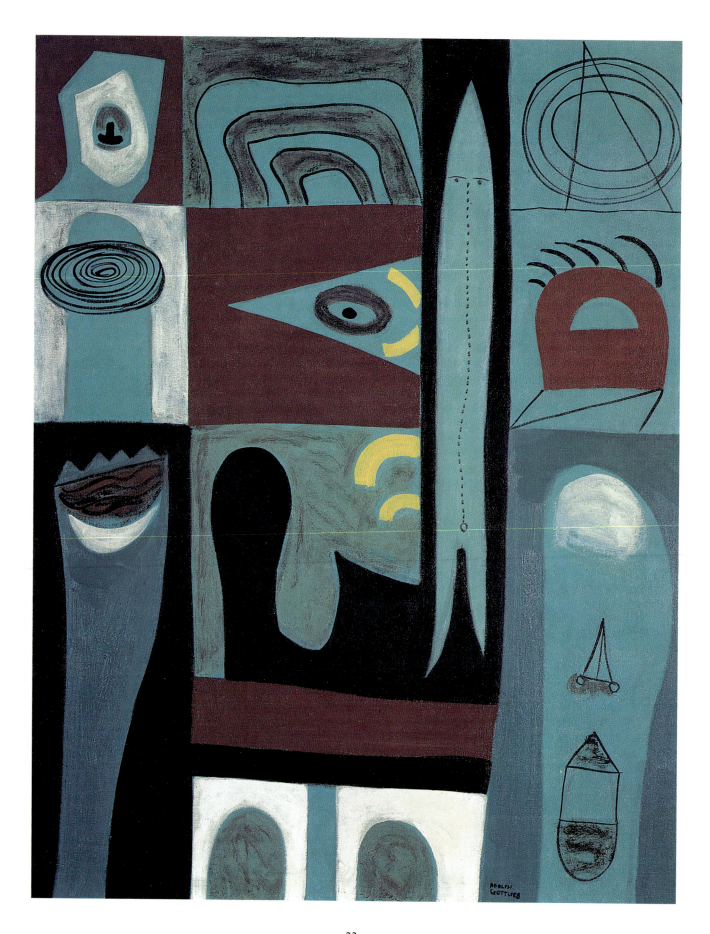

33

Night Voyage
1946
oil on canvas
38 x 30"
Hirshhorn Museum and Sculpture Garden, Smithsonian Institution.
Gift of Joseph H. Hirshhorn, 1966.

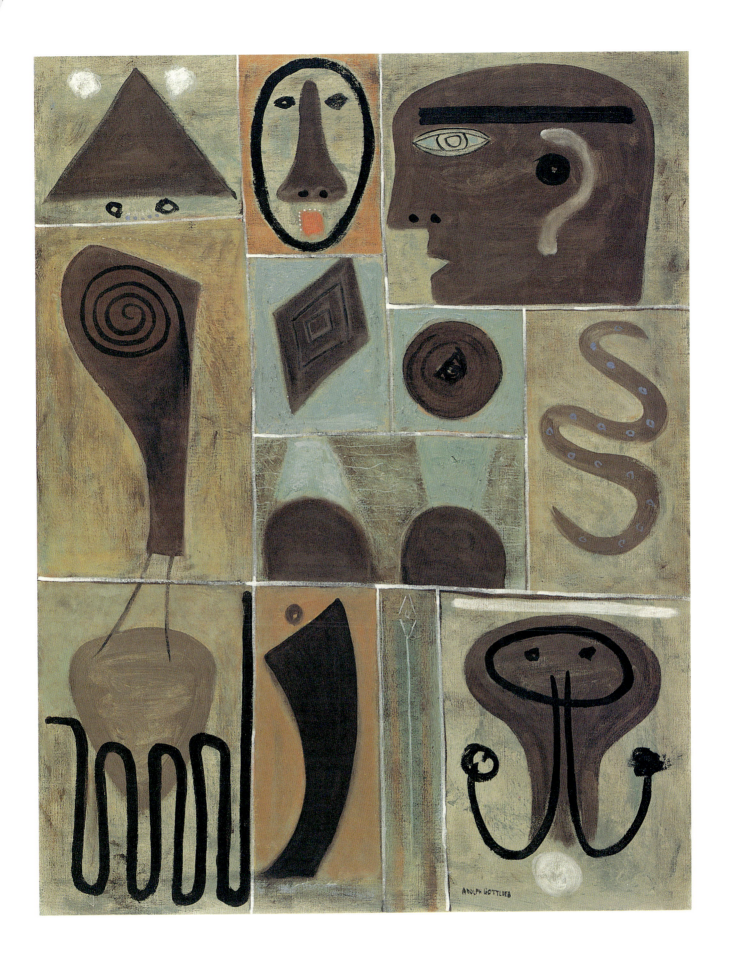

34

Voyager's Return

1946

oil on canvas

37 ⅞ x 29 ⅞ "

The Museum of Modern Art, New York

Gift of Mr. and Mrs. Roy R. Newberger

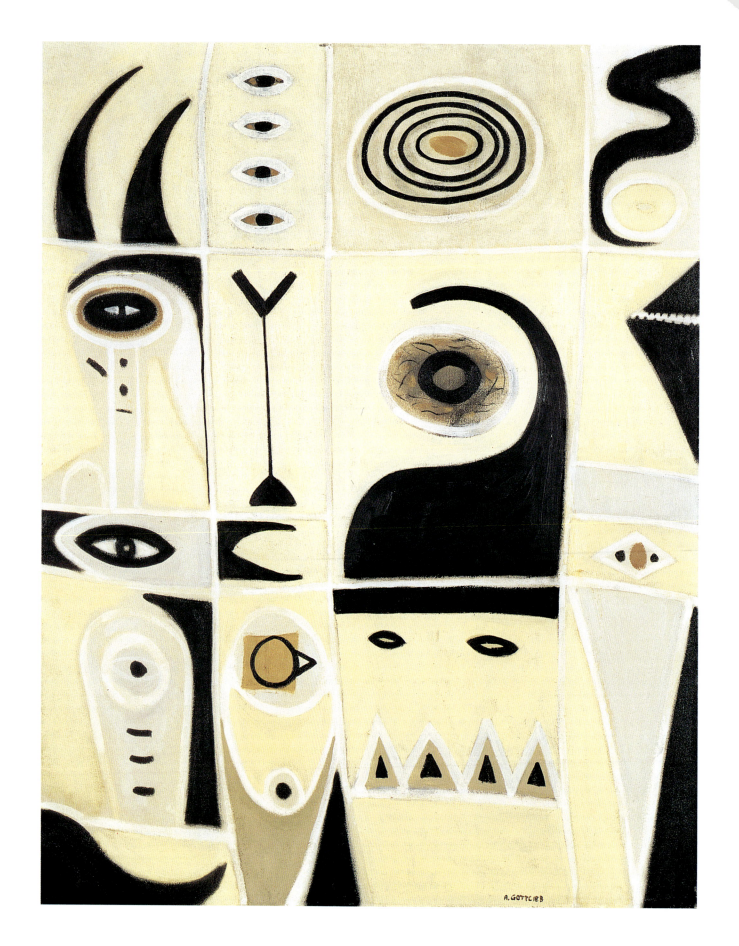

35

Evil Omen

1946

oil on canvas

38 x 30"

Neuberger Museum of Art, State University of New York at Purchase, gift of Roy R. Neuberger

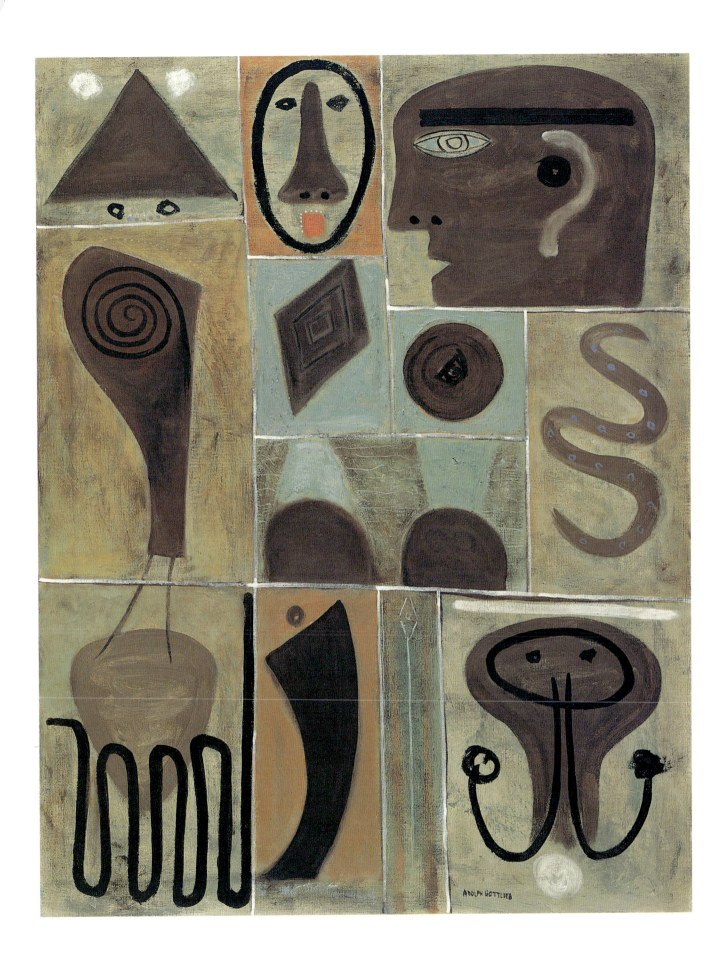

34

Voyager's Return

1946

oil on canvas

37 7/8 x 29 7/8 "

The Museum of Modern Art, New York

Gift of Mr. and Mrs. Roy R. Newberger

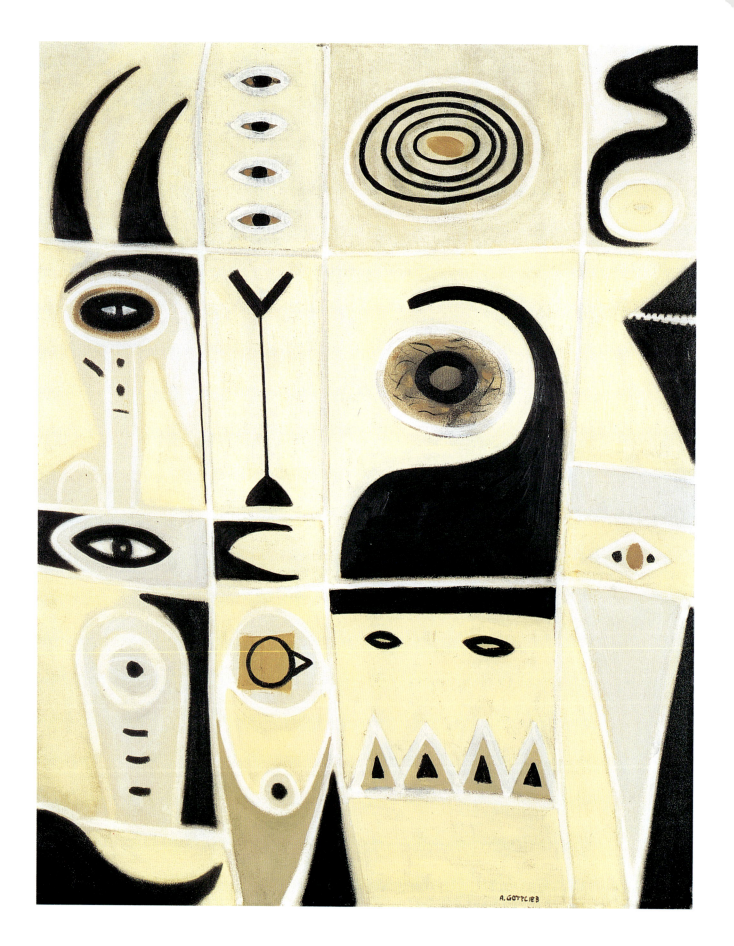

35

Evil Omen

1946

oil on canvas

38 x 30"

Neuberger Museum of Art, State University of New York at Purchase, gift of Roy R. Neuberger

36

Voyage
ca. 1946
etching and aquatint
8 ¾ x 6 ¾" plate

38

Evil Eye

1946

oil on canvas

34 x 22"

Richard E. Lang, Jane Lang Davis Collection, Medina, WA.

39

Chimera

ca. 1946

etching

6 ½ x 5" plate

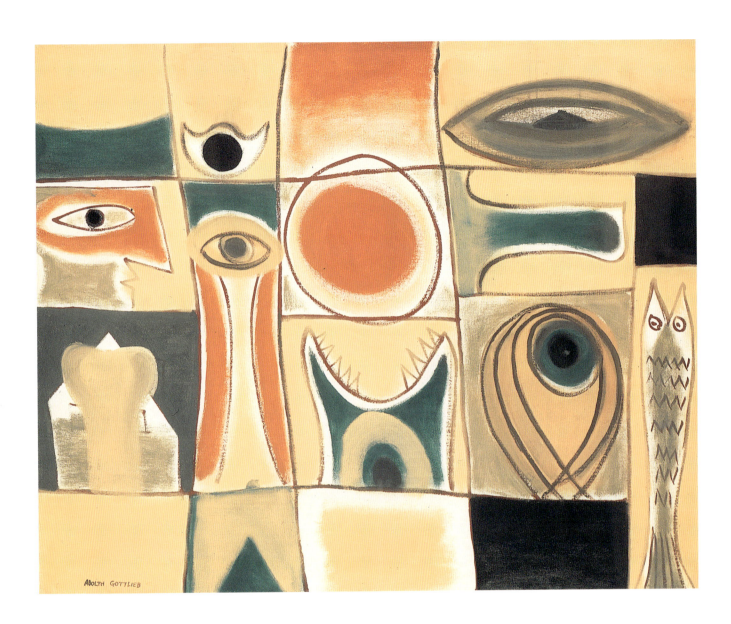

40

Forgotten Dream

1946

oil on canvas

24 x 30

Herbert F. Johnson Museum of Art, Cornell University.

Gift of Albert A. List, 55.57.

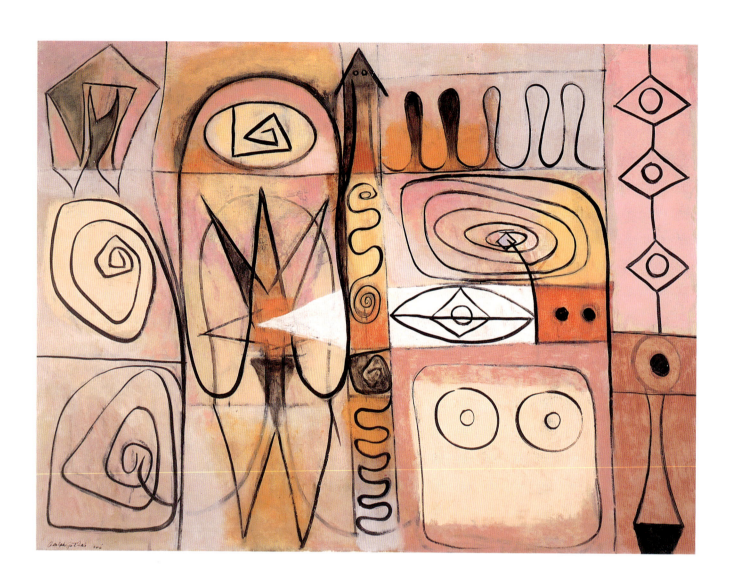

41

Pictograph
1946
oil on canvas
36 x 48"
Albright-Knox Art Gallery, Buffalo, New York
Gift of Mr. and Mrs. David Anderson to The Martha Jackson Collection, 1976

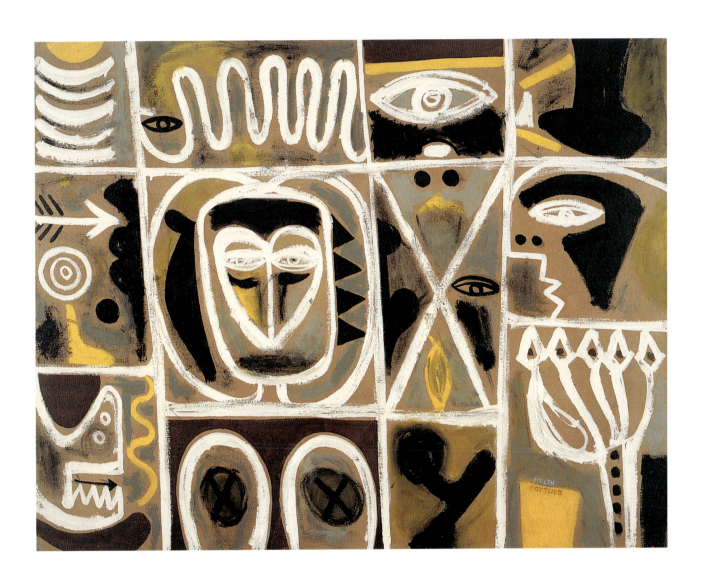

42

Omen for a Hunter

1947
oil on canvas
30 x 38"

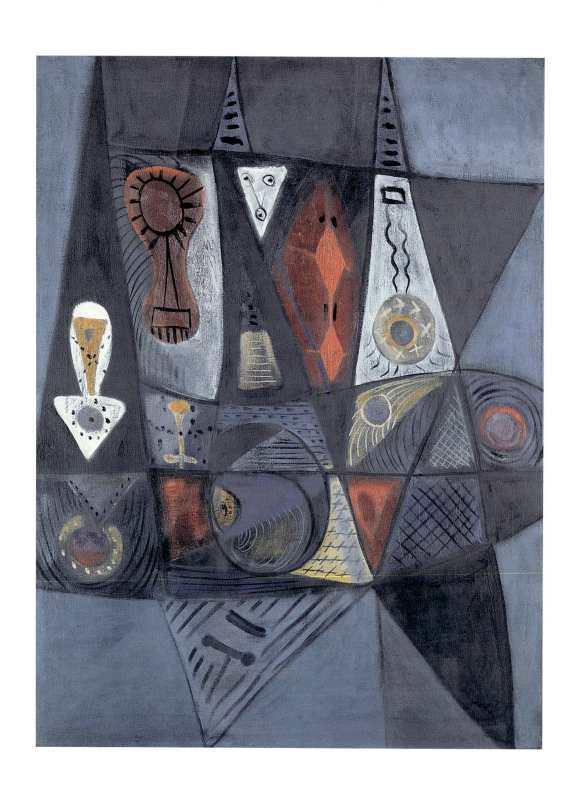

43

Blue and White Pictograph

1947

oil, gouache and tempera on canvas

33 $^{15}/_{16}$ x 25 $^{7}/_{8}$"

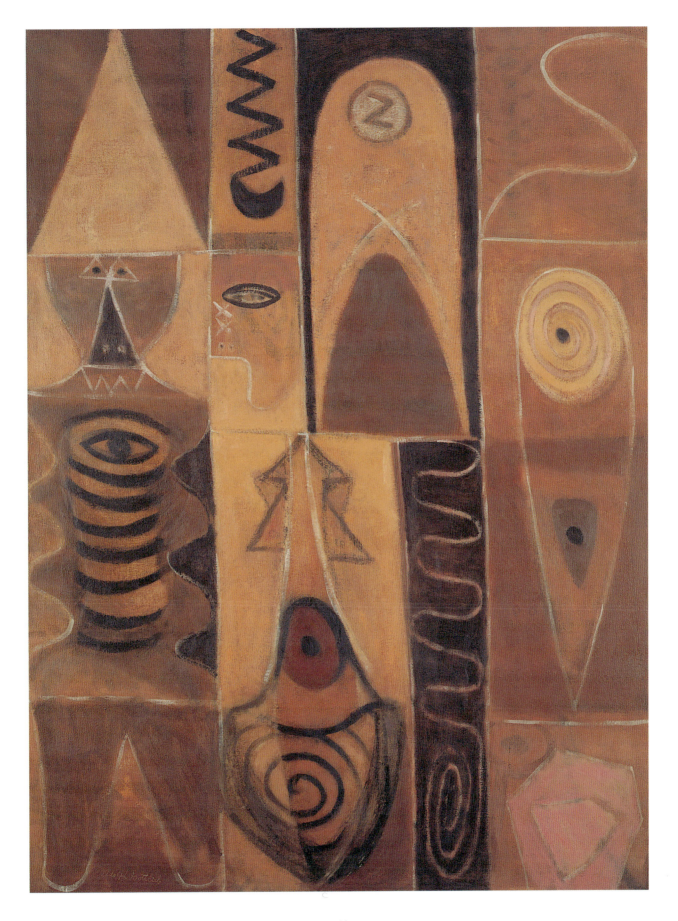

44

Sorceress

1947
oil on canvas
48 x 36"
Columbia University in the City of New York,
Gift of Mr. and Mrs. Samuel M. Kootz, 1960

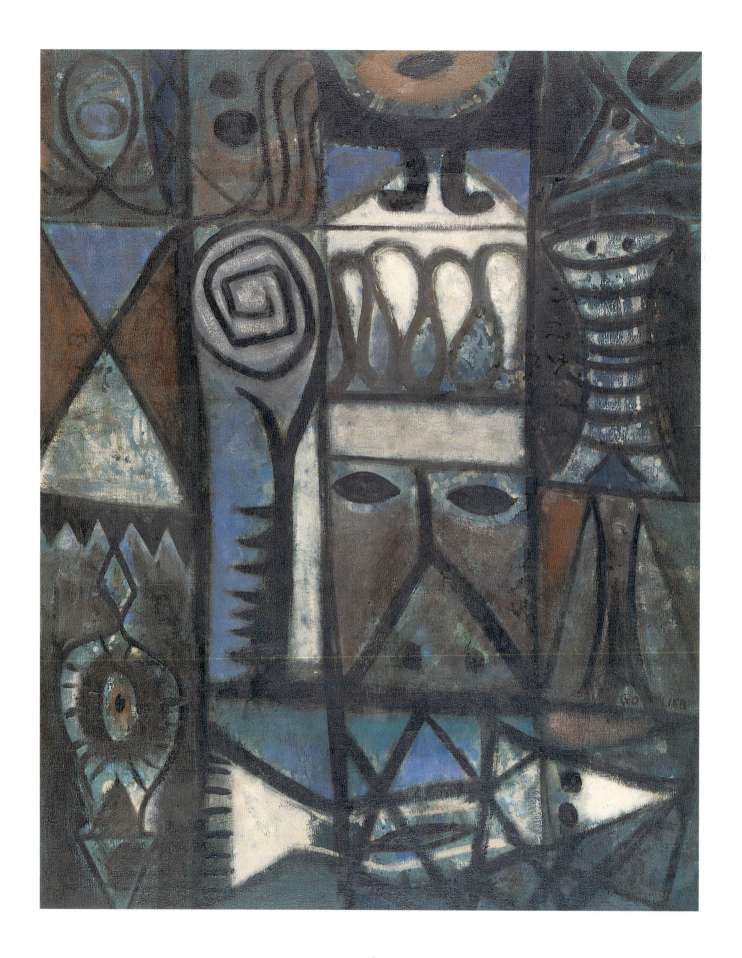

45

Pursuer and Pursued

1947

oil on canvas

38 x 36"

Yale University Art Gallery, Gift of Fred Olsen

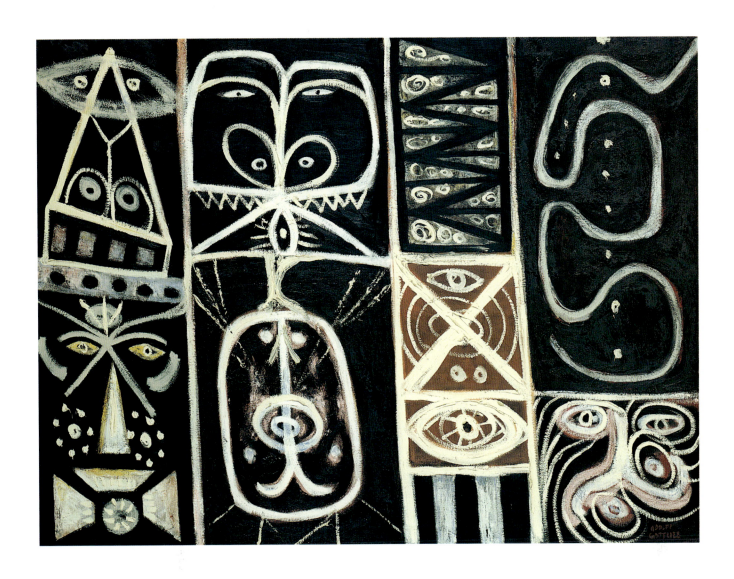

46

Vigil

1948

oil on canvas

36 x 48"

Collection of Whitney Museum of American Art, purchase 49.2

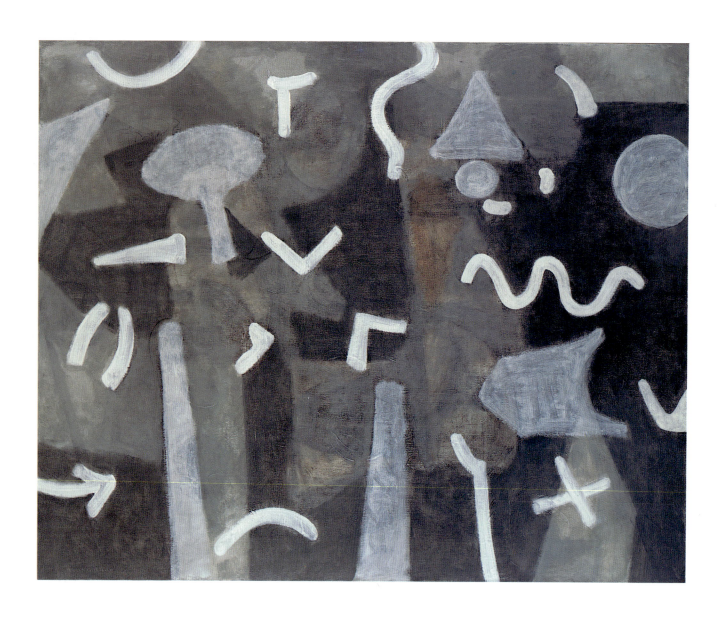

47

Sounds at Night

1948

oil and charcoal on linen

48 ⅛ x 60"

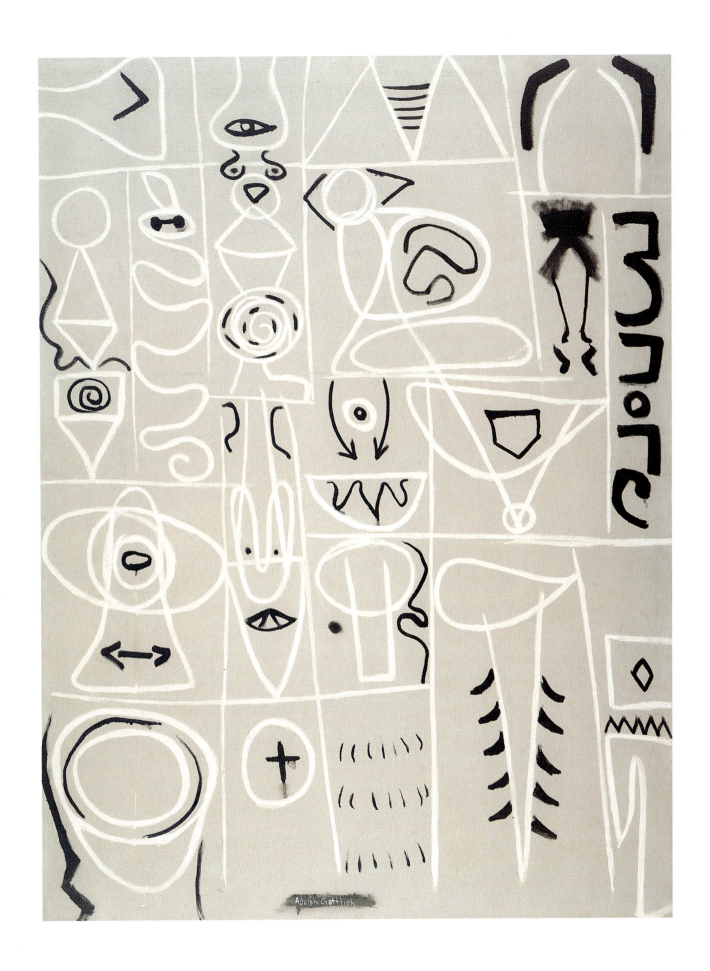

48

Letter to a Friend

1948

oil, tempera and gouache on canvas

47 ⅞ x 36 ¼"

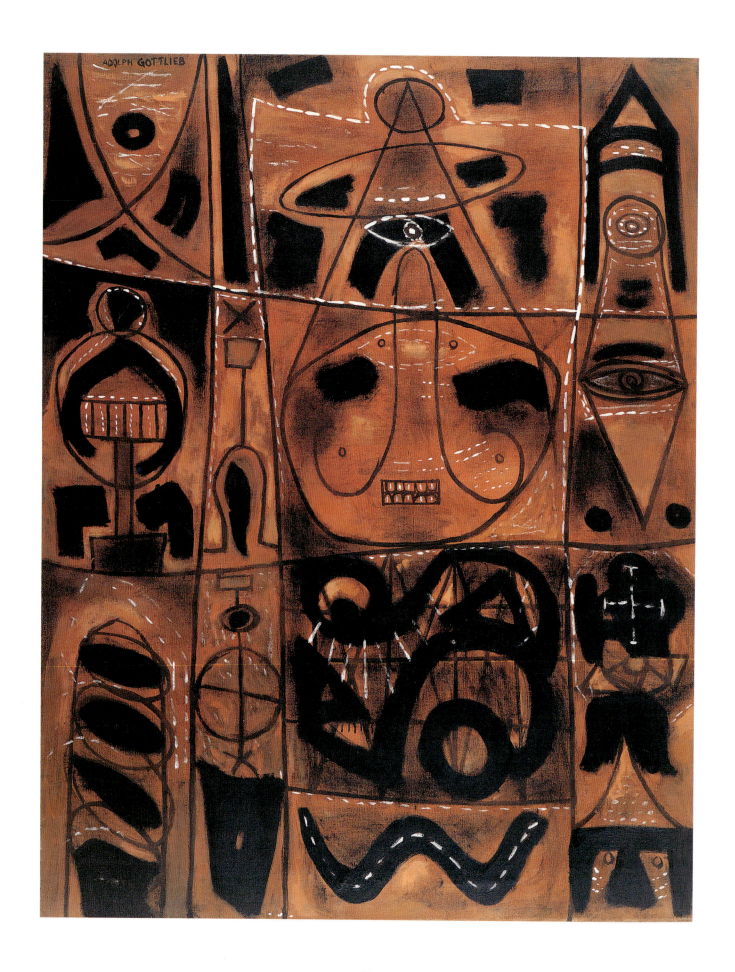

49

The Terrors of Tranquility
1948
oil on canvas
38 x 30"

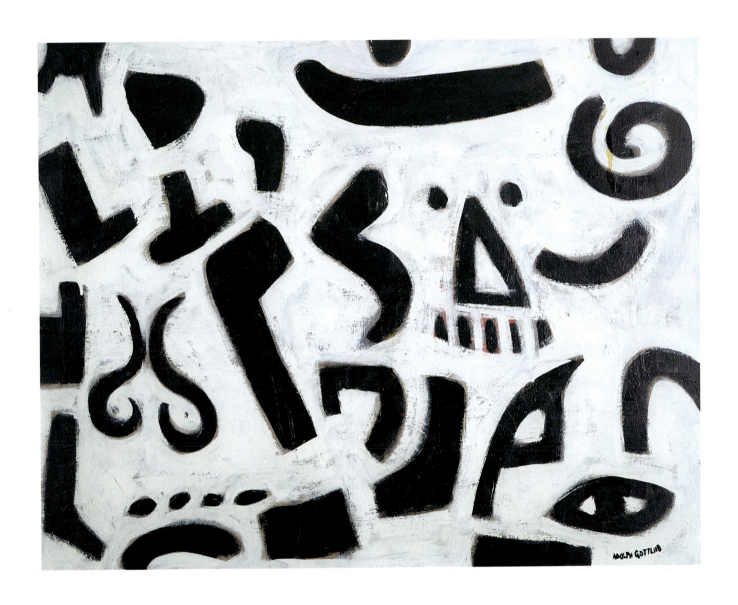

50

Inscription to a Friend

1948

oil on canvas

25 x 32"

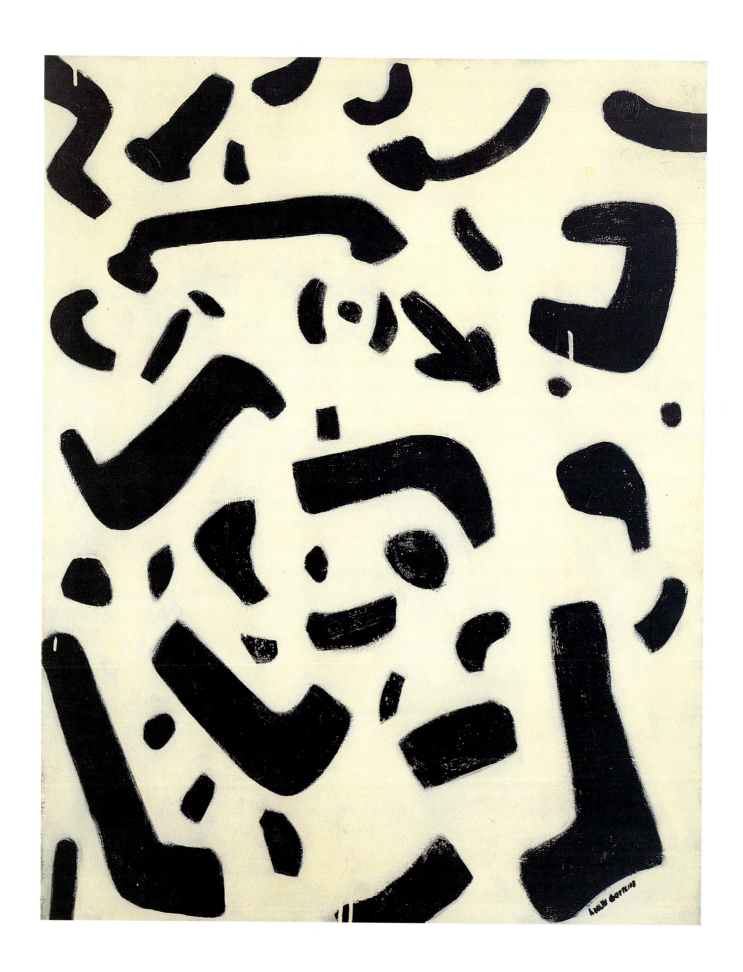

51
Running
1948
oil on canvas
38 x 30"

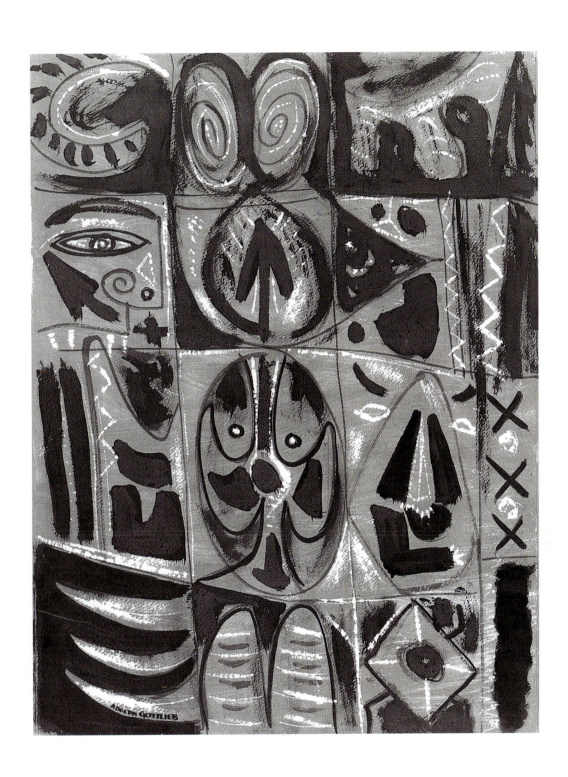

52

Black Arrow

1948

gouache on paper

23 ⅞ x 18"

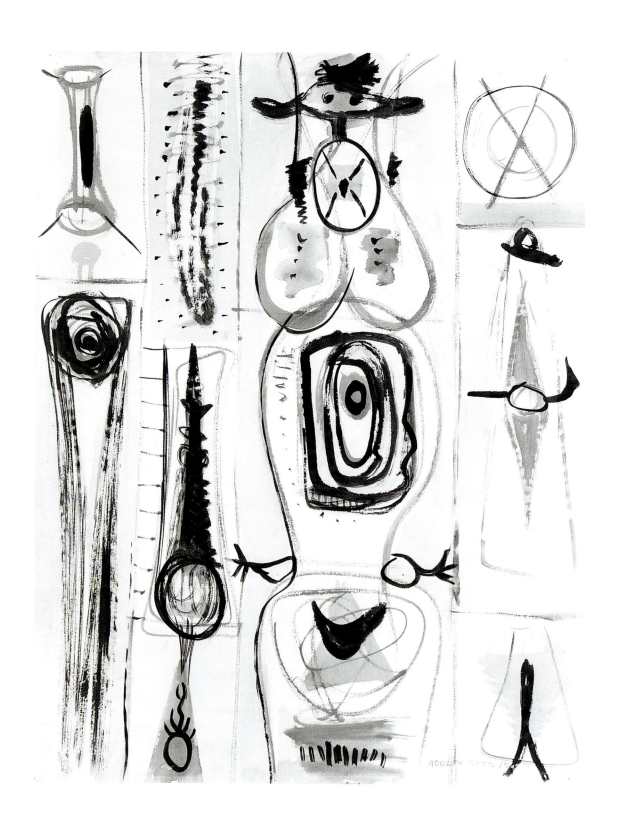

53

Figures
1948
gouache on paper
25 ¾ x 20 ⅛"

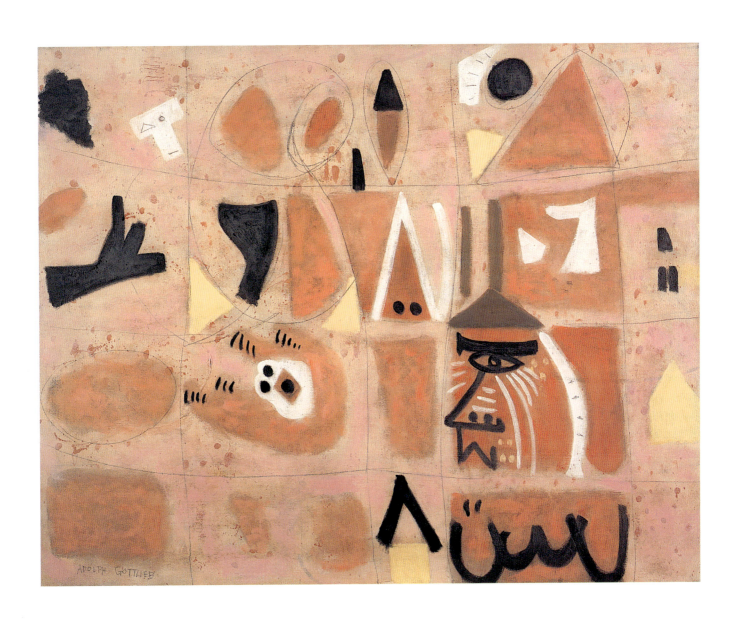

54

Centurion

1949

oil, tempera and pencil on linen

29 ¾ x 37 ⅞"

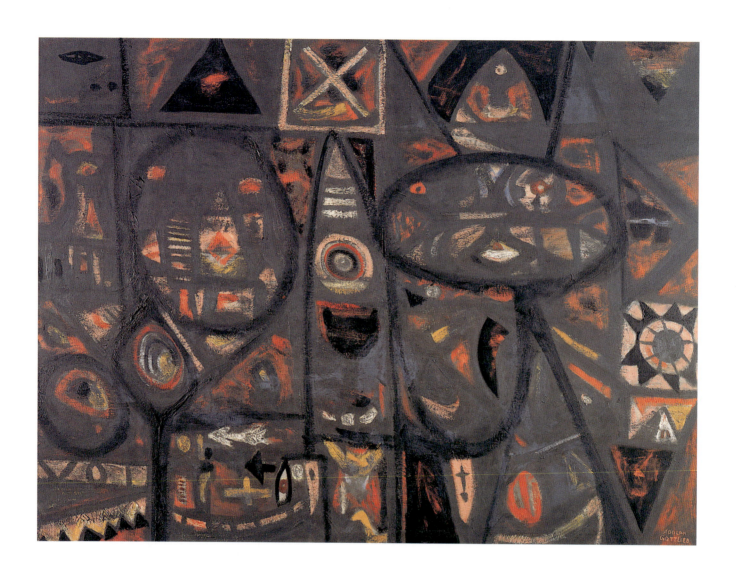

55

Dark Journey

1949

oil on canvas

40 x 54"

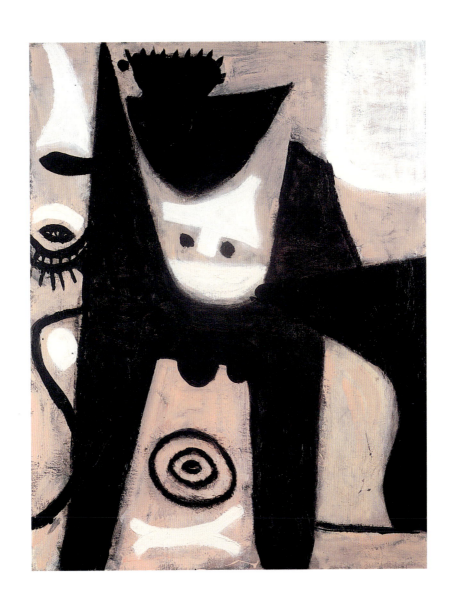

56

Black Silhouette

1949

oil and enamel on canvas

31 ¹³⁄₁₆ x 24⅞"

Jean and Lewis Wolff, Los Angeles, California

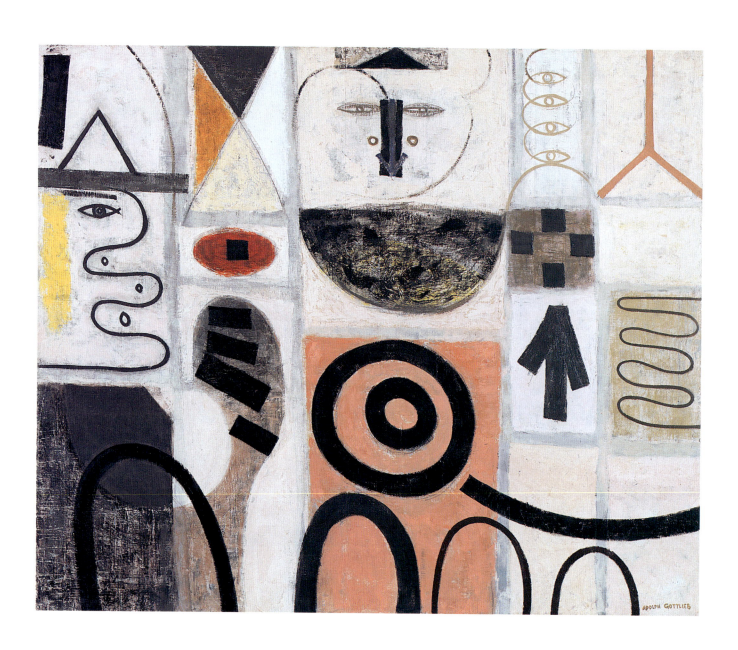

57

The Seer

1950

oil on canvas

59 ¾ x 71 ⅝"

The Phillips Collection, Washington, D.C.

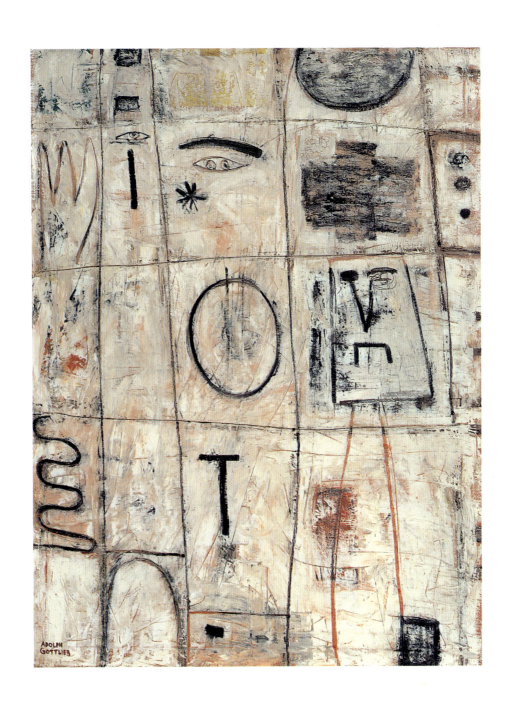

58

T

1950

oil on canvas

48 x 36"

Lent by The Metropolitan Museum of Art.

Purchase, Mr. and Mrs. David M. Solinger. Gift, 1952

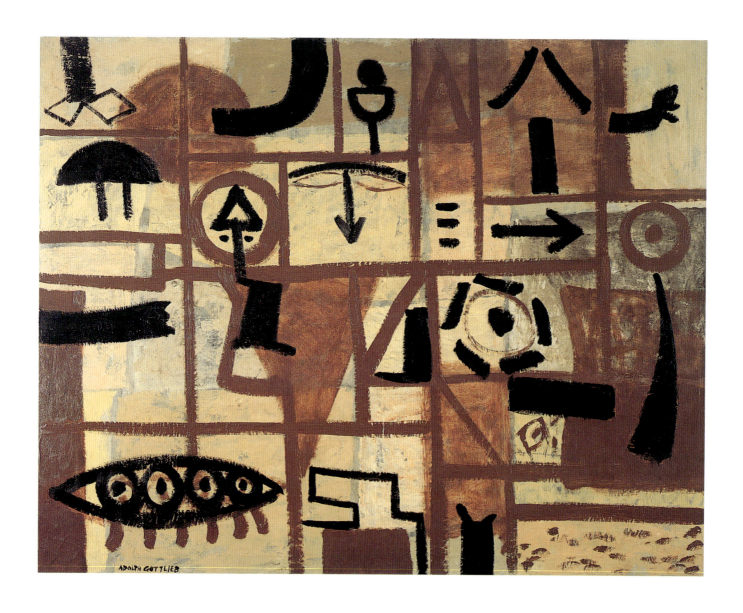

59

Hidden Image

1950

oil on canvas

42 x 54"

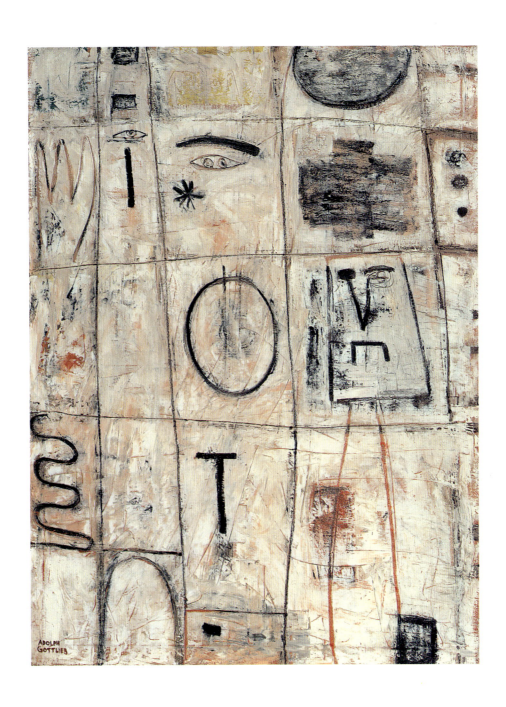

58

T

1950

oil on canvas

48 x 36"

Lent by The Metropolitan Museum of Art.

Purchase, Mr. and Mrs. David M. Solinger. Gift, 1952

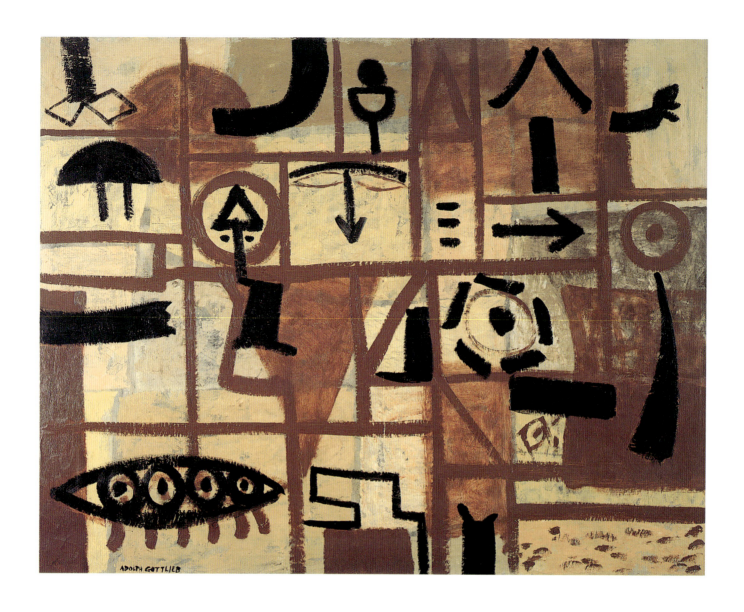

59

Hidden Image

1950

oil on canvas

42 x 54"

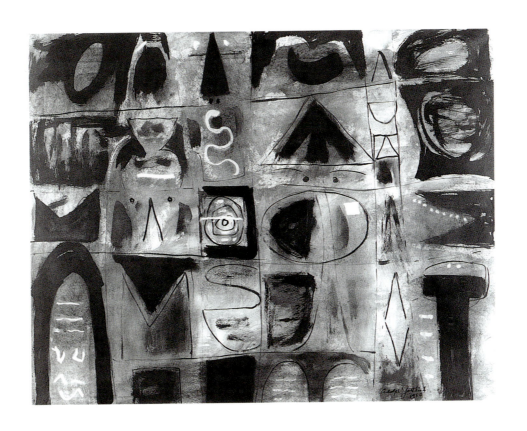

60

Night

1950

gouache on paper

18 ½ x 23 ½"

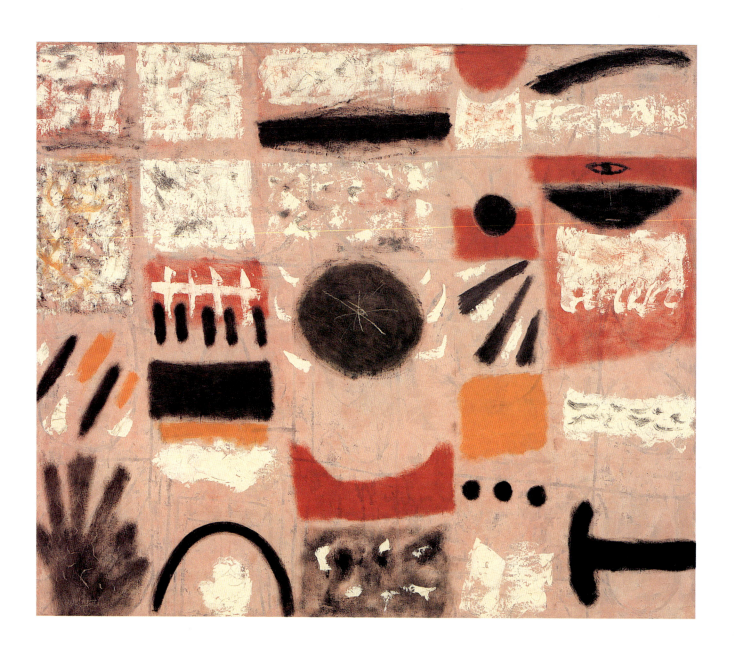

61

Tournament

1951
oil on canvas
60 ⅛" x 72 ⅛"
The Museum of Modern Art, New York
Gift of Esther Gottlieb

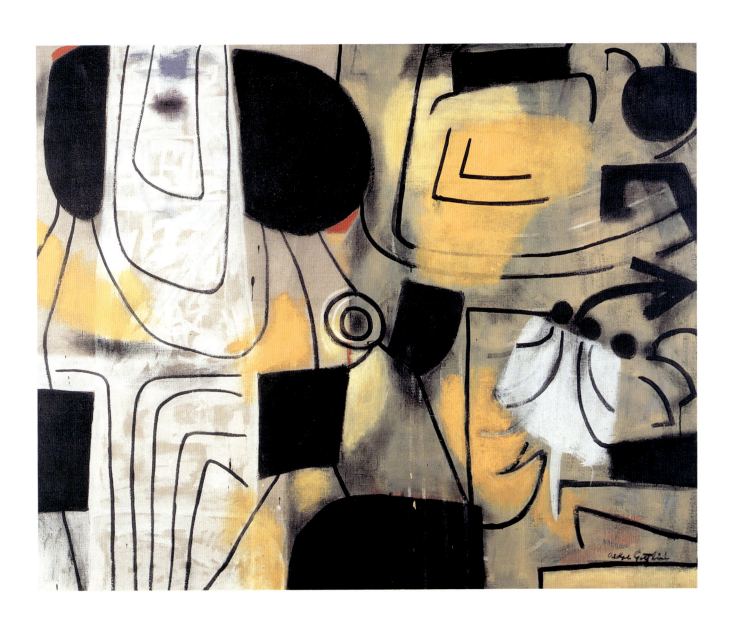

62

Figurations of Clangor

1951

oil, gouache and tempera on unsized burlap

48 1/16 x 60 1/8"

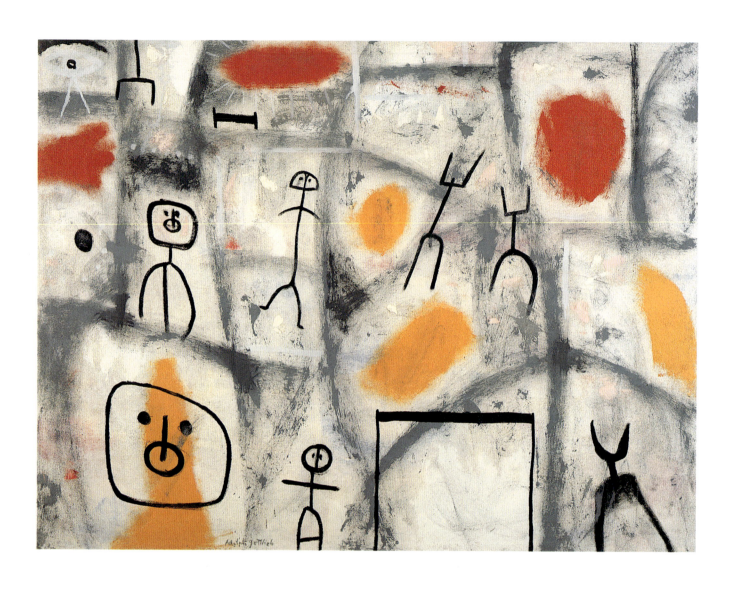

63

Figuration (Two Pronged)

1951

oil on canvas

36 x 48"

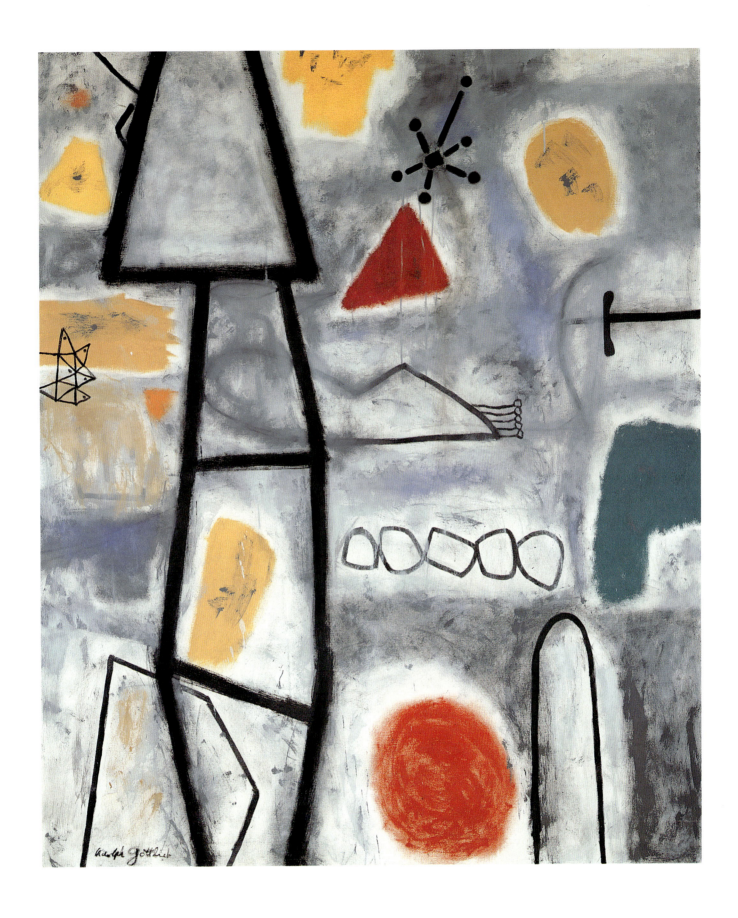

64

Archer

1951

oil, casein and gouache on canvas

73 x 60"

Private Collection, San Francisco

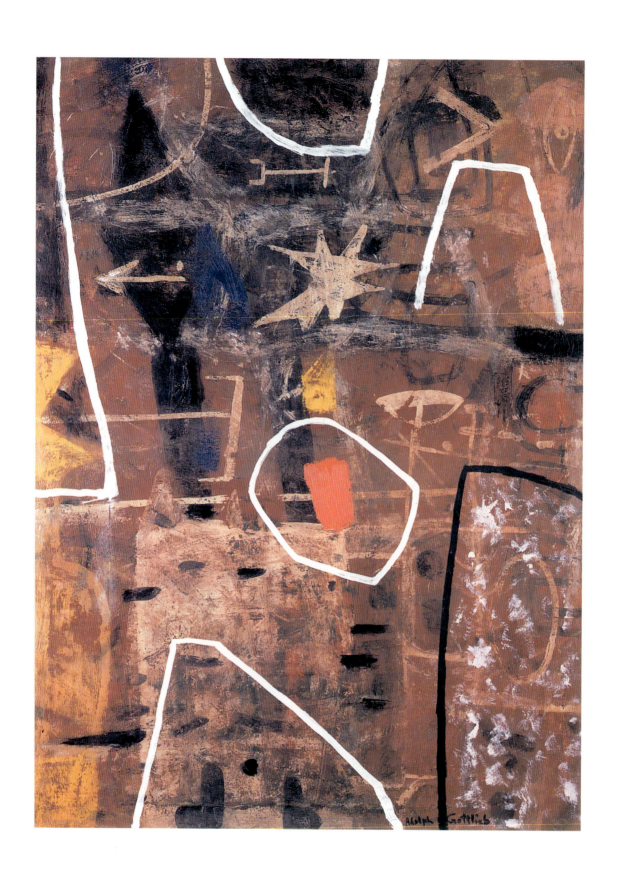

65

Night Flight

1951

oil, tempera, casein and gouache on canvas

48 ⅛ x 35 ¾ "

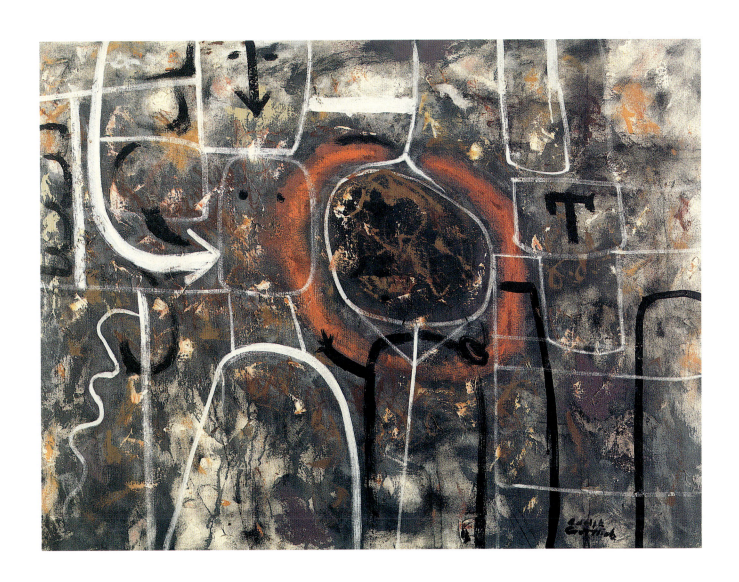

66

Plutomania

1951

oil on canvas

36 x 48"

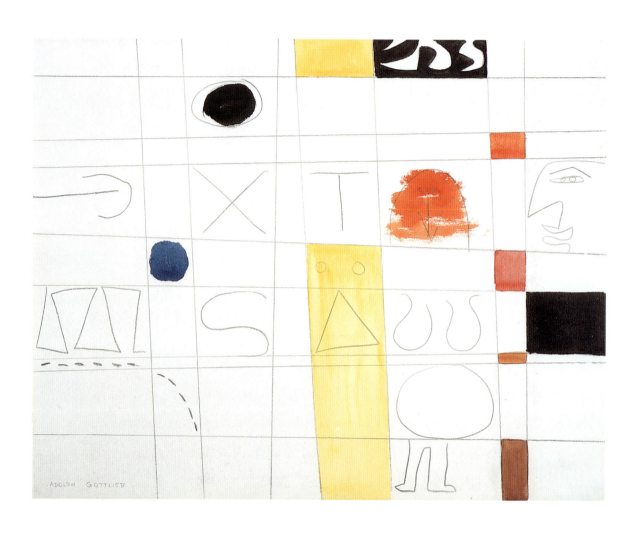

67

Untitled (Study from Man Looking At Woman)
1951
gouache and pencil on paper
19 ½ x 25"

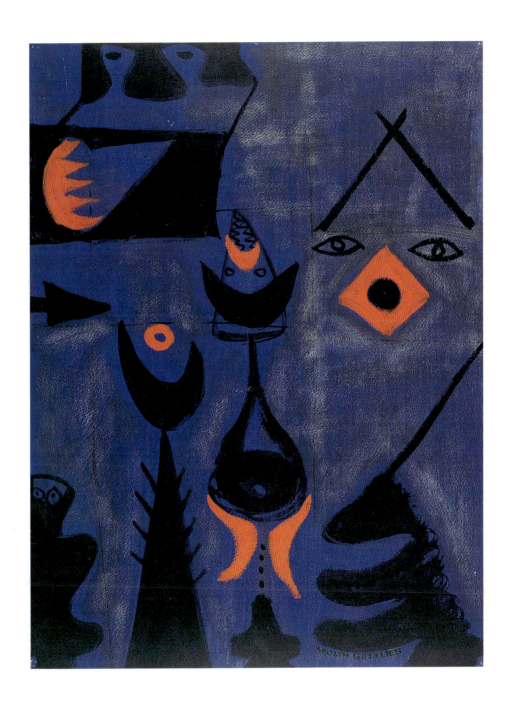

68

Night

1952
gouache on paper
23 ½ x 17 ¾ "

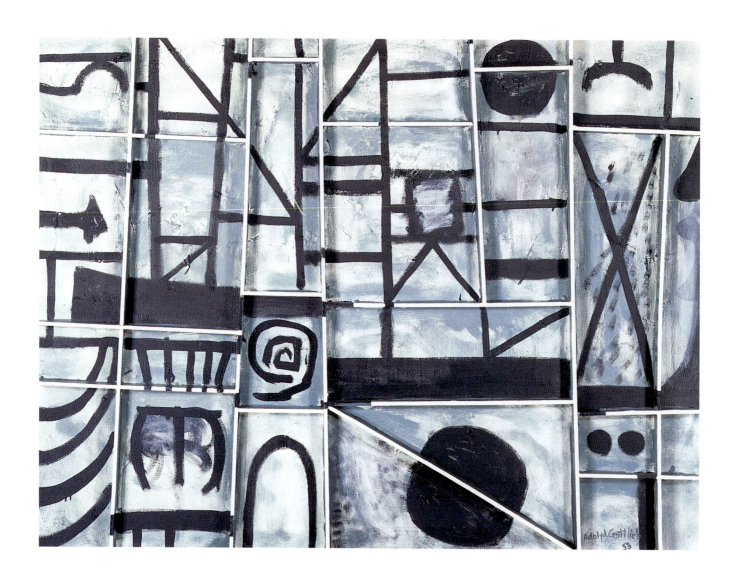

69

Construction #1

1953

oil and gouache on wood on canvas

36 x 47 ⅝"

CHECKLIST

Unless another credit line is provided, the work is
in the collection of the Adolph and Esther Gottlieb
Foundation, New York

1. *Oedipus*
1941
oil on canvas
34 x 26"

2. *Eyes of Oedipus*
1941
oil on canvas
32¼ x 25"

3. *Phoenix*
1941
oil on canvas
24¾ x 32"

4. *Pictograph*
1942
oil on canvas
48 x 36"

5. *Pictograph—Symbol*
1942
oil on canvas
54 x 40"

6. *Pictograph (Yellow and Purple)*
1942
oil on linen
48 x 36"

7. *Minotaur*
1942
oil on linen
35¾ x 27¾"

8. *Oedipus*
1942
oil and sand on linen
33¹⁵/16 x 25⅞"

9. *Palace*
1942
oil on canvas
32 x 24⅞"

10. *Hands of Oedipus*
1943
oil on canvas
40¼ x 35¹⁵/16"
Private Collection

11. *Pictograph #4*
1943
oil on canvas
35¼ x 22⅞"

12. *Black Hand*
1943
oil on linen
30 x 24"

13. *Home*
1943
oil and pencil on canvas
23⅞ x 19⅞"

14. *Red Portrait*
1944
oil with cotton waste on canvas
29½ x 23½"

15. *Lion*
1944
oil on linen
24 x 29⅞"
Colin J. Adair, Montreal

16. *Nostalgia for Atlantis*
1944
oil on canvas
20 x 25"

17. *The Enchanted Ones*
1945
oil on linen
48 x 36"

18. *Alkahest of Paracelsus*
1945
oil on canvas
60 x 44"
Museum of Fine Arts, Boston. The
Tompkins Collection. 1973.599

19. *Masquerade*
1945
oil and tempera on canvas
36 x 24"

20. *Mariner's Incantation*
1945
oil, gouache, tempera and casein on canvas
39¹³/16 x 29⅞"

21. *Expectation of Evil*
1945
oil, gouache and tempera on canvas
43⅛ x 27⅛"
Los Angeles County Museum of Art, Purchased
with funds provided by Burt Kleiner and Merle
Oberon (M.89.4)

22. *Composition*
1945
oil, gouache, tempera and casein on linen
29¹³/16 x 35⅞"

23. *The Token*
1945
oil, tempera and casein on canvas
31⅞ x 24⅞"

24. *Apparition*
1945
etching and aquatint
20 x 15" plate

25. *Augury*
1945
oil on canvas
40 x 30"
Solomon R. Guggenheim Museum,
New York

26. *Divisions of Darkness*
1945
oil on canvas
24 x 30"
The Everest Group, Ltd., St. Paul, Minnesota
Photography ©1990 Sothebys, Inc.

27. *Jury of Three*
1945
oil on canvas
34 x 26"
Marlborough International Fine Art

28. *Birds*
ca. 1945
gouache on paper
26 x 20"

29. *Black Enigma*
1946
oil on canvas
25 x 32"
Hood Museum of Art, Dartmouth College,
Hanover, N.H.; Bequest of Lawrence
Richmond, Class of 1930

30. *Recurrent Apparition*
1946
oil on canvas
35½ x 53½"
Elvehjem Museum of Art, University of
Wisconsin–Madison. Elvehjem Associates
Fund, Friends of the Elvehjem Fund, Emily
Baldwin Bell Fund and Tenth Anniversary Fund
purchase, 1980.56.

31. *The Spectre*
1946
oil and gouache on canvas
33¹⁵/16 x 26"
Fayez Sarofim Collection

32. *The Prisoners*
1946
oil, gouache and tempera on canvas
24⅞ x 31¹⁵/16"

33. *Night Voyage*
1946
oil on canvas
38 x 30"
Hirshhorn Museum and Sculpture Garden,
Smithsonian Institution.
Gift of Joseph H. Hirshhorn, 1966.

34. *Voyager's Return*
1946
oil on canvas
37⅞ x 29⅞"
The Museum of Modern Art, New York.
Gift of Mr. and Mrs. Roy R. Neuberger.

35. *Evil Omen*
1946
oil on canvas
38 x 30"
Neuberger Museum of Art, State University of
New York at Purchase, gift of Roy R. Neuberger

36. *Voyage*
ca. 1946
etching and aquatint
8¾ x 6¾" plate

37. *Omen*
1946
etching and aquatint
9⅞ x 11¾" plate

38. *Evil Eye*
1946
oil on canvas
34 x 22"
Richard E. Lang, Jane Lang Davis
Collection, Medina, WA.

39. *Chimera*
ca. 1946
etching
6½ x 5" plate

40. *Forgotten Dream*
1946
oil on canvas
24 x 30"
Herbert F. Johnson Museum of Art, Cornell
University. Gift of Albert A. List, 55.57.

41. *Pictograph*
1946
oil on canvas
36 x 48"
Albright-Knox Art Gallery, Buffalo,
New York
Gift of Mr. and Mrs. David Anderson to
The Martha Jackson Collection, 1976

42. *Omen for a Hunter*
1947
oil on canvas
30 x 38"

43. *Blue and White Pictograph*
1947
oil, gouache and tempera on canvas
33 ¹⁵/₁₆ x 25⅞"

44. *Sorceress*
1947
oil on canvas
48 x 36"
Columbia University in the City of New York,
Gift of Mr. and Mrs. Samuel M. Kootz, 1960

45. *Pursuer and Pursued*
1947
oil on canvas
38 x 36"
Yale University Art Gallery, Gift of Fred Olsen

46. *Vigil*
1948
oil on canvas
36 x 48"
Collection of Whitney Museum of American
Art, purchase 49.2

47. *Sounds at Night*
1948
oil and charcoal on linen
48⅛ x 60"

48. *Letter to a Friend*
1948
oil, tempera and gouache on canvas
47⅞ x 36¼"

49. *The Terrors of Tranquility*
1948
oil on canvas
38 x 30"

50. *Inscription to a Friend*
1948
oil on canvas
25 x 32"

51 *Running*
1948
oil on canvas
38 x 30"

52. *Black Arrow*
1948
gouache on paper
23⅞ x 18"

53. *Figures*
1948
gouache on paper
25¾ x 20⅛"

54. *Centurion*
1949
oil, tempera and pencil on linen
29¾ x 37⅞"

55. *Dark Journey*
1949
oil on canvas
40 x 54"

56. *Black Silhouette*
1949
oil and enamel on canvas
31 ¹³/₁₆ x 24⅞"
Jean and Lewis Wolff, Los Angeles, California

57. *The Seer*
1950
oil on canvas
59¾ x 71⅝"
The Phillips Collection, Washington, D.C.

58. *T*
1950
oil on canvas
48 x 36"
Lent by The Metropolitan Museum of Art.
Purchase, Mr. and Mrs. David M. Solinger
Gift, 1952

59. *Hidden Image*
1950
oil on canvas
42 x 54"

60. *Night*
1950
gouache on paper
18½ x 23½"

61. *Tournament*
1951
oil on canvas
60⅛ x 72⅛"
The Museum of Modern Art, New York. Gift of
Esther Gottlieb.

62. *Figurations of Clangor*
1951
oil, gouache and tempera on unsized burlap
48¹/₁₆ x 60⅛"

63. *Figuration (Two Pronged)*
1951
oil on canvas
36 x 48"

64. *Archer*
1951
oil, casein and gouache on canvas
73 x 60"
Private Collection, San Francisco

65. *Night Flight*
1951
oil, tempera, casein and gouache on canvas
48⅛ x 35¾"

66. *Plutomania*
1951
oil on canvas
36 x 48"

67. *Untitled (Study from Man Looking At Woman)*
1951
gouache and pencil on paper
19½ x 25"

68. *Night*
1952
gouache on paper
23½ x 17¾"

69. *Construction #1*
1953
oil and gouache on wood on canvas
36 x 47⅝"

SELECTED BIBLIOGRAPHY

STATEMENTS BY THE ARTIST (Listed Chronologically)

Gottlieb, Adolph, and Mark Rothko. Letter to the Editor, in Jewell, Edward Alden. "The Realm of Art: A New Platform and Other Matters: 'Globalism' Pops Into View." *New York Times*, 13 June 1943, p. 9.

———. "The Portrait and the Modern Artist." *Art in New York*. Typescript of a radio broadcast, directed by Hugh Stix. WNYC, 13 October 1943.

Gottlieb, Adolph. Sidney Janis, *Abstract and Surrealist Art in America*. New York: Reynal and Hitchcock, 1944.

———. *Personal Statement: A Painting Prophecy—1950*. Washington, D.C.: The David Porter Gallery, 1945.

———. Letter to the Art Editor, *New York Times*, 22 July 1945.

———. "New York Exhibitions." *Limited Editions*, no. 5 (December 1945): 4, 6.

———. "The Ides of Art: The Attitudes of Ten Artists on Their Art and Contemporaneousness." *The Tiger's Eye* 1, no. 2 (December 1947): 43.

———. "Unintelligibility." Typescript of *The Artist Speaks* forum. Museum of Modern Art, 5 May 1948. The Adolph and Esther Gottlieb Foundation, New York.

———. "The Ides of Art: Eleven Graphic Artists Write." *The Tiger's Eye* 1, no. 8 (June 1949): 52.

———. *Selected Paintings by the Late Arshile Gorky*. New York: Kootz Gallery, 1950.

———. *American Vanguard Art for Paris*. New York: Sidney Janis Gallery, 1951.

———. *Forty American Painters, 1940—1950*. Minneapolis: University of Minnesota, 1951.

———. "My Painting." *Arts and Architecture* 68, no. 9 (Spring 1951): 21.

———. *Contemporary American Painting and Sculpture*. Urbana: University of Illinois, 1955.

———. Baur, John I.H., ed. *The New Decade: Thirty-Five American Painters and Sculptors*. New York: The Whitney Museum of American Art, 1955.

———. "Integrating the Arts." *Interiors* 114 (June 1955): 20, 171.

———. "Letters to the Editor." *College Art Journal* 14 (Summer 1955): 373.

———. "Artist and Society: A Brief Case History." *College Art Journal* 14 (Winter 1955): 96-101. Revised from "The Artist and the Public." *Art in America* 42, no. 4 (December 1954): 267-272.

———. Baur, J.I.H. *Bradley Walker Tomlin*. New York: The MacMillian Company, 1957.

———. Baur, J.I.H. *Nature in Abstraction*. New York: The MacMillian Company, 1958.

———. *The New American Painting*. New York: International Council at The Museum of Modern Art, 1959, 36.

———. Talese, Gay. "Stevenson Studying Abstract Art." *New York Times*, 23 December 1959.

———. "Representational or Abstract?" *Junior League Magazine* 50 (November-December 1962): 2.

———. *Adolph Gottlieb: Estados Unidos da America*. Sao Paulo: VII Bienal do Museu de Arte Moderna, 1963.

———. "Postcards from Adolph Gottlieb." *Location* I (Summer 1964): 19-26.

———. Willard, Charlotte. "In the Art Galleries." *New York Post*, 10 January 1965, 20.

———. Meeting of the International Association of Art Critics. Typescript of a tape recording. Metropolitan Museum of Art, May 22, 1959. Archives of American Art, Smithsonian Institution, Washington, D.C.

———. Art Education Forum. Typescript of a tape recording. New York University, 1965.

———. Gruen, John. *The Party's Over Now: Reminiscences of the Fifties*. New York: Viking Press, 1967.

———. Questions for Artists Employed on the WPA Federal Art Project in New York City and State. New Deal Research Project, March 5, 1968. Archives of American Art, Smithsonian Institution, Washington, D.C.

———. "Jackson Pollock: An Artists' Symposium." *Art News* 66 (April 1967): 31.

———. Varian, Elayne. *Twenty-One Over Sixty*. East Hampton, NY: Guild Hall, 1973.

INTERVIEWS (Listed Chronologically)

Celentano, Francis. "The Origins and Development of Abstract Expressionism in the United States." Master's thesis, New York University, 1957.

Rodman, Selden. *Conversation with Artists*. New York: Devin Adair, 1957.

Friedman, Martin. "Interview with Adolph Gottlieb." Typescript of tape recordings. East Hampton, 1962. The Adolph and Esther Gottlieb Foundation, New York.

Sylvester, David. "Adolph Gottlieb: An Interview with David Sylvester." *Living Arts* 2 (June 1963): 2-10.

Brown, Gordon. "A New York Interview with Adolph Gottlieb." *Art Voices* 3, no. 2 (February 1964): 12-13.

Sister Corita. "Art 1964." *Jubilee* 12 (December 1964): 17-21.

Kashdin, Gladys. "Conversation with Adolph Gottlieb." Typescript of a tape recording. New York, 28 April 1965. The Adolph and Ester Gottlieb Foundation, New York.

Jones, John. "Interview with Adolph Gottlieb." Typescript of a recording. New York, 3 November 1965. Archives of American Art, Smithsonian Institution, Washington, D.C.

Hudson, Andrew. "Interview with Adolph Gottlieb." *The Washington Post*, 31 July 1966. Quoted in Andrew Hudson, "Adolph Gottlieb: An Artist Who is Surviving." *Art Magazine* (Canada), (March-April 1978): 18-23.

Seckler, Dorothy. "Interview with Adolph Gottlieb." Typescript of a tape recording. New York, 25 October 1967. Archives of American Art.

Hudson, Andrew. "Dialogue with Adolph Gottlieb." Typescript of a tape recording. New York, 1968. The Adolph and Esther Gottlieb Foundation, New York.

Siegel, Jeanne. "Adolph Gottlieb: Two Views." *Arts Magazine* (February 1968): 30-33. Transcript of an interview with Adolph Gottlieb, originally broadcast on WBAI-FM, New York, May 1967.

———. "Adolph Gottlieb at 70: I Would Like to Get Rid of the Idea that Art is for Everybody." *Art News* 72 (December 1973): 57-59.

ARCHIVAL MATERIAL AND LETTERS

American Artists' Congress. Papers. Archives of American Art, Smithsonian Institution, Washington, D.C.

Baumbach, Harold. Papers. Archives of American Art, Smithsonian Institution, Washington, D.C. Containing corres. from Adolph Gottlieb to Baumbach from Arizona, 12 December 1937-19 April, 1938.

Bodin, Paul. Letters. Gottlieb corres. to Bodin from Brooklyn, Arizona, and East Gloucester, Massachusetts, 20 June 1932-19 July 1944.

Federation of Modern Painters and Sculptors. Papers. Archives of American Art, Smithsonian Institution, Washington, D.C.

Gottlieb, Adolph. Papers. Archives of American Art, Smithsonian Institution, Washington, D.C.

———. Papers. The Adolph and Esther Gottlieb Foundation, Inc., New York.

Kootz, Samuel M. Papers. Archives of American Art, Smithsonian Institution, Washington, D.C.

Pearson, Stephen. An Interview with Esther Gottlieb. Master's thesis, Hunter College, The City University of New York, 1975.

Provincetown Art Association. Papers. Archives of American Art, Smithsonian Institution, Washington, D.C.

Registrar's records for Adolph Gottlieb. New York: Art Students League, Cooper Union, Parsons School of Design.

SOLO EXHIBITIONS (Listed Chronologically)

Adolph Gottlieb: Paintings. New York: Artists' Gallery, 1943.

Newman, Barnett. *Adolph Gottlieb: Drawings*. New York: Wakefield Gallery ,1944.

Stroup, Jon. *Adolph Gottlieb*. New York: 67 Gallery, 1945.

Wolfson, Victor. *Adolph Gottlieb*. New York: Kootz Gallery, 1947.

Adolph Gottlieb. New York: Jacques Seligmann Galleries, 1949.

Kootz, Samuel M. *New Paintings by Adolph Gottlieb*. New York: Kootz Gallery, 1950.

Gottlieb: New Paintings. New York: Kootz Gallery, 1951.

Adolph Gottlieb. New York: Kootz Gallery, 1952.

Kootz, Samuel M. *Imaginary Landscapes and Seascapes by Adolph Gottlieb*. New York: Kootz Gallery, 1953.

———. *Adolph Gottlieb: An Exhibition of Recent Paintings*. New York: Kootz Gallery, 1954.

Greenberg, Clement. *A Retrospective Show of the Paintings of Adolph Gottlieb*. Bennington, Vermont: Bennington College Gallery, 1954.

Adolph Gottlieb. New York: Martha Jackson Gallery, 1957.

Greenberg, Clement. *Adolph Gottlieb*. New York: The Jewish Museum, 1957.

Adolph Gottlieb: New Paintings. New York: André Emmerich Gallery, 1959

Greenberg, Clement. *Gottlieb: École de New York*. Paris: Galerie Rive Droite, 1959. Text in French and English.

Adolph Gottlieb: Paintings 1949—1959. London: Institute of Contemporary Art, 1959.

Adolph Gottlieb: New Paintings. New York: French and Company, Inc., 1960.

Rubin, William. *Gottlieb*. Milan: Galleria dell' Ariete, 1961. Text in Italian.

Gottlieb. Basel: Galerie Handschin, 1962.

Adolph Gottlieb. New York: Sidney Janis Gallery, 1962.

Friedman, Martin. *Adolph Gottlieb.* Minneapolis, Minnesota: Walker Art Center, 1963.

———. *Adolph Gottlieb: Estados Unidos da America.* Sao Paulo: VII Bienal do Museu de Arte Moderna, 1963. Text in English and Portuguese.

Adolph Gottlieb. New York: Marlborough-Gerson Gallery, 1964.

Recent Works of Adolph Gottlieb. Chicago: The Arts Club of Chicago, 1967.

Doty, Robert, and Diane Waldman. *Adolph Gottlieb.* New York: Whitney Museum of American Art and Solomon R. Guggenheim Museum, 1968.

Landgren, Marchal E. *Gottlieb: Sculpture.* College Park, Maryland: University of Maryland, 1970.

Passoni, Aldo. *Adolph Gottlieb.* Bergamo: Galleria Lorenzelli, 1970. Text in Italian.

Adolph Gottlieb: Acrylics on Paper. Regina, Canada: Norman MacKenzie Art Gallery, and Alberta, Canada: Edmonton Art Gallery, 1971.

Adolph Gottlieb: Paintings 1959—1971. London: Marlborough Fine Art, and Zurich: Marlborough Galerie AG, 1971.

Adolph Gottlieb. New York: Marlborough Gallery, 1972.

Memorial Exhibition: Adolph Gottlieb. New York: American Academy of Arts and Letters, 1975.

Sandler, Irving. *Adolph Gottlieb: Paintings 1945—1974.* New York: André Emmerich Gallery, 1977.

Wilkin, Karen. *Adolph Gottlieb: Pictographs.* Edmonton, Alberta, Canada: The Edmonton Art Gallery, 1977.

MacNaughton, Mary Davis. *Adolph Gottlieb: Pictographs 1941—1953.* New York: André Emmerich Gallery, 1979.

Roberts, Miriam. *Adolph Gottlieb: Paintings 1921—1956.* Omaha, Nebraska: The Joslyn Art Museum, 1980.

Alloway, Lawrence, and Mary Davis MacNaughton. *Adolph Gottlieb: A Retrospective.* New York: Adolph and Esther Gottlieb Foundation, 1981; Distributed by Hudson Hills Press, 1994.

Adolph Gottlieb: Works On Paper. Allentown, PA: Muhlenberg College, 1984.

Adolph Gottlieb. Köln: Galerie Wentzel, 1984. Text in German.

Hirsch, Sanford. *Adolph Gottlieb.* New York: M. Knoedler & Company, Inc., 1985.

Kingsley, April. *Adolph Gottlieb: Works on Paper.* San Francisco: Art Museum Association of America, 1986.

Adolph Gottlieb: Pictographs. London: M. Knoedler & Co., 1986.

Hirsch, Sanford. *Adolph Gottlieb: A Retrospective.* Stockholm: Heland Wetterling Gallery, 1989.

MacNaughton, Mary Davis. *Adolph Gottlieb, Works on Paper: 1966–1973.* Los Angeles: Manny Silverman Gallery, 1990.

Polcari, Stephen. *Adolph Gottlieb: Epic Art.* Stony Brook, NY: University Art Gallery, Staller Center for the Arts, State University of New York at Stony Brook, 1991.

Hirsch, Sanford. *Adolph Gottlieb: The Pictographs 1942—1951.* Los Angeles: Manny Silverman Gallery, 1992.

———. *Pictograph Into Burst: Adolph Gottlieb Paintings In Transition.* New York: Adolph and Esther Gottlieb Foundation, 1992.

Adolph Gottlieb: Important Works. Montreal: Landau Fine Art, 1993.

Harvey, Ian. *Adolph Gottlieb: The Complete Prints.* New York: Associated American Artists, 1994.

REVIEWS

"Adolph Gottlieb: A Retrospective." *Indianapolis Museum of Art Quarterly Magazine,* March-May 1982, 13.

"Adolph Gottlieb: A Retrospective." *Los Angeles County Museum of Art, Member's Calendar* 20, no. 7 (July 1982).

"Adolph Gottlieb: Works on Paper." *Fort Wayne (Indiana) Museum of Art Newsletter,* January-February 1987.

Ashton, Dore. "Adolph Gottlieb at the Guggenheim and Whitney Museum." *Studio* 175 (April 1968): 201-202.

Bannon, Anthony. "Gottlieb's Art Is Ultimately Exalting." *Buffalo Evening News,* 19 September 1982, 10(C).

Bass, Ruth. "Adolph Gottlieb." *Art News* 84, no. 10 (December 1985): 119.

Benbow, Charles. "Gottlieb Retrospective Best Art Show in Years." *St. Petersburg (Florida) Times ,* 4 September 1981, 3(D).

Berger, Maurice. "Painting Jewish Identity." *Art In America* 80, no. 1 (January 1992): 92-93.

Bernatchez, Raymond. "Une Mini-Rétrospective Gottlieb." *La Presse* (Montreal), 13 November 1993. Text in French.

"The Bienal's Best." *Time* 82 (4 October 1963): 30.

Bode, Ursula. "Dramatiker im Abstrakten Raum." *Die Zeit* (Hamburg) no. 45, 2 November 1990. Text in German.

Bowness, Alan. "Adventurous American." *The Observer* (London), 7 June 1959.

Braff, Phyllis. "Drawing Lines: East End Anthology." *New York Times,* 6 November 1988, 32.

———. "A Tribute To Adolph Gottlieb." *New York Times,* 8 August 1991, 12.

———. "From The Studio." *East Hampton (New York) Star,* 25 August 1983, 8.

Brenson, Michael. "Image and Reflection: Adolph Gottlieb's Pictographs and African Sculpture." *New York Times,* Friday, 29 December 1989, 22(C).

Cavaliere, Barbara. "Adolph Gottlieb." *Arts Magazine* 53, no. 9 (May 1979): 4.

Colby, Joy Hakanson. "A Gripping Panorama of Gottlieb's Art." *Detroit News,* 22 November 1981.

Dietrich, Linnea S. "Gottlieb: Translating Experience Into Visual Language." *Tampa (Florida) Tribune,* 10 September 1981, 1-8(D).

Drolet, Owen. "Adolph Gottlieb." *Flash Art,* March-April 1994.

Duncan, Ann. "Adolph Gottlieb." *Art News,* February 1994, 152.

———. "Modernist Groundbreaker Comes to Landau." *Gazette* (Montreal), 30 October 1993, 1(J).

"Ein Erneuerer Aus Amerika." *Frankfurter Allgemeine Zeitung,* no. 251, 27 October 1990, 33. Text in German.

Fitzsimmons, James. "Adolph Gottlieb." *Everyday Art Quarterly,* no. 25 (1953): 1-4.

Forgey, Benjamin. "Adolph Gottlieb: Intellect, Integrity." *Washington (D.C.) Star,* 26 April 1981, 8(C).

Frank, Peter. "Adolph Gottlieb: The Pictographs." *L.A. Weekly,* 22 May-4 June 1992, 111.

Fried, Michael. "New York Letter." *Art International* 6 (25 October 1962): 75-76.

Goldfine, Gil. "Adolph Gottlieb: Man and Myth." *Jerusalem Post,* 26 November, 1982, 10-11.

Goldwater, Robert. "Reflections on the New York School." *Quadrum,* no. 8 (1960): 17-36.

Goosen, E.C. "Adolph Gottlieb." *Monterey (California) Peninsula Herald,* 12 May 1954.

Greenberg, Clement. "Art." *The Nation* 165 (6 December 1947): 629.

Hakim, Mona. "L'art Abstrait et Libérateur d'Adolph Gottlieb." *Le Devoir* (Montreal), 28 November 1993. Text in French.

Harvey, James E. "FIA Show Features Gottlieb, Artist Who Captured Contradictions." *Flint (Michigan) Journal,* 21 March 1982, 14-15(C).

Henkel, Gabriele. "Leuchtende, Berstende Farben." *Die Welt* (Bonn) no. 252, 27 October 1990. Text in German.

Hess, Thomas B. "The Artist as a Pro." *New York,* December 1972, 96-97.

———. "Reluctant Symbolist." *New York,* 7 February 1977, 63-64.

Hilton, Tim. "An American Master." *London Observer,* 11 May 1986.

Hudson, Andrew. "Adolph Gottlieb's Paintings at the Whitney." *Art International* 12, no. 4 (20 April 1968): 24-29.

———. "Adolph Gottlieb: An Artist Who is Surviving." *Art Magazine* (Canada), March-April 1978, 18-23.

Huxtable, Ada Louise. "Gottlieb's Glass Wall." *Arts Digest* 29 (15 January 1955): 9.

Janson, Anthony F. "Adolph Gottlieb." *Indianapolis Museum of Art Quarterly Magazine,* March-May 1982, 5-9.

J.L. "'Whitney Dissenters' Hold Their Own Exhibition." *Art News* 38, no. 7 (12 November 1938): 15.

Kingsley, April. "Adolph Gottlieb in the Fifties: 'Different Times Require Different Images'." *Arts Magazine* 60, no. 1 (September 1985): 80-83.

Klein, Jerome. "Ten Who are Nine Return for Second Annual Exhibition." *New York Sun,* 19 December 1936.

Knight, Christopher. "Gottlieb's Art Raises Pivotal Concerns." *Los Angeles Herald Examiner,* 21 July 1982, 1, 6(B).

Königs, Sabine. "Ungebändigte Kraft Neben Göttlicher Ruhe." *Rheinische Post* (Düsseldorf) no. 236, 10 October 1990. Text in German.

"Konrad Cramer, Adolph Gottlieb, Dudensing Galleries." *Art News* 28 (17 May 1930): 15.

Kramer, Hilton. "Art: A Perspective on Adolph Gottlieb." *New York Times,* 23 March 1979.

———. "Art: Two Periods of Adolph Gottlieb." *New York Times,* 15 February 1968, 48(L).

Kunter, Janet. "UT Exhibit Portrays Gottlieb's Complexity." *Dallas Morning News.* 16 February 1982, 1-3(C).

Lipson, Karin. "A Glimpse of Gottlieb." *New York Newsday,* 19 July 1991.

McKenna, Kathryn. "Decoding Gottlieb's Adventures in Finding His Own Art." *Austin (Texas) American-Statesman,* 17 January 1982, 32-33.

Merritt, Robert. "Gottlieb, Guston: Personalizing the Abstract." *Richmond (Virginia) Times-Dispatch,* 3 May 1981, 4(C).

O'Doherty, Brian. "Adolph Gottlieb: The Dualism of an Inner Life." *New York Times,* 23 February 1964.

Pagel, David. "Adolph Gottlieb." *Art issues,* no. 24 (September-October 1992): 40.

"Pionier der Modernen Kunst." *Stradtteilzeitung* (Düsseldorf) 24 October 1990, 8. Text in German.

Richard, Paul. "Explorer of Conflict." *Washington Post,* 4 May 1981, 13(B).

Riley, Maude Kemper. "New York Exhibitions." *MKR's Art Outlook* 1, no. 28 (20 January 1947): 2.

Rosenblum, Robert. "Adolph Gottlieb: New Murals." *Art Digest* 28 (15 April 1954): 11.

Russell, John. "Art: 14 Pictographs From Adolph Gottlieb." *New York Times,* 13 February 1987.

Sandler, Irving. "Adolph Gottlieb." *Art News* 57 (February 1959): 10.

Seckler, Dorothy Gees. "Adolph Gottlieb Makes a Facade." *Art News* 54 (March 1955): 42-45, 61-62.

Smith, Roberta. "Tempus Fidget." *Village Voice* (New York), 20 April 1982, 89.

Stavitsky, Gail. "Adolph Gottlieb." *Arts Magazine,* (December 1985): 121.

Stretch, Bonnie Barrett. "Gottlieb's Northern Exposure." *Art News,* February 1994, 27.

Tillim, Sidney. "New York Exhibitions: In the Galleries." *Arts Magazine* 38 (April 1964): 32.

Twardy, Chuck. "Seeing To Believe." *News & Observer* (Charlotte, NC), 31 October 1993, 1-3(G)

Vielhaber, Christiane. "Ein Vergessener Amerikaner." *Artis* 6 (June 1984): 12-13. Text in German.

Wepman, Dennis. "Adolph Gottlieb at Associated American Artists." *Journal of the Print World* 17, no. 1 (Winter, 1994): 27.

Wilson, William. "A New Take on Adolph Gottlieb's Pictographs at Silverman." *Los Angeles Times,* 4 May 1992, 4(F).

————. "Gottlieb Retrospective at County Museum Fizzles." *Los Angeles Times,* Calendar, 1 August 1982, p. 86-87.

BOOKS AND CATALOGUES

Abstract Expressionism: A Tribute To Harold Rosenberg. Chicago: The University of Chicago, The David and Alfred Smart Gallery, 1979.

Alloway, Lawrence. *Topics in American Art Since 1945.* New York: W.W. Norton, 1975.

American Art Since 1945: From the Collection of the Museum of Modern Art. New York: Museum of Modern Art, 1975.

Anfam, David. *Abstract Expressionism.* World of Art Series. London: Thames and Hudson, 1990.

Arnason, H.H. *American Abstract Expressionists and Imagists.* New York: The Solomon R. Guggenheim Museum, 1961.

Ashton, Dore. *The New York School: A Cultural Reckoning.* New York: Viking Press, 1972.

————. *The Unknown Shore: A View of Contemporary Art.* Boston: Little, Brown, 1962.

Barnett, Vivian Endicott. *Handbook: The Guggenheim Museum Collection 1900—1980.* New York: The Solomon R. Guggenheim Foundation, 1980.

Carmean, E.A., Jr., and Eliza E. Rathbone. *American Art at Mid-Century: The Subjects of the Artist.* Washington, D.C.: The National Gallery of Art, 1978.

Celentano, Francis. "The Origins and Development of Abstract Expressionism in the United States." Master's Thesis, New York University, 1957.

Chevlowe, Susan, and Norman L. Kleeblatt, eds. *Painting a Place In America: Jewish Artists in New York 1900—1945.* New York: The Jewish Museum, 1991.

Cox, Annette. *Art-as-Politics: The Abstract Expressionist Avant-Garde and Society.* Ann Arbor, MI: UMI Research Press, 1977.

Delehanty, Suzanne. *The Window in Twentieth-Century Art.* Purchase, NY: Neuberger Museum,

State University of New York at Purchase, 1987, and Houston: Contemporary Arts Museum, 1987.

Elementarzeichen. Berlin: Neue Berliner Kunstverein, 1985, and Berlin: Frölich & Kaufmann, 1985. Text in German.

Faberman, Hilarie. *Modern Master Drawings: Forty Years of Collecting at The University of Michigan Museum of Art.* Ann Arbor, MI: The University of Michigan Museum of Art, 1987.

Franklin, Deborah, Bettye Harris, Susan M. Mayer, and Janet Ross. *Words In Action: Abstract Expressionism.* Austin, TX: Huntington Gallery, The University of Texas at Austin, 1976.

Geldzahler, Henry. *American Painting in the Twentieth Century.* New York: The Metropolitan Museum of Art, 1965.

————. *New York Painting and Sculpture: 1940—1970.* New York: E.P. Dutton & Co., and New York: Metropolitan Museum of Art, 1969.

Gibson, Ann Eden. *Issues in Abstract Expressionism: The Artist Run Periodicals.* Ann Arbor, MI: UMI Research Press, 1990.

Goerg, Charles. *Peinture Américaine en Suisse.* Geneva, Switzerland: Musée d'Art et d'Histoire, 1976. Text in French and English.

Grabenhorst-Randall, Terree. *Jung and Abstract Expressionism: The Collective Image Among Individual Voices.* Hempstead, NY: Hofstra Museum, Emily Lowe Gallery, Hofstra University, 1986.

Graham, Lanier. *The Spontaneous Gesture: Prints and Books of the Abstract Expressionist Era.* Canberra, Australia: Australian National Gallery, 1987.

Greenberg, Clement. *Art and Culture: Critical Essays.* Boston: Beacon Press, 1961.

Gruen, John. *The Party's Over: Reminiscences of the Fifties.* New York: Viking Press, 1967.

Guggenheim, Peggy. *Art of this Century: Informal Memoirs of Peggy Guggenheim.* New York: Dial Press, 1946.

Henry, Sara Lynn. "Paintings and Statements of Mark Rothko (and Adolph Gottlieb), 1941 to 1949: Basis of the Mythological Phase of Abstract Expressionism." Master's Thesis, New York University, 1966.

Hess, Thomas B. *Abstract Painting.* New York: Viking Press, 1951.

Hobbs, Robert Carleton, and Gail Levin. *Abstract Expressionism: The Formative Years.* New York: Whitney Museum of American Art; and Ithaca, NY: Herbert F. Johnson Museum of Art, Cornell University, 1978.

Hunter, Sam. *An American Renaissance: Paintings and Sculpture Since 1940.* Fort Lauderdale, FL: Museum of Art, 1986.

Janis, Sidney. *Abstract and Surrealist Art in America.* New York: Reynal and Hitchcock, 1944.

Kertess, Klaus. *Drawing On the East End, 1940—1988.* Southampton, NY: The Parrish Art Museum, 1988.

Kingsley, April. *The Turning Point: The Abstract Expressionists and the Transformation of American Art.* New York: Simon & Schuster, 1992.

Kleeblatt, Norman L., and Vivian B. Mann. *Treasures of the Jewish Museum.* New York: The Jewish Museum, and New York: Universe Books, 1986.

Krauss, Rosalind. *Grids: Format and Image in 20th Century Art.* New York: The Pace Gallery, 1978.

————. *Works on Paper: American Art 1945-1975.* Seattle: Washington Art Consortium, 1977.

Lawrence, Ellen, Judith E. Tolnick, and Nancy R. Versaci. *Flying Tigers: Painting and Sculpture in New York 1939—1946.* Providence, RI: Bell Gallery, Brown University, 1985.

Leja, Michael. *Reframing Abstract Expressionism: Subjectivity and Painting in the 1940's.* New Haven: Yale University Press, 1993.

Messinger, Lisa Mintz. *Abstract Expressionism: Works On Paper Selections from The Metropolitan Museum of Art.* New York: The Metropolitan Museum of Art, 1993.

Monaghan, Kathleen. *American Masters: Six Artists from the Permanent Collection of the Whitney Museum of American Art.* New York: Whitney Museum of American Art at Equitable Center, 1992.

Morrin, Peter. *Chase Manhattan: The First Ten Years of Collecting, 1959—1969.* Atlanta: The High Museum of Art, 1982.

Motherwell, Robert. *Seventeen Modern American Painters.* Beverly Hills, CA: Frank Perls Gallery, 1951.

Motherwell, Robert, and Ad Reinhardt, eds. *Modern Artists in America.* 1st ser. New York: Wittenborn Schultz, Inc., 1951.

O'Connor, Francis V., ed. *The New Deal Art Projects: An Anthology of Memoirs.* Washington, D.C.: Smithsonian Institution Press, 1972.

The Painterly Print : Monotypes from the Seventeenth to the Twentieth Century. New York: The Metropolitan Museum of Art, 1980.

Parente, Janice, and Phyllis Stigliano. *Sculpture: The Tradition In Steel.* Roslyn Harbor, NY: Nassau County Museum of Fine Art, 1983.

Peltier, Philippe. *"Primitivisme" et Art Moderne.* Paris: No. 82 Actualité des Arts Plastiques, Centre National de Documentation Pedagogique, 1991, 58. Text in French.

Perlman, Bennard B. *The Immortal Eight and Its Influence: The Art Students League of New York.* New York: The Art Students League of New York, 1983.

Pisano, Ronald G., and Tony Vevers. *The League at the Cape.* Provincetown, MA: Provincetown Art Association and Museum, 1993.

Polcari, Stephen. *Abstract Expressionism and the Modern Experience.* London: Cambridge University Press, 1991.

————. *From Omaha to Abstract Expressionism: American Artists' Responses to World War II.* Potsdam, NY: Roland Gibson Gallery, Potsdam College of the State University of New York, 1992.

Rose, Barbara. *American Art Since 1900.* Rev. ed. New York: Praeger, 1975.

Rosenberg, Harold. *The Tradition of the New.* New York: Horizon, 1959. Reprint, New York: Grove, 1961.

Rosenzweig, Phyllis. *The Fifties: Aspects of Painting In New York.* Washington, D.C.: Smithsonian Institution Press, 1980.

Ross, Clifford. *Abstract Expressionism: Creators and Critics.* New York: Harry N. Abrams, Inc., 1990.

Rubin, William. *"Primitivism" in 20th Century Art.* New York: The Museum of Modern Art, 1985.

Russotto, Ellen. *Paths To Discovery The New York School: Works on Paper from the 1950's and 1960's.* New York: Sidney Mishkin Gallery, Baruch College, 1992.

Sandler, Irving. *The New York School 1940—1960: The First Generation of Abstract Expressionism.* Reno, NV: Sierra Nevada Museum of Art, 1979.

————. *The New York School: The Painters and Sculptors or the Fifties.* New York: Harper & Row, 1978.

————. *The Triumph of American Painting: A History of Abstract Expressionism.* New York: Harper & Row, 1970.

Schimmel, Paul. *The Interpretive Link: Abstract Surrealism into Abstract Expressionism, Works on*

Paper 1938—1948. Newport Beach, CA: Newport Harbor Art Museum, 1986.

Schwartz, Constance. *The Abstract Expressionists and Their Precursors*. Roslyn, NY: Nassau County Museum of Fine Arts, 1981.

Seckler, Dorothy Gees. *Provincetown Painters, 1890's—1970's*. Syracuse, NY: Everson Museum of Art, 1977.

Seitz, William. "Abstract Expressionist Painting in America: An Interpretation Based on the Work and Thought of Six Key Figures." Ph.D. diss., Princeton University, 1955.

Sims, Patterson. *Twentieth-Century American Art*. New York: Whitney Museum of American Art, 1986.

———. *Whitney Museum of American Art: Selected Works from the Permanent Collection*. New York: Whitney Museum of American Art, 1985.

Sloan, John. *Gist of Art: Principles and Practice Expounded in the Classroom and Studio, Recorded with the Assistance of Helen Farr*. New York: American Artists Group, 1939.

Tuchman, Maurice, ed. *New York School: The First Generation, Paintings of the 1940's and 1950's*. Los Angeles: Los Angeles County Museum of Art, 1965.

Tuchman, Maurice. *The Spiritual In Art: Abstract Painting 1890—1985*. New York: Abbeville, and Los Angeles: Los Angeles County Museum of Art, 1986.

Varnedoe, Kirk. *A Fine Disregard*. New York: Harry N. Abrams, 1990.

Wechsler, Jeffrey. *Abstract Expressionism: Other Dimensions (An Introduction to Small Scale Painterly Abstraction in America, 1940—1965)*. New Brunswick, NJ: The Jane Voorhees Zimmerli Art Museum, Rutgers, The State University of New Jersey, 1989.

———. *Watercolors from the Abstract Expressionists Era*. Katonah, NY: The Katonah Museum of Art, 1990.

Whiting, Cécile. *Antifascism in American Art*. New Haven: Yale University Press, 1989.

Wilkin, Karen. *The Collective Unconscious: American and Canadian Art: 1940—1950*. Edmonton, Alberta, Canada: The Edmonton Art Gallery, 1975.

ARTICLES

Alloway, Lawrence. "The Biomorphic Forties." *Artforum* 4, no. 1 (September 1965): 18-22.

———. "Melpomene and Graffiti." *Art International* 12 (April 1968): 21-22.

———. "The New American Painting." *Art International* 3 (1959): 3-4, 21-29.

———. "Residual Sign Systems in Abstract Expressionism." *Artforum* 12, no. 3 (November 1973): 36-42.

———. "Sign and Surface: Notes on Black and White Painting in New York." *Quadrum*, no. 9, (1960): 49-62.

Berger, Maurice. "Pictograph Into Burst: Adolph Gottlieb and The Structure of Myth." *Arts Magazine* 55, no. 7 (March, 1981): 134-139.

Breckenridge, Jack. "A Conversation Between Adolph Gottlieb and Jack Breckenridge." *Phoebus 2: A Journal of Art History*, 1979.

Cavaliere, Barbara, and Robert C. Hobbs. "Against a Newer Laocoön." *Arts Magazine* 51, no. 8 (April 1977): 110-118.

Cone, Jane Harrison. "Adolph Gottlieb." *Artforum* 6, no. 8 (April 1968): 36-40.

Davis, Mary R. "The Pictographs of Adolph Gottlieb: A Synthesis of the Subjective and the Rational." *Arts Magazine* 52, no. 3 (November 1977): 141, 142-147.

Dervaux, Isabelle. "The Ten: An Avant-Garde Group in the 1930's." *Archives of American Art Journal* 31, no. 2 (1991): 14-20.

Doty, Robert McIntyre. "Adolph Gottlieb: Printmaker." *The American Way* 1, no. 6 (1968).

Elderfield, John. "Grids." *Artforum* 10 (May 1972): 52-59.

Emmerich, André. "The Artist as Collector." *Art in America* 46 (Summer 1958): 25.

Friedman, B.H. "'The Irascibles': A Split Second in Art History." *Arts Magazine* 53, no. 1 (September 1978): 96-102.

Graham, John. "Primitivism and Picasso." *Magazine of Art* 30, no. 4 (April 1937): 236-239, 260.

Greenberg, Clement. "After Abstract Expressionism." *Art International* 6 (25 October 1962): 24-32; Reprinted in Henry Geldzahler, *New York Painting and Sculpture, 1940-1970*. New York: E.P. Dutton, 1969.

———. "'American-Type' Painting." *Partisan Review* 22 (Spring 1955): 185-196; Reprinted in Clement Greenberg, *Art and Culture: Critical Essays*. Boston: Beacon Press, 1961, 208-235.

Jewell, Edward Alden. "The Realm of Art: A New Platform and Other Matters: 'Globalism' Pops into View." *New York Times*, 13 June 1943, 9.

Kagan, Andrew. "Paul Klee's Influence on American Painting: New York School." Part II, *Arts Magazine* 50, no. 1 (September 1975): 84-90.

Kainen, Jacob. "An Interview With Stanley William Hayter." *Arts Magazine* 60, no. 5 (January 1986): 65.

———. "Our Expressionists." *Art Front* 3, no. 1 (February 1937): 14-15.

Kozloff, Max. "The Critical Reception of Abstract Expressionism." *Arts Magazine* 40 (December 1965): 27-33.

Lader, Melvin P. "Howard Putzel: Proponent of Surrealism and Early Abstract Expressionism in America." *Arts Magazine* 56, no. 7 (March, 1982): 92-95.

MacNaughton, Mary Davis. "Adolph Gottlieb: The Early Work." *Arts Magazine* 55, no. 9 (May 1981): 125-133.

Monroe, Gerald. "The American Artists' Congress and the Invasion of Finland." *Archives of American Art Journal* 15, no. 1 (1975): 14-20.

Motherwell, Robert. "The Modern Painter's World." *Dyn*, no. 6 (November 1944): 9-14.

Newman, Barnett B. "La pintura de Tamayo y Gottlieb." *La revista Belga* 2 (April 1945): 16-25. Text in Spanish.

Paul, April J. "Introduction à la Peinture Moderne Américaine: Six Young American Painters of the Samuel Kootz Gallery: An Inferiority Complex in Paris." *Arts Magazine* 60, no. 6 (February 1986): 65-71.

Polcari, Stephen. "Gottlieb on Gottlieb." *Nightsounds*, March 1969, 11.

———. "Martha Graham and Abstract Expressionism." *Smithsonian Studies in American Art* 4, no. 1 (Winter 1990): 4-5, 7, 11, 17, 21-23.

Rand, Harry. "Adolph Gottlieb in Context." *Arts Magazine* 51, no. 6 (February 1977): 112-136.

Read, Sir Herbert, and H. Harvard Arnason. "Dialogue on Modern U.S. Painting." *Art News* 59, (May 1960): 32-36.

"Revolt of the Pelicans." *Time*, 5 June 1950, 54.

Rose, Barbara. "Portfolio: Abstract Art In America." *Dialogue*, no. 50 (April 1980): 47, 51.

Rosenberg, Harold. "The American Action Painters." *Art News* 51, no. 5 (September 1952); Reprinted in Henry Geldzahler, New York Painting and Sculpture, 1940-1970. New York: E.P. Dutton, 1969.

———. "The Concept of Action in Painting." *New Yorker*, 25 May 1968.

Rosenblum, Robert. "The Abstract Sublime." *Art News* 59, no. 10 (February 1961); Reprinted in Henry Geldzahler, *New York Painting and Sculpture 1940-1970*. New York: E.P. Dutton, 1969.

Rubin, William. "Adolph Gottlieb." *Art International* 3 (1959): 3-4, 34-37.

———. "Arshile Gorky, Surrealism and the New American Painting." *Art International* 8, no. 3 (February 1963); Reprinted in Henry Geldzahler, *New York Painting and Sculpture, 1940-1970*. New York: E.P. Dutton, 1969.

———. "The New York School—Then and Now." *Art International* 2 (May-June 1958): 4-5, 19-22.

———. "Pollock as Jungian Illustrator: The Limits of Psychological Criticism." *Art in America* 67, no. 7 (Part I: November 1979): 104-123, and 67, no. 8 (Part II: December 1979): 72-92.

Sandler, Irving. "Adolph Gottlieb." *Art International* (May-June 1977): 35-38.

Smith, Roberta. "Famous Eye Speaks In a House Of Memory." *New York Times*, 3 October 1991, 17(C).

Solman, Joseph. "The Easel Divison of the WPA Federal Art Project." *New Deal Art Projects: An Anthology of Memoirs*. Edited by Francis O'Connor. Washington, D.C.: Smithsonian Institution Press, 1972, 115-130.

Tillim, Sidney. "Abstraction Revisited." *Art In America*, April 1986, 167-171.

"Wild Ones." *Time* 67 (20 February 1956): 70.

Wilkin, Karen. "Abstract Expression Revisited." *New Criterion* 9, no. 6 (February 1991): 28-29, 33-34.

———. "Adolph Gottlieb: Pictographs." *Art International* 21, no. 6 (December 1977): 27-33; Reprinted in *Vanguard* (Vancouver), December 1977-January 1978, 11.

"Young American Extremists: A Life Round Table on Modern Art." *Life* 25 (11 October 1948): 62-63.

INDEX

Unless otherwise noted, the works cited are by Adolph Gottlieb. Illustrations and plates are listed by page number in boldface type. Works by Adolph Gottlieb or by anonymous tribal artists are listed by title.

Notes are cited by page number and note number, using "n" (for example, "26n36", or when more than one note is cited on a page, "29n62 and 65").

THE PICTOGRAPHS OF ADOPH GOTTLIEB
was produced for
The Adolph and Esther Gottlieb Foundation
by Perpetua Press, Los Angeles

Edited by Letitia Burns O'Connor

Designed and composed on a Macintosh II Computer
by Dana Levy
with the assistance of Darlene Hamilton and Agnes Sexty

Display type is Compact and text type is Adobe Garamond

Printed on 128 gsm matte paper
by C&C Printing Co. Ltd, Hong Kong